PRAISE FOR
Jeff Gammage and *China Ghosts*

"A moving geographic and psychological odyssey to China. . . .
Gammage grapples with the challenges presented by fatherhood and
the mysteries associated with taking in a child about whose birth and
upbringing he knows almost nothing. . . . [This] dramatic account will
be a boon to prospective parents who follow in his footsteps."
—*USA Today*

"The most informative and heartfelt book I've read about the adoption
of girls from China. Jeff Gammage has a big and good heart, so he
doesn't shy away from the deepest emotions—positive, negative, and
ambivalent—that come with changing his family so abruptly and
irrevocably." —Lisa See, author of *Snow Flower and the Secret Fan*

"[Gammage's] moving story of that adoption is an emotional account of
a father's love for his daughter." —*Booklist*

"In this riveting book, journalist and author Jeff Gammage asks you
to take a journey with him. Accept his invitation; you will not be
disappointed." —Gloria Hochman, director of communications,
National Adoption Center

"Touching. . . . Gammage's beautifully written memoir, which weaves
together emotionally wrenching narrative with insightful social
commentary, will resonate with any American who has taken the
same journey. . . . What distinguishes this book is Gammage's fine
writing, his unflinching honesty about the losses his daughters will
experience, and his poignant reflection on his own personal journey
as the high-achieving professional becomes the engaged father who
opens his heart to the small things that ultimately matter more than
any assignment at work. . . . In an age of busy-ness and careerism,
that is a lesson for all parents, not just those who have adopted from
China." —*Philadelphia Inquirer*

"*China Ghosts* is rousing, tender, and, at times, riveting. A powerful,
eloquent writer, Jeff Gammage tells the surprising story of his own
family and offers a fascinating look at the poignant, wrenching, life-
altering world of foreign adoption."
—Adam Fifield, author of *A Blessing Over Ashes:
The Remarkable Odyssey of My Unlikely Brother*

"Gammage provides a revealing portrait of the Chinese adoption process and how becoming a father changed his life. . . . A father-daughter love story from a sensitive writer who doesn't neglect thorny issues of race and culture."
—*Kirkus Reviews*

"A passionate and triumphant account of a man's unanticipated love for a daughter from a world away, both geographically and sociopolitically. Written with the eloquence and candor that characterize Jeff Gammage's work, this book places a personal journey in a carefully researched historical context."
—Dr. Rena Krakow, Temple University research specialist in the language development of internationally adopted children

"A love story between father and daughter. . . . Powerful emotions."
—*Washington Post Book World*

"With a journalist's sharp eye, a novelist's imagination, and a once-reluctant father's deep love, Jeff Gammage has created a memoir that is at once global and intensely intimate, full of the awe of new love and the analysis of a seasoned observer."
—Lorene Cary, author of *The Price of a Child*

"As more Americans adopt Chinese children, the bookshelves fill with firsthand accounts of their experiences. Perhaps because many adoptions are preceded by infertility issues, most of these memoirs are written by women. So this, a father's account of going to China with his wife to adopt their first and second daughters, is particularly useful."
—*Publishers Weekly*

"*China Ghosts* is a gem of a book, as informative as it is moving. Smart, sincere, enlivened by philosophical musings on love and fatherhood, it serves both to provide an honest account of Chinese adoption and to reawaken any parent's appreciation of the joys and trials of loving and raising a child."
—Roland Merullo, author of *A Little Love Story*

"Jeff Gammage writes a narrative that is both thoughtful and thought-provoking. While an intensely personal story, Gammage's book compels us to examine the ghosts inherent in our own lives as we create new families and communities through adoption, immigration, and birth."
—Katherine Toy, former executive director of the Angel Island Immigration Station Foundation

Jack Booth

About the Author

JEFF GAMMAGE is a reporter for the *Philadelphia Inquirer*. He lives with his wife, Christine, and their daughters, Jin Yu and Zhao Gu, in Elkins Park, Pennsylvania.

CHINA GHOSTS

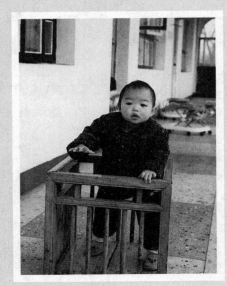

CHINA GHOSTS

My Daughter's Journey to America,
My Passage to Fatherhood

Jeff Gammage

HARPER PERENNIAL

NEW YORK • LONDON • TORONTO • SYDNEY • NEW DELHI • AUCKLAN

HARPER ● PERENNIAL

A hardcover edition of this book was published in 2007 by
William Morrow, an imprint of HarperCollins Publishers.

HarperCollins books may be purchased for educational,
business, or sales promotional use. For information please
write: Special Markets Department, HarperCollins
Publishers, 10 East 53rd Street, New York, NY 10022.

FIRST HARPER PERENNIAL EDITION PUBLISHED 2008.

Designed by Betty Lew

The Library of Congress has catalogued the hardcover edition
as follows:

Gammage, Jeff.
 China ghosts : my daughter's journey to America, my
passage to fatherhood / Jeff Gammage—1st ed.
 p. cm.
 ISBN: 978-0-06-124029-4
 ISBN-10: 0-06-124029-X
 1. Gammage, Jeff. 2. Adoptive parents—Biography.
3. Intercountry adoption—China. 4. Intercountry adoption—
United States. I. Title.

 HV874.82.G36A3 2007
 362.734092—dc22
 [B] 200761204

ISBN 978-0-06-124030-0 (pbk.)

08 09 10 11 12 DT/RRD 10 9 8 7 6 5 4 3 2 1

For my daughters,

Jin Yu

金玉

and

Zhao Gu

兆估

CONTENTS

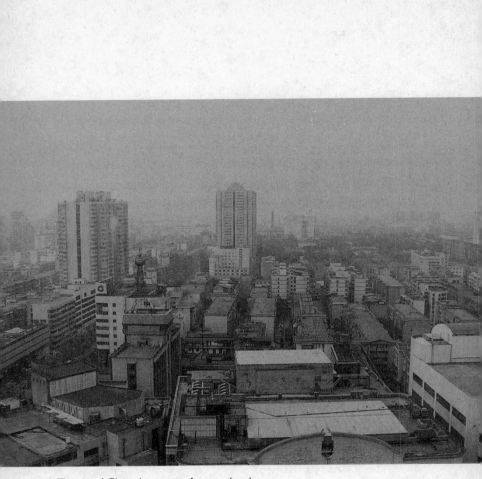

The city of Changsha, as seen from our hotel room

AS SUMMER drifted toward fall, and long months of waiting dwindled to weeks and then to days, I began to dream of her.

This stranger, small and far away. This unknown child.

I didn't yet know what she looked like, had no idea where or how she lived. I didn't know her name. Yet in those final days she came to me every night, her appearance as certain as the moon.

It was always the same dream. A winter night, cold and clear. I'm alone, hurrying through a series of alleyways, moving past darkened homes and shuttered stores. I can see my breath in the frozen air. Farther and farther I go, deeper into the labyrinth of narrow streets. I know she is here, somewhere. I can sense her in the darkness. I'm nearly running now. I can't see her, but I know I am close. And she knows it too. She knows I am coming, and she is pleased.

In my dream, she is willing me forward, faster and faster through the night to her side. She is happy. She is well. In my dream we will be together soon, and we will rejoice, father and daughter.

In my dream, it is all so simple.

THE RICE fields stretch in every direction, an endless patchwork of marshy paddies containing an infinite number of sprouts, all the identical shade of radiant green, all illuminated by the glare of a fierce summer sun. It is like arriving in Oz, a place where even the ground is the dazzling color of emerald.

The bus bounces and dips, groaning as it parts this shimmery ocean of green from atop a ribbon of new, hard blacktop, pushing on toward the city of Changsha. People in the middle rows make polite small talk—where they're from, what they do, who they know.

Not me.

I'm too tired. And too nervous.

I'm sitting in the back, trying to stay alert after days with little sleep, trying to stay calm despite the anticipation of all that awaits. My wife, Christine, sits on the seat beside me, the two of us grouped with thirty other Americans, people we don't know, all of us thrown together to witness some of the most intimate moments of each other's existence.

I'm looking out the window, trying to take in the sight of all that surrounds me, certain that later on I will be questioned about the details of this day, these last hours, before everything changed.

There will not be much to tell.

Today, a Sunday, the highway is all but deserted, and the fields are empty of people and beasts. The jade gloss of the rice paddies rushes to the horizon, where it collides with the royal blue of the sky. The only signs of life, one every couple of miles, are the soaring spires of smokestacks, the flues of small, hand-fed kilns that fire bricks from clay dredged from the fields. The chimneys spew plumes of thick black smoke, inky smudges on the two-color tableau of sky and land.

Changsha is the capital of Hunan Province, the local center of politics, education, trade, and most important for my wife and me, government. The city rests in a valley along the lower length of the Xiang River, a principal tributary of the mighty Yangtze. Most of the province stands south of Lake Dongting, a Yangtze flood basin, and its name means exactly that, "South of the Lake."

Humans have lived here for millennia. Settlers came to this region some three centuries before the birth of Christ, many of them Han Chinese from the north, farmers who set about clearing the forests and woods to grow wheat and rice. Within a hundred years, Changsha had become a fortified city—some of the old walls survive today. During the Han Dynasty, Changsha served as the capital of its own kingdom. During the Song, it gave birth to the famed Yuelu Academy.

By the 1850s, word of the area's fertile fields and abundant harvests had circulated far and wide, attracting waves of new settlers. Soon the province was home to more people than it could support. And soon the rich soil was sown not just with dung but with blood. Landowners began to force out tenant farmers in the early 1900s, bringing death by riot and famine. In 1927 the peasants rose up—not for the first time, but this time with arms—in a battle that became known as the Autumn Harvest Uprising. The man who led the people in that fight was a headstrong Hunan native named Mao Tse-tung, who was born not far from Changsha. It was from the Hunan-Jiangxi-Province border that Mao and his loyalists later launched the Long March, the storied, strategic retreat to Shaanxi that allowed the Communists to regroup and, ultimately, to conquer China and establish the People's Republic.

Today Hunan's capital is known for its ancient tombs, its Neo-lithic pottery and bronzes, for the scenic appeal of Mount Yuelu, which lies like the profile of a sleeping giant, a natural barrier to the

west. But Changsha is no tourist haunt. And it's not a pretty city. During the 1940s, the nationalist Kuomintang Army burned parts of Changsha to the ground as the soldiers tried to root out the Japanese. Much of what remained was cleared during more recent modernization campaigns that have turned Changsha into a nondescript capital of gray governmental buildings, big white-tile offices, and incessant smog.

As I stare out the window, I wonder if my daughter will care. About this place. About these people.

I wonder if it will matter to her that the people here take great pride in their tongue-scalding, chili-pepper cooking, and in their local style of opera. That their hand-stitched, double-sided Xiang embroidery is regarded as among the most exquisite in the world. That monuments to Mao can be found across the region, his office in Changsha a museum, buses and trains running daily to the shrine of his birthplace in the mountain village of Shaoshan.

I wonder if she will care that people here followed the chairman with heart and mind, that they were slow to embrace the economic reforms that followed his death. That today, Hunan ranks among the poorest provinces in China. That, despite the passage of long centuries in which dynasties rose and fell and even Mao himself passed from the scene, most people here do what their families have always done: grow and harvest rice. The breakneck speed of modernization in other parts of China has done little to free them from backbreaking labor.

Slowly, over miles of fresh highway, the rice fields give way to low-slung brick houses, and then to more modern buildings and office towers. Tall apartments appear on either side. The sidewalks grow crowded with people. The bus brakes as it's absorbed into the swarm of downtown traffic. We Americans draw stares and pointed fingers. A woman on the back of a motorcycle flashes the peace sign.

A laborer, his face smeared with dirt, waves hello from his seat in the bed of a pickup truck. A man in a dark suit, behind the wheel of a fine car, looks up at us, unsmiling.

I study the faces of the people on the sidewalk and in the street, searching for a resemblance to the small face on the photo in my wallet. But I see no one I recognize. And no one recognizes me. I'm a stranger here, a visitor to this land of rice and revolution, come halfway around the world to make good on an offer and a promise.

Five weeks ago, representatives of the Chinese government sent me a letter and a photograph, a snapshot of a little girl. They said they had chosen her to be my daughter.

The bus bounces across a rough patch of sidewalk and up a paved entryway, stopping outside the translucent glass doors of the Xiang-quan Hotel on North Shaoshan Road. One by one, bleary-eyed travelers file off the bus, led by two adoption agency guides, the leader a smart young woman from the city of Xian, home of the famous Qin terra cotta warriors. Like many contemporary Chinese, she has taken an American first name, Mary. She is shortish, of medium build, neither fat nor thin, commanding of a certain authority. In a brief time she has molded a crowd of flustered, jet-lagged Americans into something resembling a cohesive travel group, marrying the skill of someone who has done this a thousand times with the enthusiasm of someone who is doing it for the first.

The hotel lobby is a cavernous, U-shaped sweep of cream-colored tile, the shiny squares continuously washed and wiped by rotating teams of workers. You can see your reflection in the floor. A small gift shop sells jade and porcelain, and the guest services office offers access to the Internet. Unlike the stolid, Soviet-style hotels of the old Eastern Bloc, this residence could fit comfortably into any midsized city in the United States. It even has Western toilets.

Still, it's an odd place to become a father. It's not a hospital. Or

even home. Home is a northern suburb of Philadelphia, where I write for a newspaper, the *Philadelphia Inquirer,* and where Christine mends children's psyches as a school psychologist. Home is an old, rambling Colonial Revival near a train station. Home is a place that needs a child.

But what had been advertised as a breezy, nine-month jaunt to parenthood has, after a slowdown by Chinese officials, turned into a grueling eighteen-month marathon, one that's pushed both our patience and our government approvals to the edge of expiration. In the past three days, we have flown seven thousand miles, hiked the broad thoroughfares of Beijing, whisked from the Forbidden City to the Summer Palace, hopped on another plane and flown nine hundred miles more to the Huanghua Airport near Changsha. We've smashed through eleven time zones—losing twelve hours, ten pounds, and one very expensive camera.

At the front desk, check-in takes forever. None of the hotel staff speaks English, none of the Americans more than a few words of Chinese. There's confusion over room assignments. Christine and I are well traveled, having been to Germany and Switzerland, England and Austria and France, but this is different. The language is more than a barrier. It's a wall. If there was a fire, we wouldn't even know how to shout for help.

Mary instructs all of us to go to our rooms and wait—she'll call when the children arrive, delivered from an orphanage in the city of Xiangtan, an hour's drive south of here. My fatigue is not distracting. It's disorienting. The upward glide of the hotel elevator induces vertigo. When the car stops on the twenty-third floor, I need to steady myself against a wall before undertaking the forty-step walk to our room.

Our quarters are small, and made smaller by the bulk of an empty crib. For a moment I think there has been a mistake. What do Christine and I need with a crib? Then I remember.

After eighteen years together, we are down to our last hour or so as a couple. By dinner we will be a threesome. The time does not feel precious. But it does seem strange to stand so firmly atop a generational fault line, to know for sure that in an hour you'll be a parent, to understand that your old life is disappearing before your eyes, that a new one is about to begin.

Mary told us to stay by our phones. And no one can stand it.

Up and down the hallway, doors are propped open, anxious about-to-be parents wandering in and out of their rooms. Each distant jangle of a telephone jangles nerves as well, driving the people in the hall into their rooms and the people in their rooms out into the hall. I restlessly join the back-and-forth parade, reporting each new nondevelopment to Christine, who sits serenely in a wooden chair, her legs tucked beneath her, finishing the last pages of a novel.

After forty minutes of pacing, I notice the couple across the hall heading for the elevator. They seem to be moving with a certain assurance. And they're carrying a diaper bag. Down the hall a door claps shut. Then another.

That's good enough for me. I'm not waiting any longer.

"Let's go," I say to Christine.

We're halfway out the door when our phone rings. I rush back and grab the receiver.

"William?" a voice says. It's Mary. Who else would be phoning us in China? She calls me by my legal name, the name I've typed or printed onto countless government forms and applications during the last two years. In the United States, the only callers who ask for William are hoping to sell me new rain gutters.

"William?" she repeats. I hadn't answered the first time. "Your baby is here."

"We'll be right there," I say. As if waiting was an option.

A little more than a month ago, well over a year after we had sent

a thick dossier to the China Center of Adoption Affairs in Beijing, a FedEx envelope arrived at our front door. It contained three pictures of a girl, age two. She had eyes colored dark brown, almost black, and a mouth shaped like an upside-down Valentine's heart. An accompanying letter said her name was Jin Yu, and her health was "normal." It said she was frightened of people she didn't know. And that she loved the color red.

The authorities said Jin Yu was living in the government-run Social Welfare Institute in Xiangtan, an industrial town about forty miles from Changsha. They said if Christine and I would promise to always love and care for Jin Yu, to educate her, to never forsake her, then she could be ours. We put an "X" in the box marked "accept" and sent the letter back.

The elevator starts down, bobbing to a stop on the twentieth floor. The doors slide open. The hallway is warm, the air-conditioning weak.

I feel like an actor in a play, about to walk onstage before a full and expectant house. Except I don't know my lines. Or even the plot. As if I have boarded a roller coaster, realizing too late, after the shoulder harness has locked and the machine begins to glide forward, that the ride is going to speed higher and faster than I ever imagined. Realizing that, despite years of dedicated effort to get here, to this point, to this place, to a pedestrian hotel in a colorless city, I may not be ready. Realizing that the deadline for such hesitation has long since passed.

We turn the corner toward Mary's room.

It's a mob scene.

THE FIRST time I ever thought about China was in grade school when I was assigned to write a class report. It was known as Red

China then. Or at least that's what Americans called it. I chose a sheet of bright red construction paper as a logical cover.

As an adolescent, I glanced at the television news long enough to notice Nixon plodding along the Great Wall. In my late twenties, I watched a little longer as the tanks rolled into Tiananmen Square.

After that I didn't pay much attention. To me China seemed not just foreign but removed, a place of constant internal turmoil and incomprehensible political struggle. And if China was far off, then adoption was a different world, a planet inhabited by another species of human beings, people not like me. My perception of adoption came straight out of a Mickey Rooney movie—healthy, freshly clothed children, plucky if a bit down on their luck, being organized into intramural baseball teams by a benevolent parish priest.

For people like me, born in the late 1950s near the end of the baby boom, having children was not a duty or even an expectation. It was an option. Children were something you embraced once you had decided you were ready. Once you had concluded that you were mature and independent enough to take care of someone else, someone smaller and weaker. For Christine and me, that moment of clear choice and full preparation lingered always in the distance, forever growing nearer but never quite in sight, a decision delayed and put off and postponed until the day we discovered that, without our ever noticing, the time we had been allotted to bear children had expired.

We figured adopting a baby would be fast and practically effortless. We figured that as healthy, law-abiding members of the middle class, a child would be waiting for us, that the friends and relatives who spoke so assuredly of "all the unwanted children who need homes," knew what they were talking about. We figured there was bound to be a large government bureaucracy that sought to match childless couples with parentless children, that pretty much all we would have to do was phone and put our names on the list.

We didn't know anything.

In the United States there are indeed thousands of children in the foster care system, many of them older. But there are not nearly as many healthy, newborn babies as there are people who want one. People compete for those children, and that competition is intense and expensive and often bruising. Christine and I discovered that by the time a couple successfully adopts, they may have spent years searching across the country for a baby. They may have been interviewed and rejected by pregnant teenage girls seeking just the right couple to raise their as-yet unborn children. They may have had a baby placed in their arms—and then taken away, reclaimed by the birth family after everything seemed final. We learned that for those couples the lost child remains forever on their minds.

Christine and I didn't think we could take the emotional beating that domestic adoption seemed to promise.

We began to consider adopting a child from another country. And at first the prospects overseas seemed equally dispiriting. Romania's program was stumbling toward collapse. Vietnam was in similar disarray. Cambodia was a purgatory, Thailand unpredictable, Guatemala shaken by accusations of baby trafficking. Poland preferred prospective parents to be Polish, and Kazakhstan wanted them to stay for a month. Russia required two trips overseas, which seemed excessive, even as American newspapers carried accounts of adopted Russian children suffering from harrowing developmental disabilities.

The more we read and the more we talked to other parents, the more we were drawn to China. The adoption system was operated by the central government. The rules were posted, the same for everyone. You didn't need a lawyer to figure it out. You didn't need a lawyer at all.

All applicants had to complete the same three-part procedure.

First, the paper chase, the creation of a dossier in which would-be parents must document virtually every aspect of their lives, from the shape of their house to the size of their bank account, to their philosophies of religion and child-rearing, to the health of their hearts and their heads. Second, after all that data have been gathered and forwarded, comes the wait, the months of torturous inactivity while the Chinese government sets about matching the prospective parents with a child—a child almost invariably female, abandoned by her Chinese family. Third, and last, comes travel—the exhilarating two-week journey to China to complete the final stages of the Chinese and American paperwork, meet your new daughter, and bring her home.

To Christine and me, China promised stability and certainty. At the end of the process, however long and demanding it might prove to be, we would have a child. And no one could take her back.

Surprisingly, picking the country was easier than choosing an adoption agency. On the surface the agencies all look pretty much the same. They're not. Adoption agencies are alike only in the sense that teachers or doctors or attorneys are alike: all have a basic certification to practice, but beyond that there's wide disparity. Many agencies are highly skilled and experienced, others moderately staffed and able, some barely competent. Some programs trumpet narrow advantages and ignore major failings.

Christine and I eventually signed on with a Texas-based agency, Great Wall China Adoption, informally known as Great Wall. Friends teased that the name sounded like a Chinese restaurant. But we liked that Great Wall handled strictly Chinese adoptions. We thought the staff would know the intricacies of the process and the country. Great Wall even maintained a satellite office in Beijing. We figured that nonprofit businesses are still businesses, and we wanted an agency whose financial interests were inextricably entwined with our familial desires. Because it worked solely in China, Great Wall

couldn't expect to offset a failed Chinese adoption with a successful one in Guatemala or Russia. The agency had all its eggs in one basket, and that was exactly how we wanted it.

Still, as we explored Chinese adoption, we never felt like we were hearing the full story or getting all the information we needed.

As we evaluated half a dozen agencies, reading their literature and Internet websites, we couldn't find a single one willing to openly acknowledge a few hard truths: That the smiling, teddy bear–cuddling kids pictured in the brochures can bear little resemblance to the real children who arrive malnourished or sick with parasites. That some adopted Chinese children may be slowed by painful joint ailments brought on by chronic inactivity. That they may suffer from nightmares that go on for years, or even from diagnosable psychological conditions like post-traumatic stress disorder. That in the isolation of the orphanage, some kids may have learned to comfort themselves by bashing their heads against the sides of their cribs.

Except in the finest of fine print, the agencies tend not to mention that between the time you fall in love with the photograph of your daughter-to-be and the time you arrive in China to claim her, she may have become desperately, irreversibly ill.

These things we found out for ourselves.

THE CROWD at the front of Mary's hotel room door is a full-scale scrum, all elbows and knees, people jostling for position. Christine and I are nearly the last to arrive, stuck at the rear of the pack. All I can see are the backs of people's heads.

Mary's door is open, a last invisible barrier to parenthood.

Those at the front of the crush can see the children, can hear them, call out to them.

"Ni Hao! Ni Hao!" the grown-ups shout. *Hello! Hello!*

The only response is an occasional loud giggle.

Cameras flash like faint lightning, the dim corridor illuminated by the weird sway of video camera lights. The hall smells like dust. It's stuffy with body heat. Someone in the center of the crowd begins to break down, taking in loud, tear-drawn breaths. I can hear Mary but can't see her, approximating her location by the sound of her voice. Her English is sharp and formal as she takes roll call, counting the families by number.

We are minutes from becoming parents.

I think, *This is a moment I'll remember the rest of my life.*

And I feel terrible.

Not for myself. For the child who is about to become my daughter. For the children who surround her.

The little girls in this hotel room, at this moment so busily chasing one another across the carpet, have no idea how perfectly their lives are about to be rent. They have no way to imagine the wrenching change they'll be forced through, to comprehend how neatly their existence is about to be severed into Before and After, how completely they'll be swept from everything they've ever known.

Christine leans against the hallway wall. Throughout this long and winding process, through endless, unexpected delays and reversals, she has been calm to the point of tranquillity. Nothing could dent her spirit or knock her confidence. Now she is near tears. She has waited so long for her child. Through eighteen years of marriage. Two years of adoption procedures. A month of travel preparation. Three days in China.

And now, apparently, we're going to wait a little longer.

Mary has disappeared back into her room to juggle some last piece of paperwork.

Our travel group is not just big, it's gigantic, two or three times the usual size—fourteen families accompanied by an entourage of

helpers and older children. Even if Mary moves quickly, which she probably will, and if everything goes smoothly, which it probably won't, the joining of parents and daughters could take an hour or more.

I find a spot against the wall beside Christine. At forty-two, she is still slight and girlish, the first lines of gray only now beginning to weave highlights into her hair. We settle back for this last wait, this final delay, when Mary reappears at her door, papers in hand, all crispness and efficiency.

"Okay," she calls out. "First family, the Gammages."

People turn toward one another, trying to sort out who is who. Are you the Gammages? Are you? You?

Slowly, every head swings toward us, the couple at the back.

Why are we first? I don't know. On the travel roster we're family number three. Later, when this trip is over, I will have other, more important matters to consider, and the time to ponder them, to contemplate the things that happened in China and the things that didn't but should have, to mull how events that seemed trivial at the time will weigh on us forever.

The crowd begins to part, people shuffling back to create a narrow aisle. I grab hold of Christine's hand. It is only a few steps to the door.

CHILDREN LOST AND FOUND

AT BADALING, the steps of the Great Wall are as smooth as river rock.

The center of each thick slab bears a deep indentation, the stone worn away by the small, steady pressure of millions of tamping feet. As sojourners move upward, they must carefully fit each foot into each succeeding groove, lest they land awkwardly and trip. It's a long fall to the bottom. Here the wall goes nearly straight up, more the Great Staircase than the Great Wall.

As I trudge on, I'm thankful that during one of the wall's periodic restorations, someone had the presence of mind to equip this most ancient of structures with the most simple of modern conveniences: a handrail. The thick metal tube is warm in my grip, heated by the summer sun.

The first sections of the Great Wall were built three hundred years before the birth of Christ, the last nearly two thousand years after that, a defensive barrier to block Mongol and Manchu invaders from the north, a deft psychological warning to all who would

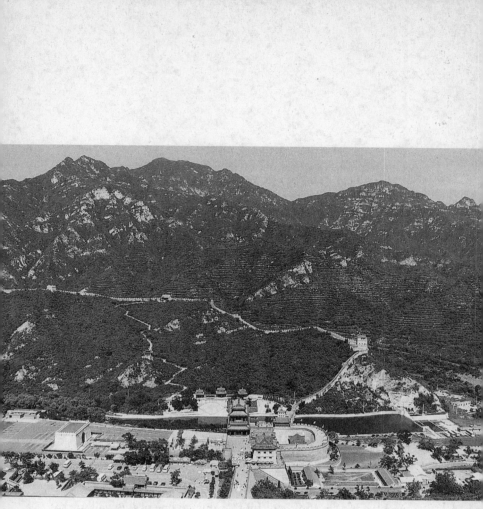

The Great Wall at Badaling

question China's resolve. The wall stretches nearly the breadth of China, from the eastern fortress of Shanhaiguan, near the Yellow Sea, to the Gobi Desert stronghold of Jiayuguan, which marks its western terminus and once marked the western edge of the empire.

The wall's precise length is a mystery. It's not contiguous. The Great Wall began as several different segments, built in stages across millennia, its sections connected or left separate as the current ruling dynasty decreed.

Today, some parts lie buried beneath sand or water, and others are crumbling, battered by harsh weather, encroaching desert, and perpetual neglect. The visible sections traverse an estimated 4,100 miles. To walk from one end to the other would be like hiking from Washington, D.C., to Salt Lake City, Utah—and back.

The wall at Badaling is relatively new, at least by Great Wall standards. Construction began in 1368—just after the Black Plague wiped out much of Europe, just before Chaucer began writing *The Canterbury Tales*—and continued for two centuries. It's guarded by nineteen watchtowers, early signal posts from which messages were transmitted by firelight at night and during the day by black clouds of smoke created by the burning of wolf dung.

Today, no one burns animal dung on the wall. And the only soldiers who prowl its battlements are People's Liberation Army troops on leave. These days the wall is under attack by a different invader, one against which it can offer little defense: tourists. Thousands of them are just like me. Americans looking to wander across one of the world's great monuments, to make some small, spiritual connection with old China, and mostly, to kill a day or so while they wait for their life to change, wait for the flight that will carry them north, south, or west and into the arms of their child.

Our adoption agency has dropped our travel group here a day before we are scheduled to receive our daughters, part of a twenty-

four-hour cram course on Chinese history and culture. It's a chance to pacify our psyches with exercise, to try to take our minds off the only thing anyone can think about while our bodies figure out whether we should be eating dinner or breakfast.

I stop halfway up the mountain to the first watchtower, trying to catch my breath. The air is thick, the view hazy. Christine is a dozen steps behind. My legs are weak, from strain and suspense. Standing there, panting, one thought is clear:

I never wanted children.

Not one. Not once.

That's the truth.

I never saw the need.

People nurse their pet peeve. Mine has always been redundancy. Needless duplication. When I was in my twenties, prime child-raising years, I saw no need to add more demanding voices and hungry mouths to an already noisy and starving world. Nor did I wish to take on the hour-to-hour grind of tending a new baby. However much people may coo and cluck, the fact is there's nothing as boring as a baby. Food in, food out. That's pretty much the day.

Christine and I had crafted a satisfying life, both of us working at jobs that kept us engaged and fulfilled. We got used to living on two salaries. If we felt like going out to dinner, the only question was Italian or Indian. If we wanted to go on vacation, the question was mountain or ocean.

The prospect of scrimping to buy Huggies did not fill me with joy.

Older kids I met—not that I sought them out—often seemed to be saying something rude to their parents, the people who labored to feed and clothe them. The people who, in the face of their children's shocking disrespect, opted to sit mute, wearing frosted smiles, unable or unwilling to assert themselves or even acknowledge that their kids were ill mannered.

Now, twenty years on, a day from my own fatherhood, I can see that I was judging these kids not as small people-in-training, but as full-grown adults. That was unfair. But at the time it hardened my view: Who needed the headache? The financial burden? The responsibility? Assuming stewardship of a human infant—a creature that would die if left to its own resources—was not a challenge I wanted.

By temperament and profession, I'm an outsider, an observer. Politically I'm a registered independent, voting for whomever I think might do a better job. As a journalist, I've long honed my detachment. My job—my passion—is to tell people's stories, not to heal their souls or bind their wounds. I've watched parents weep on their children's caskets and seen demonstrators beat one another bloody with sticks, and never felt an inclination to intervene. So why would I deliberately create a being who would require my constant intervention?

Besides, and most of all, I had Christine. And with her I was complete. I didn't need a family. In her, I had a family, less a separate person than my other better self. To me, our "we" was a fully populated universe, one in constant, pleasurable motion, filled with travel, concerts, movies, books, plays, and sports.

We married at twenty-four—kids by today's standards. Lord knows what she saw in me. I didn't see it. But I know her gentleness softened me, made me a better and more caring person, and I reveled in being the man she loved.

It was also true that, even after marriage, after years away from my parents and my childhood home, living in different areas of the country, part of me continued to enjoy the limelight that came with being an only child. I liked having each new job and promotion applauded, as all my achievements had always been, since the day I'd taken my first steps. If a family is a play, with different members

assuming different roles, then I had the lead, and I'd grown comfortable in the part. When it came to the subject of having children, the role of Most Important Person in the Story of My Life was already filled by someone infinitely better suited for the job: me.

I didn't need an eight-pound understudy.

But by my mid-thirties, the chorus of family members who had cheered at every hockey game and graduation was growing old, and those already old, frail. More and more, instead of being the person for whom others felt responsible, I became responsible for other people. A life comfortably structured as a triangle—a thick base of attentive support at the bottom, ascending to me at the pinnacle—turned inverse, the pointed weight of others' age and illness pressing down. I learned—later than most, to be sure—that people you love can die quickly, without warning. And that others can die too slowly, after long and needless suffering.

Once, when I was a teenager, I was desperately sick with mononucleosis, two weeks racked with fever, unable to eat or even stand up. I remember my father sitting next to me. He was not a demonstrative man. In all the years I knew him, I never heard him say, "I love you," though of course even as a teen I knew he did love me, knew that if I'd asked him for a limb he'd have gladly hacked one off. He sat there beside me, silent, and when he finally spoke it was almost as if he were speaking to himself.

"Jeffrey," he said—he only called me Jeffrey when he was deadly serious—"If I could, I would take your illness from you."

And at the time I thought, *Whatever does he mean?*

By the end of his life, I knew too well. Listening to every heaving rasp as he fought to breathe, his ruined lungs unable to draw air, I found myself speaking the same words to him, telling him how, if only it were possible, I would eagerly trade places.

When he died, it was plain, at last and even to me, that this sup-

portive group of family members had always had other demands on their time, other people they needed to see and things they needed to do. I saw that their faithful participation in the details of my life was not my gift to them, but theirs to me.

Where children were concerned, that realization did little to change my mind. But perhaps it opened my heart.

Most of all, as Christine and I edged into our late thirties, she became impatient to have kids. To her, children were the biggest and most important part of a long-imagined future. Children would make everything better—holiday celebrations, vacation trips, outings to the grocery store. Home would be a place where we wanted to live, strewn with toys and happily disorganized, not just another temporary rental in a new city.

Time was running out. The human body was not designed to readily reproduce after forty.

And I wanted Christine to be happy. She deserved it. She is a person who asks for little, who gives more to others than she ever seeks for herself. A woman who faces hardship without complaint, whose instinct in the face of calamity is to roll up her sleeves, not crumple in a heap. She had always done all she could for me. I could do this for her.

So I gave in. We tried. And we failed. The details are unimportant.

What's important is that at the end, when the doctors with their magic patches and glistening balms had done what they could, Christine was bereft, as wounded as a human being can be. She is by nature an optimist, discarding every bad today in belief of a better tomorrow. Now it was as if she had lost the ability to envision a future, as if she had taken a blow from which even she did not believe she could recover. She was hurt in her soul.

I came downstairs early that morning, not long after we'd learned

that we two would not produce a third. Christine was already up and sitting at the dining room table. The newspaper lay folded in front of her. Her cup of coffee was untouched and growing cold. She loves the sunlight, but that morning she seemed not to notice the beams streaming through the dormer window. It might as well have been raining.

She sat very still, as if painted onto a canvas background, and she looked so tired and beaten that I didn't speak. It took her almost a minute to notice me standing there. Finally she lifted her head.

"Would you be willing to adopt?" she said.

"Of course, definitely," I said.

I had no idea what I was agreeing to.

I only knew that she was in pain, and I wanted it to stop. That I had the power to make it stop.

That morning, I didn't know much about adoption or about China. But I learned fast.

EVERY SCHOOLCHILD hears how the Chinese invented gunpowder. And kites. And cannons.

They invented paper. And printing. They invented fireworks and fans, the magnetic compass and the wheelbarrow, created the planetarium, the blast furnace, and a process for casting iron. They found ways to turn long poles of bamboo into toys, baskets, and houses.

In the last decade or so, the Chinese invented something else: a world-leading adoption program.

In 2005 China set an all-time, one-year record for foreign adoptions to the United States, sending 7,906 children to new homes here. In 2006 the figure was 6,493. China has led the world in adoptions to the U.S. in each of the last seven years and in nine of the last twelve.

Thousands of other Chinese kids go to households in Canada, the Netherlands, and Spain each year.

China's ascendance is a new phenomenon.

As recently as 1990 the Middle Kingdom didn't complete a single state-sanctioned adoption to this country—or any other. The Chinese government wasn't interested in foreign adoptions. And for the most part, Americans didn't think to ask. They focused their attention on other lands, particularly South Korea, then the established, traditional leader in adoptions to the United States.

People in this country started to adopt foreign-born children at the end of the Second World War, in 1945, drawn by a desire for larger families, and prodded by news images of pitiful orphans scouring the ruins of bombed-out towns and villages around the globe. Children were adopted from war-ravaged Europe, particularly Germany, and even from hated, defeated Japan. In the late 1940s, while European nations recovered and rebuilt, Greek children arrived here as their country fought a bloody civil war. The outbreak of the Korean War in 1950 commenced a new surge of adoptions, a migration encouraged by news coverage that publicized the children's plight. Evangelicals Harry and Bertha Holt became well known, and emulated, after they adopted eight Korean War orphans and arranged for the adoption of scores more. For most of the next forty years, South Korea would be the top source of foreign adoptions to the United States.

That trend started to change in the early 1990s as South Korea came under criticism from its northern sister for exporting its children. By the middle of the decade the turn would be dramatic.

In 1992, South Korea, as usual, ranked first among adopter nations, delivering 1,840 children to this country. China, taking its first tentative steps in a new realm, placed tenth, with 206 adoptions, behind countries like Paraguay and Honduras. But within two years

China had surged to third place. That growth occurred even as nations such as Guatemala and Russia began to rapidly enlarge their programs and places like India and the Philippines held steady. In 1995, China became this country's leading broker of overseas adoptions. It has ranked first or second every year since.

During that span, from the early 1990s through 2006, the Asian giant sent nearly 62,000 children to the United States. The effect in this country has been extraordinary, altering not just the makeup of individual families but the common assessment of who belongs to a family and how one may be formed. Sometimes it can seem as if almost everybody knows somebody who has adopted a child from China. These biracial families represent something new on the societal landscape—no longer fully American, certainly not Chinese, but not Chinese-American either. They celebrate Christmas and Hanukah, Easter and Passover, but also the Autumn Harvest and especially Chinese New Year. In their homes, frozen dumplings share freezer space with carrots and peas, and on weekends, peewee soccer games may be followed by Mandarin lessons.

The rising wave of Chinese immigration has fueled the growth of a new industry, led by the adoption agencies. The biggest—Great Wall China Adoption among them—complete several hundred adoptions each year. Dozens of smaller, specialized businesses swim beside them like pilot fish, offering adoptive parents every product or service they could need or imagine. If you want a cookie cutter shaped like China or a silver pendant bearing the Chinese characters for "Forever Family," if you need a map of your daughter's hometown or a case of moon cakes shipped to an orphanage, there are companies ready to help. For a fee, of course.

The explanation for why so many people choose to adopt from China is complicated, based on the laws and characteristics of this society and that one, and in the nature and makeup of traditional

families here and there. The biggest reason is perhaps the most simple and obvious: the dearth of healthy, newborn babies available for adoption in this country. Domestic adoption statistics are notoriously unreliable, but the best estimate of the National Council for Adoption is that within the United States, the number of traditional adoptions peaked thirty years ago, at a relatively small 89,000. Today the council estimates that only about 20,000 infants are placed for adoption each year. The respected Evan B. Donaldson Adoption Institute believes the figure is even lower, maybe 13,000 or 14,000.

Why so few? Because society has changed. Unwanted pregnancies have been curtailed by the availability of birth control and legal abortion. The social stigma that once attached to out-of-wedlock births has diminished, if not disappeared, so fewer unmarried mothers decide to place their children for adoption.

As a result, in this country the number of want-to-be parents far surpasses the number of healthy babies. In China, healthy babies abound.

No one knows how many children are living in Chinese orphanages. Not for sure. Different agencies and researchers have produced widely divergent estimates, anywhere from 20,000 to a million or more. In 2006 the Chinese government announced that its orphanages held fewer than 69,000 children, a number that seems impossibly low.

What's certain is that China is spending millions of dollars to maintain a vast system of welfare institutes, a network that reaches across the country and is particularly extensive in the southern provinces. It's also clear that only a fraction of the children living in the orphanages eventually leave for new homes and new families.

Why does such a system exist? How is it that a government can fund and operate a huge organization of orphanages filled with girls, in the same way it runs a highways department filled with trucks, or

an army filled with soldiers? The reasons are old, new, and myriad. When Mao called on the people to build large families as a means to increase production and propel China forward, mothers and fathers obeyed—and the resulting baby boom put a serious strain on the nation's resources. Mao died in 1976, and in 1980, frantic to reduce the growth of a population that had surged past one billion, the government introduced the one-child policy. The idea was twofold: to avoid widespread famine, which had killed millions in China as recently as the early 1960s, and to improve living standards by controlling the number of people who would be competing not merely for jobs and education but for the most basic resources—land, food, water, energy.

Problems emerged almost immediately, as the government's strict birth-planning strategy ran into the equally firm traditions of Chinese society.

The percentages have shifted in recent years, but what was true in 1980 is still true today: most Chinese live in the countryside, where parents depend on children to help work the land and harvest crops. The parents desire sons—and not only as farm hands. In China, the son is raised to be the scion of the family. The son continues the family name and bloodline, inherits land and property, and, crucially, takes on the responsibility of caring for his parents as they grow old. Sons are considered lifelong members of their father's family, while daughters are little more than years-long visitors, eventually to marry away and help support the parents of their husbands.

With the advent of the one-child policy, the pressure to produce sons became intense, and the risks to newborn daughters grave. Girls might be immediately put to death, smothered or drowned. Or, following the introduction of ultrasound technology, they might be aborted in the womb. By the middle of the 1980s thousands of baby girls were being abandoned, set down in parks, department stores,

and markets, on the steps of hospitals and government offices, in bus stations and railway depots.

Not surprisingly, many Chinese disliked the one-child policy. And the government paid attention, eventually, and at least to a degree. The law came to be applied with some flexibility, becoming more of a "one-son-or-two-child" policy. That is, if a couple's first child was a son, then their family was considered complete. They could have no more children. If their first child was a daughter, they could have a second a few years later, making another try for that elusive son.

The hope was that this new elasticity would reduce the number of abandonments.

It didn't.

In fact, China scholar Kay Ann Johnson, a researcher at Hampshire College in Massachusetts, documented how just the opposite occurred: a slightly less onerous policy began to be much more actively enforced. Soon, the sheer numbers of girls entering the system threatened to overwhelm the orphanages. So in 1992, the government installed a kind of pressure-relief valve: it began to allow foreigners to adopt Chinese children. Within a few years Americans were going east in droves.

Today, the demand for sons is, if anything, greater than ever. With the erosion of the "Iron Rice Bowl," the cradle-to-grave welfare provided by the socialist state, more and more Chinese face an uncertain future. A son, functioning as a built-in social security system in a country with no social security, becomes not just desirable but essential. At the same time, the government exerts relentless pressure to keep families small. People caught with "extra" children may be heavily fined or fired from their jobs. Mothers may be involuntarily sterilized. Pregnant women may undergo forced abortions, even late in their term.

Like many other aspiring American parents, Christine and I started out knowing little of this broad and tortured history, of the countless private agonies imposed by the one-child policy, of the numerous ways in which we would benefit from other people's misfortune. When we sent off our application, all we really knew was that we wanted a child, and China seemed to have an excess of children.

We found, disturbingly, that the brutalities of the one-child policy transformed into big advantages for people like us.

The abandoned Chinese children are generally healthy. Illnesses like fetal alcohol syndrome, which plague Russian adoption, are practically unheard of. Many Chinese farmers barely earn enough money to feed themselves and their families—they certainly can't afford to buy alcohol or drugs. Amidst chilling stories of black-market baby sales in other countries, the one-child policy gives Americans assurance as to why the Chinese children are available. And, in an age of ever-increasing litigation and information access, adoptive parents can be certain that no distraught Chinese birth mother will appear at their door—or in court—and demand the return of "her" child.

Through her interviews with Chinese families, Johnson determined that many of the abandoned children are in fact second daughters, surrendered by couples still seeking a son.

Because China has made it illegal not only for its citizens to have additional children but also to formally place a child for adoption, the girls, and the occasional boy, are surrendered in secrecy. Chinese mothers and fathers who leave a baby on a park bench may watch from a distance to be sure the police arrive, but afterward they know only that the child is in the hands of the authorities. When that child is transferred to an orphanage, the administrators there know only that another baby has been placed in their care. If the child is eventually adopted, that secrecy is extended all the way across the sea.

The birth parents in China have no way to know if their child has found a new family. And the adoptive parents in the United States have no way to tell them.

I TAKE hold of the stones on either side of the doorway and pull myself up and into the watchtower. The humid air makes it hard to breathe. My shirt is soaked with sweat. But it is cool inside the fort, the piercing summer sunlight dulled to grayness.

Below me are hundreds of steps, above me thousands more. Looking out across the vista, wall and mountain appear to combine as one, the dragony scales of the battlements leaping and diving as they snake across the peaks. Looking down through the doorway, I see small bursts of color, bright against the wall, triangular flags of gold and blue and pink mounted on the ramparts. I see Chinese children, all boys, shouting to their parents, who linger a few steps behind. The only Chinese girls I see are those holding tight to the hands of their American parents, come back to adopt new sisters.

Christine has stopped several steps below, looking out into the distance.

Back home, as our wait dragged on, as friends replaced "How are you?" with "Heard anything yet?" the distance and time between our daughter and ourselves became more and more the focus of my day. I had expected that I would like her, that sharing my house and my life with a little girl would be, well, fine. I did not expect to fall in love with her. To fall in love with a photo. In the mornings, as I began my day, in the kitchen, I would wonder how she was concluding hers, in an orphanage. If she had played with a friend. Gone outside. Gotten enough to eat.

After making the commitment to adopt, I had finally asked myself, *Why not? Why not be a father?* What was I doing that was so

important, so vital and necessary to the world, that I was too busy to be a dad? The answer: not a thing. Not a single thing. On the days when I happened to be away from work, off on vacation or out sick, the newspaper still thudded to a stop on people's driveways, just like always.

If I'd shed the need to stand at the pinnacle of my family, I'd retained my distaste for redundancy. And China spoke to that. The efficient matching of kids who needed parents with parents who wanted kids seemed to me the completion of a certain logical symmetry. Every child deserves a chance, and from what I could tell, the kids in the orphanages weren't getting one. Maybe I could be a little girl's chance. Maybe she could be mine.

Sitting there in the shade of the watchtower, the bricks of the Great Wall warm against my back, I pluck Jin Yu's picture from my wallet. The photo is a head shot, her face big against a red background. Her hair is shorn, her expression downcast. She looks grim as a prisoner. But I also see, or think I see, an underlying determination. Chinese babies can come and go from orphanages. Six months, eight months, a year, and they're gone. Not her. She stayed. After more than two years, she waits. She stares at the camera with glum defiance, as if to say: I've taken all life can throw at me. I can take more if I must.

The sun is dropping, beginning its late-afternoon slide toward the horizon. Christine and I will have to start down soon, to pick our way across the steps before fatigue and cramps overtake our legs. I am eager to get moving, to push this day forward into tomorrow.

I wonder if Jin Yu will come here someday, to the Great Wall, perhaps to this very spot, to the shady enclosure of this tower. I wonder if this greatest symbol of China, this wall that reaches from ocean to desert, will hold weight and meaning for her. Or if, after years of an American upbringing, it will seem as remote as the monuments of Greece.

Friends who had traveled here told me that walking on the Great Wall generates a sense of disbelief. That it feels like walking on the moon, so alien that even the sky seems different, a place you recognize from a thousand pictures but never expected to see in person. They talked of how they felt humbled to walk in the steps of the emperors who envisioned the wall's creation and the laborers who made it real, many at the price of their lives.

But looking out across the Jindu Mountains, I don't feel history's hand on my shoulder. I can't see the breastplates of ancient warriors gleaming in the summer haze, nor hear the ghostly whinny of their horses as they ride again to long-concluded battles. All I see are trees. And all I can think of is a child, soon to be my daughter.

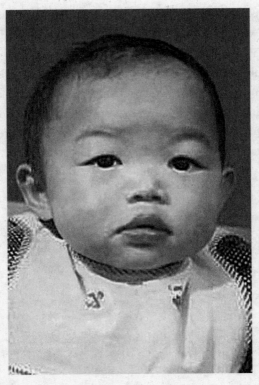

The first photo of Jin Yu sent from the China Center of
Adoption Affairs

WHENEVER I would imagine the moment that a man becomes a father—not that it was something I dwelled on—the picture that developed in my mind was straight out of a made-for-television drama: The husband in borrowed hospital scrubs, tense but triumphant. The wife, flat on her back, drenched in sweat but delighted. It's an event endlessly dissected in movies and parenting magazines, that transcending split-second when your new child lovingly looks into your eyes and melts your heart by cooing out a greeting or staring in speechless hello.

This moment could not be more different.

Standing in front of us is a frightened child. Not a baby, asleep and unknowing, but a toddler, aware and apprehensive. A child who awoke this morning in her usual bed in her usual home, perhaps not luxurious but at least familiar, and who was then hauled off into the unknown. A child who is now being turned over to people she's never seen and doesn't know, people who don't look, smell, or speak like her. A child who, at two, can comprehend that the everyday

structure and regimen of her life has disintegrated, that stability has ceded to upheaval.

Before coming to China, Christine and I had devised an elaborate plan to introduce ourselves gradually to our new daughter, a strategy to try to minimize her fear and soothe her distress. First, we would take a seat across the room, letting our child get used to our company, to the sight of these odd creatures with pale skin and big noses. After fifteen minutes or so, we would move closer, near enough to hand her a toy, to talk to her. Then, after perhaps half an hour, after she had grown comfortable with our presence and assured of our good intentions, we would attempt to actually hold her.

That plan lasts all of two seconds.

Orphanage staffers are nudging Jin Yu forward, guiding her toward us. She takes one uncertain step and stops. She is sweaty, her cheeks flushed, her hair stuck to her forehead. For a moment she stands frozen. Then she begins to rock, moving foot to foot in pink sneakers two sizes too big.

Christine and I kneel down in the hotel room doorway, each putting a hand on Jin Yu's shoulders, telling her in broken Chinese that we are her mommy and daddy.

"Wo ai ni," I say. "Wo ai ni." *I love you.*

Jin Yu glances first at me, then at Christine. Perhaps my pronunciation is poor. Perhaps she has never heard that phrase. Perhaps *love* is a word that has little use or meaning in a crowded orphanage.

Since the day the first photographs of Jin Yu arrived at our house, we have been studying every detail of her appearance. In one picture she is posed astride a green plastic rocking horse, refusing to look at the camera. She is dressed in four layers of clothes, including a new-looking blue plaid jacket. In another shot she is standing in a slatted, wooden box, a sort of undersized pen, big enough for her to stand and turn, too small for her to sit and play. Her mouth is open in a

half-cry, her hand reaching out toward the camera, reaching out toward us.

Those photos were copied and printed and posted all over our house—on the refrigerator, on the dining room table, on the nightstand. For five weeks, while we waited to get government permission to travel, Jin Yu's picture was the last thing we saw at night and the first thing we saw in the morning. Her personality—or rather, our speculation about the makeup of her personality—became our sole topic of conversation.

Now, we're shocked to meet her. Seeing her in person is like bumping into your favorite movie star on the street—you're momentarily startled to find that they exist in three dimensions, that they are more than an image flickering across a theater screen or a photograph in a magazine. More than a picture taped to a refrigerator door.

Jin Yu is short, smaller than she looked in her photos. Her legs are sticks. Her hair is thin. And coarse. She has a nick under her left eye, a scratch on her chin, and a mark on her forehead.

She is beautiful.

She's wearing a fresh-from-the-package polyester shorts suit, white with green and yellow trim. On the front of the shirt a cartoon rabbit is fishing in an imaginary river, using a carrot for bait. Spotless white socks reach to Jin Yu's knees. I wonder if she has ever worn new clothes before. And I wonder how much, if anything, she has been told about who we are or what will happen today.

I offer Jin Yu a stuffed toy rabbit. She stares at it, unmoving. I press it into her hand.

"Jin Yu," Mary calls to her from behind. "Mama, Baba!" *Mommy, Daddy!*

Mary leans down and tells her in Chinese, "These are your parents." At that, Jin Yu slowly turns her head, looking over her shoul-

der to fix Mary with a stare. If this two-year-old could have spoken English, "You have got to be kidding me" would have been her first words.

Instead, Jin Yu says nothing at all. She turns back toward us wordlessly, uncertain why these two peculiar-looking people are crowding so close, so intent on making her acquaintance, on becoming her friends.

If I could only explain to her. If she could only understand. I'm so excited I practically want to shout: You are real! You are here! You are ours, our baby, our child, our girl. We have wanted you so much, waited for you so long, wished for you so hard.

Later, when I see a videotape of this moment, footage shot by another parent, I will be stunned to realize that other people were all around, behind Jin Yu in the hotel room and behind Christine and me in the hall. Until then, had I been called to court and seated on the witness stand, I would have sworn the three of us were alone.

On that tape I will see that all the children were wearing nearly identical new outfits, each bearing the same image of the same smiling rabbit, gone fishing with the same orange carrot. And I will see that in her final minutes as a ward of the orphanage, in those last moments before her life changed forever, Jin Yu chose to stand off by herself, apart from the other girls.

"TURN AROUND," someone calls.

What?

"Turn around!"

I have a dim awareness of sounds and people, a sense of returning to consciousness, as if the volume was being turned up on a television in the next room.

Behind us, in the hallway, a party has broken out.

"Turn around for everyone!" Mary says.

Christine and I are still crouched on our knees. We shift awkwardly to either side, centering Jin Yu between us. Cameras flash. We blink in the lights. Mary raises her arms to quarter-angles, enveloping the three of us as she addresses the group: "This is She Jin Yu."

Her words are a benediction, spoken with the same assurance and satisfied formality a preacher might use to declare, "I now pronounce you man and wife."

And like newlyweds at the altar, we're not quite sure of the script.

"Okay?" Christine asks of no one in particular. "We can go?"

Not only can we go, but hands on our backs and shoulders are gently steering us out the door, making way for the next set of about-to-be parents. I lift Jin Yu up and into Christine's arms.

The whole thing is over in less than a minute.

We move away from the crowd, finding an open space near a stairwell to pose for photos. We are now parents, the titular heads of a new and different entity, no longer just a couple but a family. Others in the group approach us as they wait for their names to be called, touching Jin Yu on her arms, her hands, her face.

It's as if she is holy.

"Oh my God, oh my God," one woman says, unable to take her eyes from our child.

Jin Yu doesn't acknowledge the attention.

Through months of waiting, as the machinery of Chinese adoption shifted down, decelerating from swift to slow to stalled, it seemed impossible that this moment would come, that the government of a country we'd never seen would trust us to be the parents of a child we'd never met. Even as we boarded a plane for Beijing, it seemed impossible to believe that somewhere in southern China, a little girl, our little girl, was waiting for us.

Christine and I are ecstatic, beyond words, beyond description. Christine is at last a mother. And I am a father. But we try to imagine ourselves in Jin Yu's place. And it feels miserable.

A couple of hours ago, this child was put aboard a bus for the trip from the orphanage to the hotel. It may well have been her first ride in a motor vehicle. It was surely one of the very few times she was outside the orphanage grounds. But at least during that hour-long drive, and then in the confines of the hotel room, she was surrounded by familiar faces, by the other girls from Xiangtan and by nannies and administrators she knew and recognized.

Now, in the stifling hallway of a strange building, she has only us.

But Jin Yu doesn't cry. She doesn't flail or try to push us away. Though we've been told she can talk, she says not a word. Though we've been told she can walk, she wobbles when we place her on her feet.

A second child emerges from Mary's room, and unlike Jin Yu this girl is fighting her new mom with all the fury a two-year-old can muster.

It's only a prelude.

The next child is sobbing, the next screaming as she flings her head backward, trying to wrest herself away. One child wets herself, soaking her pants and the carpet. The hallway is becoming chaotic, the children's shrieks echoing off the walls.

And that's good.

The child development experts say that this sort of resistance, while distressing to the adoptive parents, is actually a positive sign. The children's tears and anger show that they successfully formed emotional attachments to the people who cared for them at the orphanage, that they possess the ability to bond and so can form new attachments to their parents.

As new moms and dads clamber past us toward the elevator,

straining to keep hold of howling, thrashing little girls, Jin Yu's silence seems very loud.

WE SIT our new daughter at the foot of our hotel room bed, kneeling on the carpet so we can see her eye to eye.

Her most prominent feature is her frown. She looks like someone who's been kidnapped. Or rather, she looks like someone who was kidnapped a long, long time ago, and who has given up any hope of freedom.

All we want to do is to grab this child and pull her close, to hold her thin body against ours, to bury our faces in her hair and weep upon her, to spill out the story, the legend, of how we have longed for her arrival. We want to cry out our declarations of love, our vows of unending devotion, our promises of loyalty and commitment.

And, of course, we don't dare.

Jin Yu has had enough turmoil for one day. She doesn't need us to add to it.

"Bunny, bunny, bunny," I say, dancing the stuffed toy across Jin Yu's hand and knees.

I expect her to grab for the rabbit. Instead, Jin Yu mechanically retracts her hand to her chest. She keeps it there, the pose of a silent-film actress attempting to convey that she feels a little faint.

Christine puts her palm against Jin Yu's forehead. Our new daughter neither recoils nor welcomes the touch. Her nose is running, but she doesn't seem to have a fever.

A child begins to wail in another room. Jin Yu turns her head toward the sound. Perhaps it's someone she knows.

Christine strokes Jin Yu's arm. I rub her shoulder. She looks positively forlorn. We offer her a sippy cup.

"Shui? Shui?" I ask. *Water?*

No response.

The new parents have been told to examine their daughters from head to toe, to check for any rash or bruise, any sign of injury or illness. Christine and I pull off Jin Yu's socks, then her shirt, laying her on her back on the bed. We slip off her pants. Surely now she will rebel, fight back against this indignity. Jin Yu stares at the ceiling. We roll her over onto her stomach. A large Mongolian spot, a type of Asian birthmark, covers her lower torso, a pale purple shadow reaching from hip to hip. Jin Yu doesn't try to sit up or change position, doesn't fuss as we put her clothes back on, pushing her arms through the sleeves.

It's like she's made of clay. She stays as we pose her.

We have had our daughter for thirty minutes, and already it is plain that this will not be the blissful, tearstained joining of our imagination. Neither Christine nor I says it out loud, but both of us are worried that something is wrong with our child.

We have read plenty about Chinese adoptions. We know that while many children react to the trauma of separation by acting out, some may respond by shutting down. Instead of screaming or crying or fighting, they turn inward, withdrawing from the world.

But the descriptions we've read in books and magazines don't match what we're seeing now.

It's not that Jin Yu is submissive. It's that she has no reaction at all. To anything. Her only movement is an occasional, vague shrug of her shoulders, a slight shifting motion made in response to some invisible, personal stimulus.

"I'm going to get on the floor, so she can sort of move on her own," Christine says, sliding carefully off the bed with our daughter on her lap.

Jin Yu sits there, motionless. A minute later, her head droops, her chin coming to rest on her chest.

"Are you not feeling well?" Christine asks softly.

We are trying to be light, to will this situation well, or at least better, to force some glint of cheer into the dread we are feeling.

Jin Yu tries to stand and nearly falls down.

We don't know what to do.

Christine holds our child, stroking her hair and quietly telling her that everything is all right. That we love her. That we are here for her. That she will be fine.

"Oh my goodness," Christine says, her voice sharp, her eyes on Jin Yu's head. "She's got a scar. Oh my God."

I brush Jin Yu's hair aside. What I see there is not a scar. A scar is a thin line across the surface of the skin, a faded remnant of some careful medical intervention. The left side of Jin Yu's head is not scarred, it's wrecked. A sunburst of ruined skin blooms behind her ear, the starting point of a ragged, four-inch gouge that snakes toward her temple, ending in a flap of thick, discolored flesh.

I get down on all fours and stare into her eyes.

"Are you okay, Jin Yu?" I ask, trying not to let the panic that's rising in my chest seep into my voice, forgetting that she can't understand a word I'm saying. "Did something happen to your head?"

She stares blankly.

Several realities begin to sink in, none of them good: Our child could be seriously injured. Maybe even brain-damaged. Our family doctor is on the other side of the earth. Here, in a nation of 1.3 billion people, we don't know a soul.

I am suddenly aware of the silence that has crept into the room. And how the cold breeze from the air-conditioner is flowing across my shoulder blades. I notice the early evening sun streaming unevenly through the windows, illuminating flecks of dust that float in the light. And how the room's blue carpeting hasn't been vacuumed in weeks, crumbs and dirt ground into its ridges.

Poised there, on my hands and knees on the twenty-third floor of a skyscraper hotel in downtown Changsha, I feel like I am falling.

WE HAVE to stay calm. Think clearly. Follow the steps that knowledgeable, experienced parents would take in this situation.

Except we don't know what those might be. Because that is not who we are. And because, for all we have read on adoption and child-rearing, we've never come across a chapter that outlines what to do if your child should arrive nearly inert, bearing evidence of a head injury.

Christine and I carefully run our hands through Jin Yu's hair and across her scalp. We can detect no obvious damage to her skull beneath the scar, no mass of rutted or malformed bone. Christine, who holds a doctorate in school psychology, her thesis written on facial deformities in children, puts Jin Yu through a number of basic-skills tests, checking her hearing, her reflexes, the track of her eyes. Despite our daughter's stupor, her motor functions seem sound.

All the new families are due at a meeting in Mary's room, to fill out paperwork for the Chinese authorities. Christine and I get there early and sit quietly, completing the forms. Jin Yu sits on the lap of her new mother, oblivious. We linger as the meeting breaks up, waiting until the last smiling parent bops out the door, so we can be alone with our guide. Mary must have wondered what we were doing there, hanging around her room after so long and emotional a day.

"Mary," I say, keeping my voice level, nodding toward the girl in Christine's arms, "our baby has a scar on her head and we're concerned."

Mary doesn't answer, but leads us to a lamp near her dresser, where she parts Jin Yu's hair with her fingers. She lets out a breath.

"In here," Mary says, pointing. The four of us crowd into the tiny

bathroom, which happens to have the brightest and most direct light in the room. Mary positions Jin Yu under a ceiling lamp, and in the glare we can see that the scar on our child's head is longer and deeper than we'd realized. The wound is dirty. It's oozing, wet and blistery. It looks infected. I can smell it from a foot away. It smells like feces, harsh and malodorous.

Still, standing there with my wife and new daughter, squeezed into somebody else's hotel bathroom, I hold to a strand of hope that, somehow, this will all turn out to be nothing. That in a minute Mary will pat us on the back, don the indulgent smile she reserves for inexperienced, first-time parents, and send us on our way with a patronizing, "There, there, not a thing to worry about." I hope she may even scold us, for creating undue melodrama, for troubling her with something so small. I hope she will say she has seen lots of children with this condition, and every one of those kids turned out to be fine.

Mary does not say any of these things. She says, "We need a doctor."

She pulls out her cell phone and dials the Xiangtan orphanage— itself disconcerting, another sign for alarm. Despite the lateness of the hour, despite the fact that it's a Sunday, despite the weariness that engulfs us all, our guide, who has seen dozens if not hundreds of children in varying degrees of health, believes this is something that cannot wait.

I can hear the phone ringing on the other end of the line. An orphanage administrator comes on. The ensuing conversation is loud. That's okay. I know that when people speak in Mandarin, the rising and falling tones can make the discourse sound clipped and cold. It's easy to think people are arguing when they're not. Besides, I don't speak Chinese. I have no idea what Mary is saying or what she is being told.

I know that when the call ends and Mary hangs up, she's not looking at us.

I wait for her to provide a rundown of the information she's obtained from the orphanage, to summarize the explanation of Jin Yu's injury, to describe the medical care our child has undergone to date, the plan for new treatment, the efforts that will be made to assure us, her parents, that our baby will be okay.

I wait for her to say that, despite the evidence to the contrary, this is not a crisis.

But Mary says nothing. Instead, she returns to examining the side of Jin Yu's head. Nearly a minute passes before I realize she is not going to speak.

"What did he say?" I ask.

Mary pauses.

"He says it's a scratch."

The room feels newly tight, without oxygen. I realize I have sat down on the edge of the bathtub. And that I need to think very carefully about my next words, because a lot could hinge on them.

"It's not a scratch," I say.

"No," Mary answers. "It's not a scratch."

She says she will begin making calls tonight, to try to find a physician who can help.

Christine cradles our baby, rocking her gently, whispering to her. Jin Yu, detached from the concern that swirls around her, seems to be staring at a patch of wall somewhere above the bathroom mirror.

Sitting there, on the side of the bathtub, the four of us crammed into this small, too brightly lit bathroom, I am seized by a vision. It is not an illusion. Or a hallucination. It is a fact, as certain as my own existence. It is what is going to happen, the future foretold.

I see this girl living out the years of her life between the fixed metal rails of a hospital bed. I see her body limp and mostly useless,

her eyes open but unseeing. I see Christine and me aged beyond our years, gray in looks and spirit, worn out by the around-the-clock demands of caring for a profoundly disabled child. I see all the eagerly awaited milestones of our daughter's childhood—birthday cakes and bicycles, puppies and proms—fading to black. I see Jin Yu's contemporaries grown to high school age, swinging hockey sticks on a grass field, belting out torch songs in the senior play, gossiping about boys, clothes, and colleges, all of them unaware that in a quiet bedroom of my home lies a girl just their age, a girl largely unaware of the world around her, a girl who also deserved to enjoy the rites and passages of a typical suburban adolescence.

I look in Mary's eyes for reassurance. There's none there to be found.

The fact is, our guide doesn't know this child, doesn't know anything about her. And as for Christine and me, we met Jin Yu for the first time three hours ago. We know nothing about her health or her history. For all we know, she has been lethargic and mute since the day she was born.

But there is one thing we do know, and given the circumstances it is the most important thing of all: this silent, staring little girl is now our daughter, and she needs our help.

Children at the Xiangtan Social Welfare Institute

NOT EVERYONE had come.

Some believed that their new daughters, already confused, could only be further unsettled by the visit. Others couldn't bear to see the place, to make real the ghosts of their imagination. A few wanted nothing to do with it, as they wanted nothing to do with China.

So it was a smaller coterie of Americans who clomped down the exit stairs of the bus, parked a few paces shy of the orphanage gate.

The Xiangtan Social Welfare Institute stands at 3 Ban Ma Road, a sprawling, low-slung facility made up of three separate compounds that house members of society's neediest populations—the young, the elderly and the mentally ill. Officials say the older people are permitted to mingle with the children, the psychiatric patients are not.

The orphanage houses eighty to one hundred children, the youngest days old, the eldest in their teens, the vast majority, as in all orphanages across China, female.

No one in our group knows why we have been allowed to visit.

Generally, Western travelers are not allowed inside of China's welfare institutes. It's not unusual for American parents, after traveling thousands of miles to China and hundreds of miles within the country, to be stopped short at an orphanage door. Everyone in our group has his own explanation for our good luck: Because the children's section is relatively new, built in the 1990s, and its operators want to show it off. Because the people who work here are as curious about us as we are about them. They want to meet the foreigners who are taking thirteen of the "older girls," most aged between two and three. Because we're the first group of Americans to adopt from Xiangtan in more than a year.

A friend told me that when she adopted her daughter from a different orphanage, she and her child were not only permitted to visit but borne onto the grounds like royalty, seated at tea with the institute director, presented with a thick scrapbook of photos and a handmade, embroidered quilt.

Christine and I don't expect that.

Our hopes are much more modest. We hope that this visit will offer some insight into our daughter's daze, perhaps even help to awaken her from her trance. We hope that someone here recognizes our child, that they know her. That we will see signs that Jin Yu was well cared for and perhaps even loved, that she was more than another in an endless procession of babies to be cleaned, fed, and bathed. We hope that however Jin Yu's life may unfold from here, she will want to have one last look around and a chance to say good-bye.

We have heard and read accounts of dire conditions in some Chinese orphanages, some of those stories exaggerated, some unfortunately all too true. The list of privations can be long and deadly: Malnourishment. Disease. Dehydration. Lack of clean water, heat, or the most routine medical care.

Still, Christine and I pushed for an invitation to visit the orphan-

age even before we left the United States. We needed to know. We needed to be able to tell our daughter, firsthand, from our own eyes and memory, about the place where she had lived. During our wait to be matched with a child, whenever our adoption agency asked if we had questions, we replied, "Will we be allowed to visit the orphanage?" After we received Jin Yu's name and picture, as our travel date neared, our question was transmitted to Great Wall's office in Beijing, and from there, presumably, to the China Center of Adoption Affairs, the office that administers foreign adoptions. The reply was a pristine specimen of a non-answer answer: *Decisions on whether foreigners can visit the Hunan orphanages are made by the Office of Civil Affairs in Changsha.* With that, the query was deftly tossed into the lap of a government agency with whom we had little chance of making contact.

We weren't dissuaded.

In China, when our guides asked what we would like to see or do, we would answer, "We want to visit the orphanage." We repeated the phrase again and again, like a mantra.

I don't know if our persistence had any effect. Neither our adoption agency nor our guides had the power to authorize a visit. But they were our only avenue to Chinese officialdom, so we pushed and pleaded and oh-so-politely pestered. For some reason, our wish was granted—landing us on a cement walkway heading to a central courtyard, carrying a lethargic little girl who, until three days ago, knew this place as home.

Our visit would be short, but it would teach us a useful lesson: be careful what you wish for, because you just may get it.

THE GROUNDS of the orphanage look like they once could have been the estate of a wealthy landowner. Or, at least, the estate of a

wealthy landowner who slowly went broke, and cut back on maintenance as his bank account shrank. In the courtyard is a pondlike fountain adjacent to several short stone buildings and a three-car garage.

Peng Liang is waiting for us. He is thin and wiry, strong, a thick lawn of black hair topping a square face framed by rectangular glasses. Peng is the director of the institute, and he has fast become a familiar presence at the hotel and at government offices as our children have been transferred to us. He appears unfazed by the commotion produced by fourteen newly created families, a temperament that seems particularly well suited to someone running an orphanage.

Peng speaks little or no English. He motions for us to follow, leading us toward the children's section, toward Jin Yu's former home.

The building is huge: a wide, three-story structure sheathed in scaly white shingles and trimmed with bright red accents. A high stone wall guards one side, a low brick fence the other. Beyond the bricks roll the hazy green hills of the countryside. With its broad balconies and gleaming white facade, the dormitory could be mistaken for an overgrown play castle, a sort of backwater storybook theme park.

But no children live in amusement parks. And this isn't Disneyland.

On the second-floor balcony, small girls totter forward on uncertain feet—not one child or two, or four, but more than half a dozen, trailing after toys or playmates. One girl stands holding the hand of a much-taller nanny. She stares at us, watching the advance of this weird-looking pack of guests. Another girl sits with her legs poking through the railing, swinging her feet in the air.

The scene is shocking in its banality: here are small children, all

without parents, all in need—and no one is hurrying. The kids don't seem upset. It is just another day at the orphanage.

For some reason, I'd imagined that the children would be sequestered, that we would be permitted to see the buildings but not the people. That it would be like walking into an empty stadium, staring out at the field and trying to envision what it looks like when the teams are playing and the stands are full of fans.

All the girls on the balcony are about Jin Yu's age. Or older. Some of them must have arrived here before Christine and I ever thought about adopting a child, and they'll be here after we're gone. Why is that? Why is one girl on her way to America, to a fine house, a big room of her own, more toys than she could ever need or want and—no small matter in Hunan—all she cares to eat? Why must other girls remain, waiting, aging, perhaps dying here?

I don't know the reasons, but I know they amount to the merest breeze of fate. A shuffle of paperwork in Beijing. A photo that didn't quite match. Another child deemed a little too old, or a little too young.

As far as I can tell, there is only one difference between the girls on the balcony and the child in my arms: one is my daughter, the others are not.

THE POPULAR bookstore travel guides usually don't bother to mention Xiangtan.

It's not that the city is too small to warrant a few lines. It's home to more than 500,000 people. And it's not that it is out of the way. Like Changsha, Xiangtan sits astride the bustling Xiang River, for centuries a major north-south trade route. As recently as the 1890s, Xiangtan's position on the river made it a hub of the provincial tea trade.

These days Xiangtan is ignored on merit. In modern times the city has forged no world-leading industries, developed no pioneering technologies, established no legendary sports dynasties. It's spawned few famous sons. Some residents like to claim that Mao was born here. While it's true that as a young man the chairman spent a fair amount of time in Xiangtan, helping to foment the revolution that would lead China to communism, he was actually born to the west, in Shaoshan, and attended high school to the north, in Changsha.

His birthplace lies within the county, and perhaps that allows him to be claimed as a native. Beyond Mao, the roster of Xiangtan luminaries is both short and, truth be told, not very luminous.

The famed military strategist Peng Dehuai was born in Xiangtan. He rose to become China's defense minister before making the mistake of criticizing Mao during the Great Leap Forward. The government arrested him in 1967. Better known is Qi Baishi, the painter whose most popular works portray the everyday tools and creatures of the rural farms he saw all around him—hoes, rakes, flowers, birds, mice, insects. Many of his works are displayed at the Qi Baishi Memorial Hall. Others of his paintings—or what purport to be his paintings—are for sale on eBay.

Xiangtan was founded about 1,300 years ago, in an earlier age recognized for its massive crops of rice and its steady production of medicinal herbs. Today the city may be best known for breeding a particular strain of lean-meat pig, and for its abundance of Xiang lotus, a lily the local governments hope to turn into a moneymaker by processing the flower to make juice, tea, and paste. A few specialized health researchers know Xiangtan as the epicenter of a precancerous condition called oral submucous fibrosis, caused by the habitual chewing of betel nuts and aggravated by the heavy use of hot peppers on foods. A relatively high percentage of local citizens are afflicted.

Xiangtan remains a busy commercial port, and it's emerging as something of an educational center, home to several colleges including the Xiangtan Mining Institute, Xiangtan Teachers College, Xiangtan Normal University, and Xiangtan University. But the biggest and most influential businesses in Xiangtan are those engaged in the lucrative, age-old enterprise of turning big rocks into little rocks—cement, gravel, sand, ore. In Xiangtan they dig coal and marble and especially manganese, an alloy used to make steel and aluminum, found in everything from soda cans to dry-cell batteries.

If the modern history of Xiangtan is unremarkable, then the history of the orphanage is opaque. That history mostly exists as an intermittent series of photos, videotapes and fragmentary conversations recorded by families who managed to document their impressions during what were invariably short and affecting visits. It's not as if the orphanage is a boarding school, or a university. It doesn't have its own website. It doesn't publish an alumni magazine, or distribute lists of distinguished graduates.

When was an orphanage established in Xiangtan? How many children have entered its gates? How many have left for new homes? And what happens to those who remain? No one seems to know, or be willing to say, at least not with certainty or in any detail. The orphanage is at least the second children's institution on the site. And it represents a vast improvement over the previous model.

The first families to adopt from Xiangtan in the early 1990s recall the orphanage as a red-brick building with cement floors and cinder-block walls. For some, their most vivid memory is of a row of children confined in green chairs, wailing as they aggressively rocked back and forth—a common developmental response to a lack of stimulation. The children's faces were sunburned, indicating they had been outside for some time.

Today that red-brick building is nowhere in evidence, in its stead the new white-shingled dorm.

The biggest event in the orphanage's recent history occurred in the winter of 2001, an event that would hold serious repercussions for the staff, the administration, and most of all for the children who lived there, including the girl who would become my daughter. That year several American families who were adopting from Xiangtan noticed that their children were feverish. They were told the kids were fine, just getting over the chicken pox. But one child failed a physical, and by the time the families arrived home several of the kids were sick and getting worse.

A baby in Texas was the first to be taken to a hospital. Other children began falling ill in New York, Ohio, Indiana, Minnesota. Only then did the true reason for the children's sickness emerge: measles, a contagious disease that if left untreated can cause deafness, retardation, or even death. By the time that diagnosis was made, hundreds of people had been exposed—including sixty-three families who had traveled to China, representatives from sixteen adoption agencies, the staffs at the U.S. consulate and a Chinese medical facility, along with the pilots, passengers, and crews on the airplanes that bore the families back to cities across the United States.

Whether the orphanage administration was simply ignorant of the contagion or had actively tried to hide it, the repercussions were serious. American parents were upset, Chinese officials embarrassed. The federal Centers for Disease Control and Prevention became involved. Public-health investigators eventually tracked cases into eight states, confirming fourteen cases of measles among the newly adopted children and their families.

In China the consequences were swift and severe. Changes were made in the orphanage leadership. Either as a health measure or, more likely, as the institute's punishment for causing such an inter-

national humiliation, the government imposed a one-year moratorium on foreign adoptions from Xiangtan.

The ban imposed its harshest discipline on those who bore no responsibility: the children. Every family who adopts from China is required to make a $3,000 donation directly to their child's orphanage, so halting the process cut off a crucial source of funding. It also cut off the flow of toys, clothes, and major appliances, like air-conditioners and washing machines, that adopting families often purchase for the orphanage.

In early 2002 Chinese authorities cleared the orphanage to resume international adoptions. And in August of that year, our travel group, knowing little of this troubled history, marched through the front gates. Later, some of us would glimpse official government photos of our children that had been taken around the time of the measles outbreak, the kind of pictures routinely sent to families waiting to adopt. Apparently our girls had been next in line, ready to be matched with new families and sent off to new homes, just as Xiangtan closed to the world.

They would have to wait another year.

TWO OF the children are wearing Mickey Mouse T-shirts, another the jersey of the German national soccer team. A girl of six or seven is dressed in a faded pink party gown, as if she is headed to a prom. Several of the kids are boys, and it's obvious why they're here, why they were abandoned by their Chinese parents, their exaggerated facial features signaling potential disabilities.

All of the kids are thin. But their lean frames and hand-me-down clothes do nothing to diminish their enthusiasm. The children approach us, unafraid, excited to welcome us into their home.

Our awkward procession of American families comes to a halt

beneath the arched entranceway of the children's dorm, where a dozen nannies have gathered on the steps. Most are wearing white lab coats, though several of the women—all of the caretakers are women—are dressed in street clothes, come in on their day off to say good-bye. The Americans cluster in small groups, not quite sure whom to talk to or whom to approach, unable to say much more than *Hello* and *How are you?*, helpless to understand the replies.

If the new parents are nervous, the nannies are relaxed, calling out to our children in their distinctive Hunan dialect. They know all of our girls by name, and they seem to have their favorites, different women heading straight for certain children. Visitors from across the sea? Americans come to Xiangtan? Big deal. Theirs is the informality of people who spend their lives around small children, who see scores of infants and toddlers every day and will see scores more when those are grown, people for whom troublesome questions of chance and fate are best left to others not nearly so busy.

Older children crowd close to us, one of them a boy who speaks animatedly to the sluggish girl in Christine's arms. Jin Yu does not answer or even look at him. If our child has registered that she has returned to the orphanage, if she realizes she is back on familiar ground, it doesn't show. Another little boy runs up, grabs Jin Yu's dangling arm, and kisses her on the back of the hand. Jin Yu pays him no notice.

"Maybe she thinks we're leaving her here," Christine says.

Mary, standing beside us, tries to be comforting. "I don't think she will think that," she says.

We venture a few steps inside the building. It is a place without frills, sparingly furnished. Not a place you would want to raise a child. But someone has tried to make it cheery, or at least cheerier, posting cutouts of children's cartoon characters on the walls and tying a length of colored flags across the playroom. The dormitory is

clean. Much of it looks freshly painted. I'm sure it's been recently scrubbed.

In these rooms, my child spent the first two years of her life. Unlike thousands of other adoptees, Jin Yu did not arrive in an orphanage as a newborn and depart eight or ten months later, with no memory of her surroundings or her caretakers. Here Jin Yu turned two. Here, in this place, she grew from a baby into a toddler. Here she took her first steps, spoke her first words. Did anyone notice? Did anyone hear? Did anyone care?

A nanny in a brown-print shirt walks past, her eyes darting, her face ashen. She seems to be searching for someone. Later we will learn that she twice tried to adopt a girl in our group, a child she took into her home and into her life, a child now about to depart for America. When we leave this place, we will see this woman standing on the roadside, sobbing.

A woman in a plum turtleneck has hold of Jin Yu's forearm, patting and stroking the back of our daughter's hand. She is older than the other nannies, maybe forty-five, with short black hair and rich brown skin. She talks to Jin Yu in a low voice, speaking words we don't understand, glancing up to show us a smile, then returning her attention to our baby, as if imparting some final lesson, saying something she wants this child to remember.

We want to say to her, "Please, can you tell us, what happened to our daughter? Was she hurt? Was she sick? Has she always been this way, still and silent?" But we speak no Chinese, and the nanny speaks no English. After a couple of minutes she gives Jin Yu a final pat on the arm and turns away, her eyes wet.

A young nanny in a bright red shirt begins calling to our girl, "Jin Yu-ah, Jin Yu-ah." Others pick up the chant, and now four of them are upon her, pinching her cheeks and patting her hands, poking her playfully. They pause only to fire questions at us, surprised

by the empty stares that come back in answer. The way they treat Jin Yu, teasing her in the expectation of a response, makes me think that our girl has not always been so lifeless, that at least for some portion of her time here she moved and reacted normally.

The director wants to show us the rest of the grounds. As we turn to walk back toward the courtyard, another nanny hurries up, a child in her arms. She has gone inside the dormitory to fetch this girl, a smallish child of indeterminate age, dressed in flannel pajamas. The nanny carries the girl—who possesses a big smile and a rice cracker—right up to Jin Yu, moving them so close together they nearly bump heads. At that, upon having this child's face thrust into hers, Jin Yu reacts—the first deliberate movement she's made in three days.

She turns her head to look. To see. Perhaps to recognize.

Jin Yu slowly lifts her arm toward this child, extending her hand and then her fingers. She grasps, grabbing only air, as if she were far, far out at sea, reaching back for a shore she cannot touch.

Jin Yu knows this girl.

Were they playmates, maybe even cribmates? And why is this child still in pajamas at midmorning when the other children are dressed for the day? I wonder if she's ill, too ill even to walk, and if her health somehow connects her to my daughter. If maybe they spent time in the same ward or clinic, Jin Yu moving on after she had sufficiently healed.

In the next second the nanny withdraws, carrying the girl away and back into the shadows of the orphanage. Jin Yu's arm falls limp at her side. Whatever good-byes these children will be permitted to say have now been said.

Someone hands Jin Yu a rice cracker. She robotically raises it to her mouth.

We have been told that none of the children had a primary care-

taker, that the shift schedule placed different nannies with different children at different times. That may be so. But the woman in the plum turtleneck is beside us again. She is no longer teary. She is crying. And she is insistent.

She holds out her arms, motioning for us to hand over Jin Yu, to grant her a last hug from our little girl.

Christine doesn't move.

The nanny pushes nearer.

"Should I let her go?" Christine asks, her voice rising.

"No," I say, worried that doing so could sever whatever connection we've managed to forge with our child.

The woman slides her arms around Jin Yu's waist. Christine is holding our girl by the legs and shoulders, and I have my arm on Christine, the three of us engaged in an awkward tug of war, gingerly pulling this child in different directions.

"Show her the card," Christine says.

I yank it out of my pocket and push it at the nanny, a laminated card containing a few lines that a friend has written in Chinese. It's an explanation of who we are and what we're doing here, a pledge that we will always love and care for the girl who is now our daughter. The woman lets go of Jin Yu and takes the card in her hand, her eyes roaming over the characters. Then she looks up as if some understanding has dawned. She puts both hands together, as if to beseech us in prayer.

"Xie xie, xie xie," we tell her. *Thank you, thank you.* Our words are generic, meaningless. We could be thanking her for anything— for escorting us along the walkway, for having us here to visit, for not pulling off Jin Yu's shoes while struggling to hold her. We want to say more. We want to say: Thank you for caring about our child. Thank you for remembering her, for showing us that Jin Yu was known, individual, distinct. Thank you for showing us that you

adored this girl. Thank you for showing us, through the pain of your own tears, that our daughter will be missed.

No one else seems to have noticed our little drama, this quasi-public push-and-pull over the possession of our child. Other families are absorbed in their own uncertain interactions with the nannies and the staff, trying to break through barriers of language and culture to connect with the only people in China who truly know our children.

Later on, back in the United States, when we parents fall to discussing the events of this morning, everyone will offer his or her own discrete memory, a personal recollection of a child met or a detail noticed. It will seem difficult to believe we were in the same place at the same time, and easy to understand how in moments of high tension, the worldview of the individual can narrow to a pinpoint.

Christine and I are exhausted, wearied by the Hunan heat and our worry about Jin Yu's health.

We've spent nearly an hour here, plenty long enough to disturb the morning routine. It's almost time to go. The walk to the bus seems long. Near the orphanage gate, a nanny in a purple shirt casually plants a kiss on Jin Yu's forehead. The woman is young, perhaps twenty-five. She pats Jin Yu on the cheek, tousles her hair, then pulls a ball of soggy tissue from her pocket and wipes my daughter's nose. She wraps her arm around Christine's shoulder and turns mother and child toward my camera.

"Gu loc, gu loc," she says.

We say good-bye and walk on.

When we turn back to look, she is still standing there, watching. I realize she wasn't speaking Chinese. She was speaking English, perhaps the only words she knows, the only blessing she could bestow upon us and our baby: good luck, good luck.

THE TWO-LANE road from Xiangtan is clogged with traffic, the bus choking on its clutch, trailing a black cloud of exhaust in the stop-and-go shuffle. We roll past lots strewn with trash and store-fronts guarded by steel security screens. Street and sidewalk are coated in brown dust. Huge apartment buildings stand back from the road, the mirror image of the big public-housing projects in American cities. On the sidewalks, women carry baskets of vegetables on poles set across their shoulders.

The bus is quiet, no one talking.

We pass a market. A gas station. A makeshift car wash. Horns beep as we glide past a Bank of China office. The bus picks up speed, grinding toward Changsha, jockeying for space with motorcycles, bicycles, and cars.

The roadside images rush past in a blur. A garden. Another bank. A restaurant. Another lot. An empty factory.

It's gone.

We're out of the city, onto the open highway and speeding toward the capital, leaving Xiangtan and its children behind. Christine and I stare out the window at the trees grown thick along the road, at the misty green mountains beyond.

A couple of weeks from now, when we're back in the United States, we will get e-mails from parents who had visited the orphan-age years earlier. They write: Is the girl with one hand still there? Is the albino boy still there? Yes, yes, we answer, they're there.

Jin Yu is sitting in Christine's lap, silent. Slowly, Jin Yu reaches one hand up, then the other, grabbing hold of the window frame and carefully pulling herself to standing. I glance at Christine, whose eyes are fixed on our daughter, watching this unexpected perfor-mance unfold.

Jin Yu turns her head so she can look out the window. Then she begins to rock, back and forth, swaying to the rumbling beat of the bus.

Our child is moving. On her own.

Something else is different too. For the first time since I met her, Jin Yu has an expression on her face. She is wearing a small, faint smile, as if she is secretly pleased.

THE SUN is fading, a pale gold ball peeking between the buildings of the Changsha skyline, streaking the sky with red and orange. Jin Yu is asleep in her crib.

We put her down shortly after dinner, and she dropped off in minutes. Christine and I are ready to follow her, worn out by the drama of our visit to the orphanage and by the relentless Hunan heat. The room is silent, the only sounds the ones in our heads, the voices of Xiangtan's children, calling good-bye as we left them this morning.

Christine moves around the room, putting some clothes into drawers and taking others out for tomorrow. She slips a camera into its case and then into our backpack, beside my journal. She's zipping the backpack closed when Jin Yu starts to stir.

The sound our daughter makes is not exactly a cry. It's more of a moan, a half-whimper that freezes Christine and me in place. We wait, still as stone, hoping she will slip back into sleep.

But Jin Yu does not settle. She turns in her bed, twisting her

Jin Yu in our room at the Xiangquan Hotel in Changsha

blanket around her. Her moaning continues, changing pitch and character, escalating to a throaty whine. It sounds like she's in pain. Christine and I look at each other. Is she having a nightmare? Should we wake her?

Jin Yu's cry strengthens, her voice now loud and achy.

I reach into the crib and pick her up, holding her close to my chest, her head against my shoulder.

"It's okay," I whisper. "Daddy's here."

The sound of my voice doesn't help. If anything it has the opposite effect. Jin Yu begins to sob, big tears streaming down her cheeks.

"Shh, shh, it's all right," I tell her.

Jin Yu starts to wail.

She sucks in big mouthfuls of air, then shouts them out.

Inside of a minute, the child who refused to make a sound is shrieking. The child who refused to shed a tear is howling. We wondered what her voice would sound like when she finally spoke. This is not how we expected to find out.

Jin Yu begins to thrash. She lets go of me and raises her arms above her head, then throws herself from one side to the other. I hold tight to her hips to keep her from spilling out of my arms. Christine tries to steady Jin Yu's shoulders from behind, speaking to her softly. It does no good. Jin Yu is out of control. She screams as if she's being tortured.

We lay her on the bed, on her back. I hold her there, to keep her from rolling off, trying to avoid getting kicked in the face as she flails. Christine checks Jin Yu's diaper. It's dry. We inspect her pajamas, to see if she's being scraped by a stray tag. She's not. I press my hand to Jin Yu's forehead. No temperature.

Christine brings her a cup of water. Jin Yu tries to knock it away. I hold out a palmful of Cheerios. Jin Yu slaps them out of my hand, sending the cereal flying across the room.

Christine picks up our daughter, patting her on the back, kissing her, hugging her, promising that we will always keep her safe. It does no good. We wonder if we should call Mary. But we wouldn't know what to say. There doesn't seem to be anything wrong with our baby—except that she is keening.

YOU DON'T get to become a father little by little.

It's not like learning to swim. You don't get to start in the shallow end. It's not like learning to ride a two-wheeler, someone else running alongside, supporting the handlebars and shouting encouragement. It's not even like being pregnant. You don't get to feel the child develop in your belly for nine months, to sense its growth, become accustomed to its movement.

Fatherhood comes suddenly, or rather, instantly. One minute you're responsible only for yourself, or for yourself and your spouse, who would no doubt get along just fine without you. The next minute you're a dad—with a small pair of eyes focused on you, in hope, in longing, maybe even in anger, but focused on you.

In the hours and days after Jin Yu came to us, as Christine and I saw the life we'd planned and expected slipping away, I thought purposefully of the fathers in my life, fathers past and present, known and unknown. I wondered what they would have done if they had been in my shoes.

My maternal grandfather was the son of Irish immigrants, a couple named McCaffrey. In this country they changed their surname to Caffrey, dropping the first two letters in hopes of seeming less Irish, the Irish of their era being only slightly less unwelcome than the Chinese. My grandfather died before I was born. What I know of him is he preferred drinking to fatherhood, that he abandoned his four children and his wife, making my grandmother a single mom long before it was fashionable.

My paternal grandfather drank too. He didn't leave his family, although he was distant from his children, or at least from his eldest son, my father. As a boy, I noticed that my dad would talk about his mother, sharing stories of things she said or did, but he never mentioned his father. Later, when I was in my twenties, old enough to discuss such matters, I asked him why that was, why his dad was omitted, not discussed.

He answered: "I never liked him much."

That surprised me. Because I liked my father a great deal. And I assumed that everyone else liked their fathers too. Growing up, I had friends who had lost their fathers to war or accident or illness, who were left to sort out the norms of male-parenting behavior by observing uncles or older brothers. I had friends whose fathers were present in name only, too busy or too important to be involved in their children's lives. None of those kids disliked their father. Just the opposite—they all longed for their father's presence and attention.

My father was involved in my life, always, and from the start. My earliest memory is of him walking me down the street to our church for Sunday school. As I grew, he was the commandant who insisted that homework get done, the coach who taught me how to play sports, the willing chauffeur to early-morning and late-night athletic contests and events.

The thing I most remember about my father, that I find astounding, is he always showed me the same face. Of course there were times when he was angry with my behavior or frustrated by my performance. But on a personal, day-to-day basis, he treated me with an even temperament. He didn't let the hardships he experienced in the world—long ago and every day—bleed into our relationship.

When he was a young man, my dad wanted to be an accountant, but economic depression and world war interceded, leaving no time or money for college. After the war he worked as a salesman, selling

typewriters and then steel, traveling by car across Pennsylvania, Ohio, and New Jersey.

Like many men of his generation, he worked most of his life for a single company, Morrison Steel. I can remember when I was a boy, in the 1960s, hearing him tell friends that business was slow. By the time I reached high school in the mid-1970s, the steel industry was faltering. And by the turn of the decade, my college bills big and pressing, large chunks of the industry had ceased to exist. My father was out of a job when he needed one most. Few steel companies were hiring, and those that were had little interest in a sixty-year-old salesman.

His hair began to fall out in patches. My father's head looked as if he had started to shave himself bald, then stopped with the job half-done. At the time, I thought it was just strange.

Not until a physician diagnosed the cause—hammering, body-altering stress—did I connect my father's health and appearance to his life's responsibilities. Until then it never occurred to me that the fear of continued unemployment, of being unable to pay the mortgage or keep a son in college, was devouring him from the inside. Because on the outside he was the same. He never treated me differently.

Years later, when I was grown and working, and the realities of jobs and money became apparent, I came to understand more about the nature of his behavior, about why he put up, not a brave front, obvious in its facade, but an even front. It wasn't simply that he loved me and wanted to protect me from the meanness of the world. It was that he had made a decision about a strict assignment of roles: he was the father and I was the son. It was his job to shoulder the burden of parenthood, whatever trouble it might bring. And it was mine to attend to the joy of childhood, however long it might last. He believed it was his duty to stand guard for me even as I reached toward adulthood, just as he had from the moment of my birth.

Many years later, long after he was gone, I would find a record of my first weeks of life, written in his hand, the careful, even script of someone who would have made a fine accountant. On a green ledger sheet he'd recorded the day and time of my every feeding. The length of time I slept. The hour and duration of each and every time I cried.

SHORTLY BEFORE we visited the orphanage, Mary made good on her promise. And Christine and I nearly reneged on ours.

The two of us had gone out for a walk, pushing Jin Yu around the block in a stroller, trying to clear our heads and think about our child and our future.

You read accounts of Chinese adoptions, and it can seem that in every travel group there is a family singled out for heartache, for a baby whose uncertain smile signals Down's syndrome, whose vacant stare reveals brain trauma. It can seem that amid the joyous creation of new families, there is always one couple fated for hardship.

It looked like we were that couple.

Our travelmates, barely acquaintances, offered suggestions. Did we want to try to phone a physician in the United States? Maybe we could take a digital picture, showing the damage on the side of Jin Yu's head, and e-mail it to a doctor back home? Perhaps we could send a written summary by fax? We thought about it. But besides the discouraging logistics of international time zones and local doctors' hours, what could we say to a physician? We only knew what we saw. And what could an American doctor do to help, from the other side of the world, on the basis of a photo or a few paragraphs of type?

Moreover, we had become apprehensive about our interactions with the local Chinese officials.

No one in authority said, "We will get you a different baby." Or,

"This child is injured, you don't have to take her." Or, "You should make an exchange."

Not in those words.

What they said was, "Remember, this is forever." And, "You must be sure." And, "This is for all time."

It made us uneasy. Made us concerned that somehow, despite years of effort to get here, to hold our child close, the Chinese government perceived us as somehow unready or unwilling. To us the family equation was simple: Jin Yu was now our daughter. We were now her parents. We would tend to one another as best we could.

Christine and I were torn between need and apprehension, wanting our daughter to be seen by a physician, fearful that if she was, people in Chinese officialdom could infer that we wanted to trade children. We worried we would inadvertently send some signal that we wanted a different, provably healthy child, that we could set in motion events that held terrible, unforeseen consequences.

Mary was waiting for us in the lobby when we returned to the hotel. She told us to come to her room immediately—a doctor would be meeting us there to examine Jin Yu.

We asked Mary to please make our apologies. We had decided against seeing a physician.

She insisted we come to her room.

The doctor will be arriving any minute, she said. It was too late to cancel. And, Mary said, she had consulted by phone with a second doctor, one who frequently treats children at local orphanages and knows about the illnesses that breed there. She needed to tell us about that conversation, about what it might mean for our baby. We had to come and see the doctor. Now.

"Mary," I said, "you understand that Jin Yu is our daughter, right?"

"Yes."

"You understand she's going home with us, right?"

"Yes."

Mary resumed her argument. A doctor might be able to explain what was wrong. A Chinese doctor might recognize a condition that an American doctor might not. If Jin Yu needed medical treatment, it could start here. It could start today.

Mary's reasoning made sense. And she had worn us down with her persistence. We told her we would meet her upstairs.

Ten minutes later, we walked into her room, the mundane duplicate of our own. The doctor was already there, a woman, perhaps in her fifties, her black hair beginning to gray and pulled back in a bun. She wore a white lab coat over a dark shirt and tan slacks, and sat perched on the edge of a chair on the far side of the room, near the window, in the light.

She greeted us with a wordless smile and opened her arms to our daughter. Jin Yu stood between Christine and me, holding on to our hands, wary at the sight of another stranger. She didn't fuss. She just stepped a little further back into her own darkness, turning slightly more blank to the world. I could imagine what she was thinking: Am I about to be handed off to someone new—again?

We led Jin Yu forward.

I knew nothing of the doctor's expertise or credentials, where or if she went to medical school, or what kind of medicine she practiced. And it didn't matter. This was China. This was the doctor. Take it or leave it.

The woman gripped Jin Yu's head with both hands, using her thumbs to part our girl's hair. The scar rose up like a snake from the sea. The doctor frowned but did not recoil. She glanced up, said something to Mary in Chinese, then returned to her examination. She pulled at the edges of the scar, following its length from begin-

ning to end. She put her nose close to our daughter's head, taking a deep sniff. Then she took Jin Yu's little hands in hers, edging our daughter forward until their noses were six inches apart. The doctor stared hard into Jin Yu's face, watching our daughter's eye movements. After a minute, the doctor let go, combing Jin Yu's hair back into place with her hand.

That was it. The examination was over.

The doctor—she was never introduced by name—leaned forward in her chair and began talking to Mary, who nodded at every other sentence. The conversation went on for five minutes, a long time for parents to sit by, unable to understand, as the state of their child's health is evaluated. Finally the doctor reached into her black bag and pulled out two tiny jars. One contained a green goo, the other a white paste. She handed the jars to Mary.

With that, the doctor stood up, cradled Jin Yu's cheek in her hand, and gathered her bag to leave. The fee was twenty yuan— about $2.50. I paid her from the loose change in my pocket.

The hotel room door clicked shut behind her.

Plainly, at that moment, whatever this doctor had determined or diagnosed, whatever our daughter's prognosis for the future, we were about to be told that we would have to live with it. That it was unchangeable. The doctor could have called for an ambulance, summoned a specialist, directed us to a hospital, referred us to an international clinic.

She didn't. She looked at our daughter for ten minutes and walked out.

"Well?" I snapped at Mary, my patience past thin.

"Okay," Mary said. She exhaled, then began:

The doctor does not think the scar on Jin Yu's head came from a cut, a fall, a blow, or any sort of sudden, external event or collision. She does not think the scar represents the outward evidence of inter-

nal damage. She does not think the scar is the result of any sort of medical operation or procedure. In fact, she does not think the scar is a scar at all. Not in the truest sense of the word.

She said: Imagine summer in a Hunan orphanage. The temperature soars into the nineties. And stays there. Monsoon rains add to the stifling humidity. Puddles and ponds form across the countryside, the breeding grounds for millions of flies and mosquitoes. The orphanage has little air-conditioning. Doors and windows are propped open to catch whatever breeze might pass by.

Now, imagine that a girl in the orphanage gets bitten by an insect. Her skin puffs up in an itchy welt. The child, perhaps a few months old, maybe a year, scratches at the welt, tearing it open. The welt becomes a raw, weepy wound—and even more uncomfortable.

The child sweats in the heat. Her hands are dirty. The more the wound itches and burns, the more she digs at it. The gash on her head becomes polluted with grime and germs. If the child has been scratching her bottom, as children tend to do, then her hand becomes a carrier of fecal matter, which is introduced to the open sore. At that point, the chance of infection moves from probability to certainty.

If the wound is left untreated, the skin begins to blister. The sacs fill with pus and blood. They stretch, burst, heal partially, then erupt again. The cycle repeats and repeats. If the child is lucky, she gets medical attention and the infection eventually subsides. When the wound on her head finally heals, the result is a landscape of ruined skin—that looks like a scar.

Mary said: The doctor believes this is what happened to Jin Yu. The other doctor, who I spoke to on the phone, thinks the same thing. Both doctors say that in the orphanages, this kind of injury is unusual, but not unheard of. Both have come across it before.

Mary looked at me, awaiting an answer, but for once I had nothing to say. It was not as if I'd raised this child from birth, as if I knew

something or anything about her past. I couldn't contradict or confirm any part of the doctors' opinions, or even suggest alternative possibilities.

Two doctors think Jin Yu managed to turn a mosquito bite into a raging infection? And that the infection turned the side of my daughter's head into a moonscape?

If that was what happened, the explanation didn't make me feel better. In fact it was horrifying.

Could an infection on the outside of a child's head injure her brain? Could it hurt the child's coordination and speech? Her hearing? Could it leave a little girl, my little girl, alive and conscious but largely cut off from the world?

Jin Yu's wound would have been noticeable to anyone who so much as glanced at her. But no one called a doctor? Or took her to a clinic? Her head must have been oozing blood and pus for weeks. She must have been in terrible pain. She must have cried out. And the people responsible for her care were either unable or unwilling to do anything about it.

Standing there, I was so angry I didn't even know how to respond.

It was Mary who finally broke the silence. Coat Jin Yu's wound with these, she said, holding out the little tubs of medicine. Alternate green and white. It will help heal the lesion and prevent reinfection.

I took the jars from her hand and slipped them into my pocket.

JIN YU has stopped screaming. She no longer has the strength. Her sobs croak in her throat as she goes hoarse.

Christine carries Jin Yu across the room, turns at the wall, walks our girl back, then turns at the window and covers the same eight steps again. She pauses in this back-and-forth journey only to try to

distract Jin Yu with toys and stuffed animals. It doesn't work. Our girl does not want toys. Or food or water or blankets or rest.

I take a turn holding Jin Yu. We trade back. And back again.

I wish Jin Yu would stop crying. My legs ache. I'm tired. But more than that, I can't bear her sadness. I can't bear that Jin Yu is in pain and I can do nothing to stop it. I can't stand that I, the person newly entrusted with her care and placed in charge of her well-being, am failing at the job—and failing so soon, and so spectacularly.

Jin Yu raises her head and gazes at me, not seeing. She looks at me the way you stare through a stranger on the street. Her eyes are red, her long black lashes stuck together with drops of tears.

"It's okay," I tell her, as she chokes out another sob. "Daddy's here. Daddy's here."

As if she understands English. As if she knows what a daddy is.

I'm not sure what time it is. I know it's late.

This is not how I envisioned this night, our time together, our trip to China. I thought our joining as parents and daughter would be, not easy, but not wounding either. I thought the children would be a little underweight, but basically fit. I thought our girl would shed a tear but not an ocean. I thought I would feel happy—that this union was a good thing, for her, for us, for China and America, for anyone in either land willing to take a chance on leading a different life.

Tonight, holding Jin Yu, I am learning that real children are not the freckled imps of television sitcoms who cease their tears the moment their mommies pick them up, just in time for the commercial break. Real children come to you with ravaged bodies and broken hearts. And when they weep out their sadness, their faces streak with snot and wetness, and drool soaks their shirts. They pee in their pants and on you.

I imagine myself walking until dawn, back and forth across the

dirty rug of this hotel room. This morning's visit to the orphanage feels like it was weeks ago. It seems Jin Yu's tears will never end—and then they do.

Jin Yu pulls in a deep breath. I brace for her to croak it out. Instead, her breath comes out in a long, slow exhale, like air escaping from a punctured tire. Her head flops against my chest. Her breathing steadies.

It takes me a minute to realize she's asleep.

I stand there, unmoving, for another five minutes, not daring to risk waking her. Then I silently take three steps toward her crib, one hand supporting her back, the other her head. I bend over and lay Jin Yu down.

It's easy. She doesn't weigh much.

THE MUSIC is jarring, a loud, early-morning soundtrack that forces itself through the windows of our hotel room.

Outside, the sky is close and dark, promising rain. Twenty-three floors below, on the stained, wrapper-strewn parking lot of an old theater, ballroom music blares from a speaker system, setting to movement a hundred spinning ballroom dancers. In the corners of the lot, people practice Tai Chi and fan dancing, their morning exercise conducted in the gloomy dawn, a necessity in a land where time and space are at a premium.

It takes me a moment to remember where I am. I turn my head on my pillow to glance at the clock radio. It says 6:00 A.M. My back aches. My right arm is frozen. I can't recall where I put my glasses. I slowly roll over toward Christine. She's awake, staring at the ceiling. Her hair is a tangle, the color gone from her face. She looks like she hasn't slept in days.

Jin Yu begins to stir, and Christine and I find each other's eyes,

dreading that our baby will start this day in the same state where she ended the last.

I push myself up on my elbow. I can see Jin Yu through the mesh webbing of her crib, lying on her back. She yawns, stretching her arms out and above her head. She rolls onto her stomach, works her knees up to her chest, then reaches out with her hands and grabs hold of the top rail. She hoists herself upward, first one shaky leg, then the other.

She peers over the top of the crib at us.

Her eyes are bright.

"Hi, darling," her mom says.

"Hi, Jin Yu," I echo.

Jin Yu's response is a cracked half-smile. Her look suggests she remembers us from somewhere, she just can't say where.

Christine gets up, plucks Jin Yu out of her crib, and sets her down on the bed between us. Jin Yu reaches out to touch her mother's nose—so pointed, so different from her own. She pokes and plays with her mom's nose and cheeks for a while, then wriggles free and tries to climb down. Her feet reach uncertainly for the floor, like Neil Armstrong stepping onto the moon.

On the carpet she puts one foot forward, then follows with the other, her legs trembling. She holds her arms away from her body for balance, as if making her way across a heaving deck. Six steps later she reaches the dresser, using it like a handrail to navigate her way to the luggage rack. She finds something that interests her: an open suitcase. She investigates, pulling out a shirt. She moves on around the room in a rough semicircle, giving the TV screen a pat, tugging on the strap of our backpack, stopping to slip her feet into her mom's shoes. She makes her way to the phone, where she takes the receiver from its cradle and puts it to her ear, listening to the hum of the dial tone.

Jin Yu has stirred herself as if from a coma. It's like she's broken surface after days spent underwater. Like she has decided to come and try out life in this world, to leave behind the world of her own, internal isolation.

She finds her way along the wall, to the full-length mirror. She stands there, studying her reflection for so long and with such intensity that I wonder if she has ever seen herself before. Christine fetches her a baggie full of Cheerios. Jin Yu willingly accepts. She manages to hold the bag, but when she reaches inside she's unable to grasp the bits of oats, lacking in fine motor coordination.

She lets Christine feed them to her.

In these minutes, watching my daughter munch oat after oat, I allow myself to imagine a future restored. To imagine a life with a happy, healthy child at its center. To envision a home made messily alive by her presence, a girl aware and embracing of the love that swathes her. I let myself imagine that she and I may yet rejoice, each in discovery of the other.

Our time here in Changsha is growing short. Today will be busy. Soon we'll fly south to the city of Guangzhou, the site of the sole American consulate that processes paperwork for Chinese adoptions. After a week of securing clearances and approvals, we'll fly from Guangzhou to Hong Kong, then to San Francisco, then home to Philadelphia.

Lying there in bed, watching Jin Yu watch herself in the mirror, I think about all we've learned and all we've been told, wondering how much of either is true. We were lucky to have been able to meet the orphanage director, his staff, the nannies who cared for our child. But between the language difference and the size of our travel group, we found out little that was new about our girl. The most important questions about her life and health, about the circumstances in which she was raised, remain unanswered.

We were told that all the children at the orphanage got two baths a day—which, if accurate, given the number of children living there and the minimum time needed to wash an individual child, would mean the staff spent most of every day bathing children. We were told who among our kids was talkative and who was not. Who liked to play in a group and who preferred to be by herself. That none of the girls had ever seen battery-operated toys and might be frightened of them at first.

We were told that our girls were born in hospitals, assisted by doctors armed with all their modern technology. Which seemed unlikely. If the Chinese parents did not have the money to pay the fines and penalties for the crime of having an "extra" child, they probably didn't have the resources to give birth in a hospital.

We were told that, sadly, none of the girls' Chinese parents left farewell notes. In each case, we were told, the mother or father had put down their child and walked away without leaving so much as a last scrawled good-bye.

That troubled me when I heard it, and it nags at me now as we prepare to depart Hunan. It seems so unlikely. Fourteen Chinese families abandon fourteen children at fourteen different places—but none leaves a note? None leaves so much as a record of their child's date of birth? Or wants to explain the reasons that drove them to surrender their own flesh and blood? None—God help them—wants to say they're sorry?

Later, I will find out that this statement, that none of the children had a note on them, was at best a mistake and at worst a casual lie.

One did.

Jin Yu asleep in her crib at the White Swan Hotel in Guangzhou

6 IN CHINA-LAND

IF CHANGSHA is the China of a history book, caught between the Great Leap Forward and the Cultural Revolution, a place where foreigners shop in Friendship Stores and recreation is a trip to a woodland park, then Shamian Island is its modern opposite—a small, Disney-esque China-land, where English is spoken, the dollar is king, and Pizza Hut delivery is as close as the phone.

The slender streets are lined with well-stocked, well-lit stores, many of which cater to adoptive parents. Jennifer's Place sells children's shoes, hats, dresses, games, fans, necklaces, kites, quilts, charms, bracelets, and shirts. It's followed by Sherry's Place, which is followed by Michael's Place, followed by Benjamin's Place, all of which sell more of the same. Several stores offer Internet access and same-day laundry service. They'll lend you a baby stroller for free.

Shamian Island is actually not an island but a sandbank, risen from the waters of the Pearl River and penned into permanence by thick stone walls. A series of bridges links it to the rest of the city of Guangzhou. The main boulevards are bisected by an island-long

park, a pleasant stroll of flower gardens, shade trees, and wooden benches. Traffic is restricted, and in the mornings the streets steam in the tropical sun, the rays visible in the mist. It's easy to imagine that in this place, as in Camelot, it only rains at night.

The island's fine-trimmed landscape reaches back to another century, nearly 150 years ago, when Shamian was taken at gunpoint. In 1860, as Americans embarked upon the bloodshed of the Civil War, the British claimed Shamian from the Qing, as spoils of the Second Opium War. Shamian became a foreign concession, and over time it grew to host spacious consulates and trading offices. Access to the island was guarded by gates and, supposedly, by signs that warned, "No Chinese or dogs allowed."

For Western oilmen, insurers, and diplomats, this spit of land— half a mile long—became France, England, Australia, a place to be remade in the image of home. On block after block, impenetrable granite walls went up around roomy European courtyards.

The buildings still stand, strong and imperious. The people who built them were planning to stay.

But today the consulates and banks have been reclaimed by the Chinese, turned into apartments, offices, and military barracks. Children play in the halls, and wet laundry hangs from clotheslines strung across once-grand courts.

The only signs of the buildings' previous use are the small brass plaques affixed to their fronts, naming the particular foreign power that laid claim to this particular piece of China. The United States does not go unmentioned. At least two buildings still serve their original functions, though now in the service of the Chinese and their guests. One is the Catholic church, built in 1890, closed during the Cultural Revolution, and since reopened. The other is the elegant Victory Hotel. It was once the Victoria, built by the British in the 1920s.

The most famous structure on the island is not a colonial compound but a hotel, and not the Victory. The White Swan is a soaring, thirty-four-floor white rectangle that overlooks the Pearl River on one side and the Banyan Gardens on the other. For tired Western travelers, the five-star White Swan is an oasis, in China but not truly of China.

Its main floor is a maze of fine shops, the wide halls the gallery for an unending array of sculptures and carvings of stone and jade and teak, all of them for sale. Above these offerings rise 744 rooms and 99 suites that open onto hallway floors washed in seas of thick green-and-rose-colored carpet, complemented by art-deco lighting and brass elevators. The lobby is an indoor microcosm of the South China farmland, all flowers and vegetation, its centerpiece a two-story waterfall that splashes into a pond brimming with dozens of foot-long goldfish.

At the White Swan, you can rent a Rolls Royce limousine to take you wherever you want to go. Or you can stay in, choosing from among half a dozen restaurants and bars. The hotel has its own beauty salon, karaoke lounge, driving range, and flower shop. It has a staff of at-the-ready babysitters.

It also has a nickname: the White Stork.

American families like to stay here for a couple of reasons. One is that despite its luxury, the White Swan is kid-friendly. The ground floor features the Swan Room, a big indoor play area strewn with dolls, push-cars, and games of every description, a toy kingdom presided over by its queen, Barbie, who reigns from behind a glass enclosure. The Swan Room is sponsored and supplied by Mattel, the toymaker, in an act of great kindness and marketing genius.

The second reason Americans stay at the White Swan has nothing to do with amenities and everything to do with location: the hotel is close to the American consulate, the only place in China authorized

to process adoption paperwork and send families speeding out of the country and on their way home.

At the White Swan, on Shamian Island, in the city of Guangzhou, my wife and I found all we hadn't found elsewhere: hamburgers, cold beer, potato chips—and a child newly able and determined to reveal herself.

CHRISTINE AND I are up early to prepare for the day, gathering documents to present to government officials and PowerBars to sustain us while we wait in line.

Jin Yu is still sleeping. Christine selects an outfit for her, clothes of light cotton, so she doesn't swelter in the heat. She packs a sweater for our girl, in case we go inside a building that's air-conditioned, a snack in case Jin Yu gets hungry and a sippy cup of juice for if she should thirst.

All her life Christine has wanted to be a mother. Already she is weaving a protective cocoon around her daughter.

Jin Yu awakes with a yawn, then pulls herself to standing, peeking at us from between the rails of her crib. She wants to get out and get moving. We dress her, feed her a quick snack of raisins, then take the elevator down to the main floor, strolling across the hall to a small bridge that traverses the lobby pond. Five minutes later we're being seated at the center of the hotel's River Garden restaurant, with its spectacular view of the Pearl River. I lift Jin Yu into a high chair and strap her in. Christine and I take our seats, staring out at the sparkles of sunlight on the water, watching the boats bob in the current.

Last week in Changsha, we filled our breakfast plates from trays of hard-boiled eggs, rice, and chicken feet. But here the morning buffet is fit to serve a head of state. Westerners come here by the

thousands, and the White Swan knows what they like. Chefs pre-
pare mounds of French toast, waffles, bacon, eggs, and potatoes.
There are cereals by the boxful, fresh fruit by the bowl, juices by the
pitcher.

Jin Yu wants to try it all. She devours everything we place in
front of her: Scrambled eggs. Bread. Egg rolls. She drains a bottle of
milk. Tries some yogurt. Burps. She has trouble grasping a spoon,
so we take over feeding her—mouthful after mouthful. When her
plate is empty, she utters the English word that has quickly become
her favorite, its pronunciation intense and exaggerated: "Mhh-
hoorrrr. . . ."

We fill her plate again. And she again eats it all, this time wash-
ing it down with juice.

In her first days with us, in a time when she met the world with
a dull stare, Jin Yu seemed not to know what to do when confronted
by a full plate of food. She ate what we spooned into her mouth,
mostly rice and steamed eggs. Now she will not stop eating. She is
developing preferences, establishing likes and dislikes. She enjoys
fresh melon, especially watermelon, loves bacon and the sweeter
American brands of cereal, dyed the colors of the rainbow. At first,
small brown rounds of Cheerios were all she would accept from us.
Now they've dropped toward the bottom of her personal menu, her
food of choice only if nothing better is available.

Other families sit down, eat their breakfasts, and leave. Jin Yu
continues to fill her belly.

She eats as if food were something new and exotic, as if the chance
to eat might never come again. Eventually we have to cut her off,
concerned that she'll make herself nauseous. Jin Yu doesn't like that
a bit. She quickly stuffs a last handful of cereal into her mouth, her
cheeks puffing with a reserve to be stored and savored.

It will be months before Jin Yu comes to understand that she

doesn't have to gorge herself at every seating, that food is as near as the refrigerator, and she can have more when she wants it.

For now, she sees food as a treasure for the taking.

Of course, her body needs the nutrition. And it needs fuel to create the energy to meet the demands that are being placed upon her. Every day, Jin Yu is made to experience new sights, new activities, new sounds, new people. As far as we know, until the day she was placed in our arms, Jin Yu left the grounds of the orphanage only rarely, like the other children allowed to spend an occasional night at the home of one of the nannies. Except for that, the boundaries of her world were set by the institution's brick and stucco walls. Now the walls have disappeared, and Jin Yu is being led across lawns and sidewalks, into offices and stores, over bridges and walkways.

Every place holds new wonders—and new fears. Jin Yu loves the hotel waterfall. Hates the bathtub. Loves the balcony. Hates being up on my shoulders.

At night, she is worn out but too wound up to sleep. Or to let us sleep. Freshly bathed and dressed in new pajamas, she rolls and turns in her crib. Sometimes, when she's supposed to be lying down, falling asleep, she stands up and stares at us. If we dare look back, she breaks into a big grin—and renews her efforts to stay awake.

I know a small bit of what she's facing. My wife's relatives are French-speaking Swiss. I speak a little of the language, but when the family is together, at day's end I'm tired from trying to follow the conversation. At age two, still learning her native language, Jin Yu is being asked to do more—to follow along in English even as she tries to speak and understand it.

An hour after we sit down to breakfast, the morning rush is beginning to thin. Dishes clatter as busboys clear cups and plates

from empty tables and place them in big brown tubs. I lift Jin Yu from the high chair and set her down. Her legs quiver when they hit the floor. She steadies herself against the side of the high chair.

It's clear that Jin Yu didn't get much of a chance to practice walking in the orphanage. She moves more like a one-year-old than a two-year-old. Even after a week of practice on the streets of Changsha, her steps remain uncertain. Whenever Jin Yu encounters a place where the surface is about to change—where carpet meets tile, or grass meets dirt—she has to stop. Then she stretches one leg forward, lowering her foot, toe first, like a swimmer testing the water. Only after she has assessed the quality and consistency of the next surface does she hazard to move ahead.

Still, she's slowly building strength and confidence. Her legs mostly take her in the direction she wants to go. She likes to push her own empty baby stroller, holding its lower supports for balance, the way an older person might rely on a walker. She's learning that her legs can be made to move faster, enabling her to attain, not a run, but a quick sort of clomp.

Everywhere, at breakfast and dinner and places in between, Jin Yu carries her favorite toy, the small stuffed bunny handed to her at our first meeting. The bunny has acquired a patina of grime and a name, Tu Zi, pronounced "Too-dsuh," which in Chinese means, of course, "rabbit."

Jin Yu has also developed a favorite game. When the three of us are lingering in the hotel lobby, waiting for a cab or for other families to meet us for dinner, Jin Yu will pause until she thinks we're not watching. Then she'll rush at the lobby door—which flies open, triggered by motion sensors. Sometimes she keeps going, out onto the paved entryway, dissolving in laughter as two adults—three if the doorman is on duty—chase after her. After a few attempts she figured out the precise spot at which the sensors will intersect with her

body. That's fun too. She steps forward. The doors open. She steps back. The doors close. Open. Close. Open. Close.

For a two-year-old, it's great entertainment. And vast power. For perhaps the first time in her life, Jin Yu is able to exert some control over her world.

CHINA IS many things to many people. Or, more specifically, it's something different to everyone.

It's a land where stained-glass images of John Lennon and Frank Zappa gaze down from the walls of a not-so-rockin' Hard Rock Café, and bronze images of Mao and Sun Yat-sen rise above the lawns of manicured parks. A land where the public markets stock basins full of angry brown scorpions, all crawling and squirming as they await a dip in boiling oil and a trip to the dinner plate, their fate to be shared by stoic turtles trapped in mesh bags and writhing black snakes held in glass tanks.

It's a land where monks in flowing gold robes and tourists in souvenir T-shirts line up next to one another to tour the Forbidden City. Where multimillion-dollar steel-and-glass hotels shimmer beside one-story hovels that lack electricity and running water, and the people inside of each stare out at the other.

It's a land defined by smells: The damp, wind-carried musk of plowed fields. The acrid smell of old cooking oil, cheap varnish, and burnt coal that drifts from doorways. The neon-colored scents of fruits and flowers that waft from gardens. The bland odor of dust and dirt on city streets.

For Christine and me, China is most of all a land defined by love.

In southern China, in a pitiless corner of the world, we have found more than we could have ever dreamed of. Our daughter. She

is ours, to hold, to kiss, to bathe, to feed. As we wander through the galleries and trinket stores in Guangzhou, Christine can't stop smiling. Jin Yu's every discovery—the sweet taste of sugar, the fluttery wings of a paper kite, the glass tinkle of a wind chime—is reason for celebration.

Jin Yu doesn't seem to mind when we hold her close, when we kiss her cheek. But she hasn't kissed or hugged us. I wonder if she knows how. I wonder if she understands the affection that is conveyed by drawing someone near. I think those feelings are within her. Her interaction with us has come to include a regular smile and even an occasional laugh.

In the evenings, when we meet up with the other families, Jin Yu chases after her Xiangtan sisters like the old friends they are. She seems to take comfort in the presence of the other girls, and to offer the comfort of her presence to them. Sometimes, when another child becomes upset and begins to cry, Jin Yu will move to the girl's side. She doesn't say anything, nor does she wrap an arm around her friend. She simply stands there, watching, presenting herself as a sign of the known and familiar. Often, that's enough.

These girls have spent the first two years of their lives together, the older ones, closer to three years. But time is drawing short. Soon they will be scattered, taken across the sea, to Connecticut and Texas, Minnesota and New York and Washington.

Before that happens, there is something Christine and I need to do.

THE TEMPLE of the Six Banyan Trees is as holy a place as exists in Guangdong Province, and a regular stop for American parents adopting Chinese children.

The temple was built about 1,500 years ago as a place to store

Buddhist bones brought here from Cambodia. During the Northern Song Dynasty, the great writer Su Shi visited this spot. Enchanted by the trees, he wrote out the inscription that would give the temple its name: Liu Rong, meaning Six Banyans.

Just inside the temple's front gate is a wooden stall, attended this morning by an older woman in a brown shirt. Here the faithful can buy small jade carvings of Kuan Yin, the goddess of mercy and protector of women, or choose from rows of malas, long necklaces of Bodhi-seed prayer beads. A few steps on is a dormitory, home to the monks who tend this temple. Their shaved heads and plum robes identify them as the spiritual descendents of those who watched over these same grounds ages ago.

Beyond the dormitory is the courtyard, dominated by a towering pagoda, the Flower Pagoda, painted in muted tones of rainbow. Its peak, adorned with the sculptures of one thousand Buddhas, seems to touch the sky.

It is impossible to walk these grounds and not be moved by the power of belief—or at least by the collective power of those who so fervently believe, whose certainty in a benevolent, caring spirit is but the modern incarnation of a faith that reaches back centuries.

At home, in the United States, I have friends who mark the passages of their lives by the ceremonies of their church. The regular Sunday services. The christenings, weddings, and funerals. They find strength and comfort in the routine of the rites and customs, their priests and ministers a part of their extended family.

Me, I rarely go to church. And I've never been in a Buddhist temple. I can't say that I have seen the presence of God, or a god, in the day-to-day workings of my life, not beyond anything that couldn't be ascribed to coincidence. Nor have I ever felt the need to seek Him out, to resolve in my own mind that He is real, that He or anyone is out there, listening.

But until now, I've never had a child. You do things for your child that you wouldn't do for others or even for yourself. For Jin Yu, I'm willing even to believe. It's been a long time since I prayed, for anyone or anything. Now, in our last days in China, here at this temple, I am ready to pray for everything.

We follow the scent of incense to our destination, the Great Hall. It is big and square, perhaps half the size of a basketball court. The scale of its contents makes it seem smaller, the hall dominated by three giant bronze images of the Buddha. Each one weighs about ten tons. They are the temple's centerpieces, imposing and impassive.

In the center sits Sakyamuni, the sage of the Sakyans. On the left is Amitabha, the Buddha of boundless light. And on the right is Maitreya, the future Buddha, often called the laughing Buddha. Before them is a long altar topped with trays of fresh fruit.

The hall is dusky even at mid-morning, smoky with the haze of burning incense. I take a spot in the front row, on my knees. Other parents from our group kneel down beside and behind me, holding their new daughters close. Two monks in purple-red robes silently move to either side of the altar.

Jin Yu climbs into my arms, but once there she doesn't want to stay. She squirms, insistent on getting free, wriggling until we're stomach to stomach. I take her by the shoulders and hips, and turn her to face forward. The images of the Buddha glow in the soft light.

The monks begin to chant, two voices joining to create a single melody.

I wonder if somewhere, in another temple, in another town in another province, the people who gave birth to Jin Yu might also be on their knees, beseeching the heavens to shower health and contentment upon their girl.

I wonder if Chinese gods hear only the prayers of Chinese people,

or if they'll be willing to hear mine as well. I wonder if a prayer offered in my daughter's native land will reach the heavens faster than one offered at home. If it will carry more weight with those to whom it's directed.

The chant picks up pace and rhythm, accompanied by the steady beating of a drum and punctuated by the occasional ping of a bell. The altar is pungent, the scent of oranges strong. Another monk arrives and seamlessly joins in the chant, the harmony gaining depth and volume.

I pray that Jin Yu will always be healthy. That she will always be happy, that her childhood will be filled with laughter and friends. I pray that the resilience that helped her survive two years of deprivation will remain within her, a support through life's trials. I pray that she will come to view her beginnings not as a darkness, but as a dawn. I pray that the people who gave life to her will find peace. I pray that their child, my daughter, will grow up to love China, and its people, that she will not give in to the bitterness that is surely her privilege.

The chant rushes on, fast and melodic.

I pray that Jin Yu will always be friends with the little girls who surround her now, her sisters from Xiangtan, restless in the arms of their new parents. I pray that these girls will reach for one another in times of trouble. And in times of joy.

I pray that Christine and I will have wisdom to help Jin Yu. Patience when she tests us. And time to see her grow.

I pray that tonight, Jin Yu will let us get some sleep.

A bell tings three times, and the chant slows to a stop.

My knees are locked, my legs stiff. Jin Yu, still in my arms, suddenly weighs a ton. I set her down in front of me, then use both hands to pull one leg forward. If this were a movie, the sound effect would be a loud creak.

Other mothers and fathers are already up and moving. They pause to drop bills in the offering box, notes of ten and twenty yuan, a dollar or two to help the temple, to ensure that the next time a new parent comes here, they will find a place to give thanks for their child.

Jin Yu takes Christine's hand. As we step away from the altar, one of the monks reaches out for our daughter. He takes her into his arms and begins to speak to her quietly, allowing me time to record the moment on my camera. He's young, probably no more than thirty. Jin Yu regards him the way she might regard a Martian, not frightened but cautious.

These two countrymen have not seen each other before and will probably never see each other again. Perhaps someday Jin Yu will look at the pictures. When she does, she'll see herself, a toddler, poised beside a man in a loose-fitting robe. She will know that in the days before she left her homeland, before her past fell away and her future began, her mom and dad came here, on their knees, to plead for the blessings of heaven.

Outside, monsoon rain pounds the pavement. It is time to go.

AT SUNRISE, the Guangzhou airport is already chaotic, its yawning entry hall swarming with travelers, baggage handlers, police, hustlers, beggars, and this morning, at the end of a very long line, a weary group of American families, their Chinese children in tow.

Everyone who wants to leave Guangzhou today is in the same line. It snakes down the center of the hall, which looks like a 1950s college gym, minus the bleachers. The line leads to a single door, guarded by security agents who check the identification of everyone who hopes to go from here to somewhere else. No ticket, no entrance. Even our guide, Mary, a privileged traveler in so many ways, is not

allowed through. In this place she is just another Chinese who might try to leave the country.

We can see her up ahead, near the door, waiting to say good-bye.

Time is tight. There is no more small talk among the Americans. People pat their pockets. Wallet. Passport. Plane tickets.

The line edges forward, dragging us with it.

Jin Yu is half-asleep in Christine's arms, oblivious to her pending departure, to the start of a daylong journey that will carry her across the ocean and away from everything she's known.

For the third time, Christine and I check the sealed brown envelope marked for American immigration officials, the papers that constitute our daughter's ticket into the United States.

Our time in China has sped by in a flash. And gone on forever. We can't wait to leave. We hate to go.

After thirty minutes of shuffling, half-step followed by half-step, we're almost at the entrance.

Mary is just ahead, answering a last question from the couple in front of us, shaking their hands, wishing them well.

They step away, handing their passports and tickets to the guard.

Mary turns toward us.

What can I say to her? What are the words? How do you thank someone who has helped to unite you with your daughter? How do you thank the person who has made a critical difference in the life of your child?

Two weeks ago, Mary was a stranger. Now she's our friend, our daughter's ally and protector. She fought for what was best for us and, most important, she fought for what was best for Jin Yu—even when Christine and I weren't sure what that was.

Now, our time together at an end, I could tell her, "We will

always be grateful." Or, "We will never forget you." Or, "You must come and visit."

It all sounds hollow, insufficient.

Before I can speak, Mary pulls the three of us—Jin Yu, Christine, and me—into her arms, holding on for a long second. She lets go and steps back, continuing to grasp Jin Yu's hand.

"Good luck to you," she says.

"Good-bye, Mary," I say. There's no use pretending this is anything else. "And thank you."

She walks the last few steps with us, holding Jin Yu's hand all the while. At the security gate, she gives our daughter a last kiss, then waves us on.

We press through the checkpoint, our passports and tickets in order. We fill out a departure form, then walk through a second metal detector. A humorless security officer searches our stroller and pats down our child.

Ninety minutes after we arrive, we're ducking our heads to step through the door of the plane, then settling into our seats and buckling our safety belts. Jin Yu shows no fear, just fatigue. Dark circles hang under her eyes. She sits stonily quiet as passengers file on.

A flight attendant stands in the aisle, reading from a card of safety instructions, speaking first in Mandarin, then in English.

Two rings of a bell signal that our departure is imminent. The plane backs away from the gate, executes one slow turn, then another, lumbering on until it reaches the peak of the runway. The engines rev to a high whine. The jetliner pauses, as if deciding whether to stay or go. Then it lunges forward, picking up speed. The wings stiffly sway up and down, like those of a big, arthritic bird trying to gain flight. The engines scream. The G-forces push us back against our seats. Jin Yu clings to Christine. The plane roars on, tearing

across the concrete. We're anchored to the ground. We're going to run straight off the runway.

The wheels jump off the tarmac and we're up—climbing, climbing, and then turning over the city. A wing points down, and the window fills with the rooftops of Guangzhou, as sooty as the city around them. The airplane straightens, then banks in the other direction as we aim toward Hong Kong. The plane levels, and slows, the noise of the engines reduced to a roar.

In a few minutes we'll have cleared the mainland airspace.

Jin Yu relaxes her grip on Christine. I pull a blanket across our daughter's lap, tucking it up against her chin.

I feel like I should try to say something profound. Something about all we've done and all it's meant. Something memorable, something so weighty that years from now, Christine will say to our daughter, "I'll never forget, as we were leaving China, your father turned to me and said . . ."

But I have no insight to offer. Here at the end, I have only questions. The comforting black-and-white certainties that accompanied me to China have all turned to gray.

Is it right to spirit this child from her country? To take from her the comfortable tones of her language, the tastes of her food, the faces of her people? No, it's wrong. It's the most selfish thing I've ever done. Jin Yu deserves to grow up in the nation of her birth. She deserves to be raised among fellow Chinese, in the home of the two people who created her.

And the man and woman who gave birth to Jin Yu should have the privilege of watching her flower. They deserve to revel in her laughter and to delight in the light in her eyes. As much as I love this child—and I love her completely—the joy of her parentage fairly belongs to others.

But if all that is wrong, then what is right? Jin Yu's Chinese par-

ents are long gone. Her familial home has vanished. If she were to stay in China, she would spend her childhood as a ward of the state, scratching out an existence in a leaky, rundown orphanage. Is that right? That she should be denied education, opportunity, family? No, that's wrong too.

An orphanage is no place for a little girl. It's no place for my Jin Yu.

Who would tell her that she's special? Who would listen to her stories, and laugh at her jokes? Who would be there to tell her that of all the people in all the world, she is the prettiest, the smartest, the most loved?

The plane engines whine, taking us up into the sky.

The point is moot. The decision has been made. Jin Yu's future has been changed, and I am party to those who changed it. Whether that future will be better or worse, whether it's the one she would have chosen had she been able to speak on her own behalf, is a question without answer. At least for now. Someday, Jin Yu will tell me whether I was wrong or right to do what I've done. And I will live with her judgment.

Right now, sitting sleepy-eyed in a middle seat, she knows nothing of all that's led us here, to an airplane high above the Pearl River delta. As she grows, she'll learn the facts and realities of what happened to her. I don't know what she will think of that, how she will balance one life against the other, rate the duality of her existence. Sitting here, watching Jin Yu fight to keep her eyes open, I wonder if she will blame me. If someday she will hold me accountable for the loss of her people and her culture. If she'll see me as the one who stole her chance to grow up amid the familiar.

A child begins to cry somewhere toward the front of the aircraft. A few business passengers look up, grimacing. They realize they've picked seats on the wrong flight, the one carrying fourteen

anxious children. Another girl begins to wail, following the lead of the first.

Jin Yu will take her turn. But not now. For now she is strapped in her seat, safety belt wide across her narrow waist, her head on Christine's arm. She is fast asleep. And as China fades into the distance, lost beneath the clouds, I can think of no reason to wake her.

POLITICS AND CHRISTMAS CAROLS

SHORTLY BEFORE we departed for China, our adoption agency issued us a page-long list of dos and don'ts. Among them was an index of conversational topics we should strive to avoid, lest we offend our hosts:

Don't talk about politics. Don't discuss China's leaders. For God's sake, don't mention religion. If you must bring up Taiwan, at least have the good sense not to refer to it as Free China, Formosa, or the Republic of China. Taiwan is Taiwan. And China, by the way, is China. Not Red China, Communist China, Mainland China, or any other politically volatile permutation.

Permissible subjects presumably included the weather. And maybe the state of the Chinese national soccer team.

Despite the prohibitions, and despite the too-brief, sixteen-day duration of our visit, I still managed to learn a few things about my daughter's native country.

For instance:

In China, there are no Australians. There are no British. Or

Inside a court of the Summer Palace in Beijing

French. There are no Italians, Spaniards, or Germans, no Scots, Swiss, Serbs, or Swedes. There certainly aren't any Americans.

There are only foreigners.

If you are in China and you are not Chinese, you are a foreigner.

And as a foreigner, you are not merely a visitor from a different part of the world, but a source of persistent curiosity and occasional resentment. You are subject to all sorts of restrictions and advantages, both social and financial. As a foreigner you may be charged more, or less, herded to the front of the line or pushed to the back. You may be regarded as something strange and different and perhaps even dangerous, something to be embraced or avoided, depending on the circumstance at hand.

I learned that in China, even on the hottest days, the Chinese don't *do* air-conditioning. Or at least they don't do it very well. You can walk into a restaurant or store and find an air-conditioning unit turned on full blast, pumping frigid air into a room that won't cool because all the doors and windows have been propped open.

I learned that in China, police officers will give you directions, but soldiers—and soldiers are everywhere—will not. I suppose they do not wish to be seen coddling foreigners by helping them find their way to the local market or museum.

I learned that despite China's increasing engagement with the rest of the world, and even in large Chinese cities, some people may never in their lives have seen *wai guo ren*—a foreigner. That the sight of a six-foot, 185-pound white guy with a beard is enough to make some people stop and stare, and that a few will insist you pose for a picture, for which they will gladly reciprocate.

I learned that in China, in some places, there is no such thing as garbage. Because there is always someone lower down the economic ladder, ready to make good use of what you're throwing away. Out-

side the gates of the opulent Summer Palace, young boys and old women camp beside the trash cans, pleading with visitors to hand over their empty water bottles. They are people for whom a few pennies' worth of recycled plastic can mean the difference between eating and not.

In China, I learned that poverty looks the same no matter what country you're in.

In America, we throw money at problems. In China, they throw people.

In hotels we met workers whose only job was to wipe the tile walls—which had already been wiped spotless by others. Alongside of highways we saw tons of dirt being pushed and shaped—and not an earth-mover in sight. No machinery, just a hundred men with shovels, and down the road from them, a hundred more. In an American department store you can wander for miles searching for a salesclerk. In China they're lined up like rush-hour taxis—two, three, or even four attendants eager to help, or at least eager for something to do.

I learned that in China, no matter the weather or season, it's always a good time for a Christmas carol. The people who embody what American politicians like to call mindless, godless communism enjoy nothing more than a pleasant hymn celebrating the birth of Christ. We heard carols everywhere, at every hour. At breakfast, the hotel music system played a classical rendition of "God Rest Ye Merry, Gentlemen." During a visit to a school, in the scalding heat of a South China summer, the children greeted us with a rousing performance of "Jingle Bells."

In China, I learned that while the government is avowedly socialist, capitalism is booming, from the large factories that crowd highway exits to the small entrepreneurs who spread blankets on sidewalks and sell charms and teapots.

I learned that in China, many people seem to think that because you come from the richest country on earth, you actually have a clue about what's going on in the world, and more expressly, that you have some idea of how to fix it. That you understand the problems in their community or the challenges they face in their specific line of work. During our tour of the Changsha Nobel Cradle kindergarten—a prestigious private academy—a teacher pulled me aside.

"Do you have any advice?" she asked in perfect English.

It took a minute for her to register my confusion.

"About the school," she prodded.

I told her that as far as I could see, she was doing a wonderful job. I didn't know what else to say, because the question caught me off guard. The fact is I no more know how to run a school than I do how to pilot a spaceship.

I learned that in China, practically everyone wants to come to America, but most people can't, and only a few will try through official channels. People told me that to ask for permission and be turned down—and being turned down is practically automatic—is to guarantee a black mark on your passport and government interest in your future travel activities.

In China, I learned that the children who are adopted into American homes are believed to have hit the geopolitical jackpot. That these girls, left in the flower markets and train stations of nameless cities, are viewed as having received, not what every child deserves—a home and caring parents—but some astonishing, unimaginable benefit.

Everywhere in China people approached us as if we belonged to their extended family, telling us about the cousin who lives in New York or the uncle who attended school in San Francisco. Then they would pinch our daughter's big cheeks and say, "Lucky baby, lucky baby."

People here in the United States told us the same, that Jin Yu was lucky.

At first, in that country and in this one, I would force myself to respond with a smile, to mumble some bit of bland politeness. Now I just nod.

I suppose that at a basic level, by switching her living quarters from a Chinese orphanage to an American home, Jin Yu's medical care, nutrition, and education will improve. She will neither freeze in winter nor broil in summer. She will go to the doctor when she gets sick. She will have toys that work, clothes that fit, pets to chase. She has acquired a father and mother who are crazy in love with her, two round-the-clock caretakers devoted to her well-being.

On a rough scale of "needs" to "needs met," she is perhaps better off.

But to me, Jin Yu is not lucky. To me, what has befallen my daughter is the opposite of luck.

Three days after she was born, Jin Yu was discovered alone in an alley, dressed in rags. She has lost both of her biological parents. She has lost her grandparents, aunts, uncles, and cousins, all the members of her extended family. She probably has lost an older sister—often the abandoned girls are second daughters—and if the hopes of her Chinese parents eventually came to pass, then she has lost a brother too.

She lost her home, her language, her religion, her culture. She lost her country.

When people tell me Jin Yu is lucky, I want to gag. My daughter carried exactly one thing out of China: her name. Everything else—every single thing—she surrendered.

In China, I learned that without the freak accident of an American adoption, these girls would be regarded the same way as their stay-behind sisters: the refuse of society. I learned that these children

are in effect held responsible for the actions of their Chinese parents, made accountable for their lack of name and lineage. I learned that they are given less because they are regarded as less. In China, I learned that for these children, my daughter, her orphanage sisters, there is often not enough medicine, or warmth, or clothing, or food. In China, I learned that in some orphanages, those who die outnumber those who live.

In China, I learned to be angry.

IN CHINA, I learned—or rather, finally came to realize—that information about the reality of Chinese adoption is selectively presented to would-be parents. That in the United States, among the dozens or scores of adoption agencies vying for customers, nobody actually tells a lie. They just leave out certain parts and emphasize certain others.

The ad in the American adoption magazine implores, "Chinese orphans need you!" At one time I thought that was true, a challenge to be answered. Now, I marvel at how a single sentence can contain so many distortions.

For one, the girls aren't orphans. An orphan is a child whose parents are dead. The Chinese parents of these children, the people who gave them life, are missing, hidden, unknown—but by and large they are alive and well. The repercussions of their absence are but the beginning of what goes unsaid. The beginning of what is briefly mentioned.

The process of adopting a child from China requires you to accept a vast amount of uncertainty. The health of your child, her age, where she might be living, all of these details are known only as percentages of likelihood. Until you meet her, the rest—character, personality, temperament—is mostly mystery.

I was ready for that. But I wasn't prepared for a few obvious truths, because nobody bothered to tell me, and I didn't know enough to ask.

In China, I learned that although American adoption agencies will readily mail you reams of colorful brochures and expertly shot DVDs and videotapes, they never tell you what you really need to know. Amid the photos of gorgeous, dark-eyed Chinese children and the lengths of pious texts imploring you to help, expounding on the difference that you alone can make, there's not one word about the pounding emotional assault of the experience. Not a line about the disorienting attack of conflicting feelings.

They never tell you what it might be like to venture inside an orphanage at a place like Xiangtan. To confront the life that your child, the person you love most, would have been left to lead in China. To see the life that children just like her—every bit as bright and beautiful, every bit as deserving—are living now.

They don't tell you that the children of the orphanage are all coming home with you. That these kids with their wan smiles and growling stomachs are going to follow you across the ocean, move into your house, inhabit your dreams. They don't tell you that from now on you'll never push back your chair from the dinner table without thinking of small children—just like your daughter—whose ribs are tight against the skin. That now, when you saunter through Toys 'R' Us, your child happily choosing a prize from among rows of pink-boxed Barbie dolls, you'll recall that during a morning-long visit to the orphanage, you did not see a single toy.

They don't tell you that when summer burns hot and steamy, and you're picking out a toddler's matching wardrobe of colorful pants sets and bathing suits, your mind will summon images of children wearing whatever came out of that morning's laundry—a small boy in a rumpled T-shirt, a thin girl in a washed-out gown, wafting

across the concrete carpet of a sun-scorched orphanage. Or that, in winter, as you pull thick blankets up to your child's chin on a bitter night, you'll wonder whether the children left behind are warm as well.

They don't tell you that on Christmas morning, your girl's gifts piled halfway up the wall, the extended family delighting in her presence and her excitement, your thoughts will turn to the children who will never see so many toys or experience such an outpouring of love and affection. They don't tell you that even the celebration of your daughter's birthday will be tinged with sadness. That as you watch your child lean forward to blow out the candles on her cake, you'll think of a nameless woman across the ocean, and know that, for her, this is a day of grief.

People think adopting a baby from China will be the answer to their prayers and problems, the fulfillment of their long-delayed dreams of parenthood, the antidote to their infertile physical forms. What they learn, what I learned, is that it's mostly exchanging one set of complications for another. I could write a much better brochure for the adoption agencies. One that would convey all the things that soon-to-be parents don't realize, what no one tells them, what in their deepest heart of hearts, they may not really want to know.

It would say: don't think you're going to walk into an overcrowded orphanage, take one child out, leave ninety-nine behind, and be the same person when you sit down to breakfast the next morning. You won't be. It's too cruel a lottery. And your participation in it will mark you.

It would say: from now on, wherever you may go and whatever you may do, the faces of the children left behind will come to you, unbidden, glimpsed in the eyes of a child scampering across the street in front of a crossing guard and in the smile of a girl skipping rope on a playground.

It would say: when you travel to China, you think you're bring-
ing home one little girl. Only later do you realize that a host of spec-
ters have moved in. You think you are tying your fate to the life of a
single child. You find out that you have been inextricably bound to
the lives of dozens of others. And that there is little you can offer
those children besides prayers.

ANGER IS not all I learned in China.

The country is too vast, its people too diverse, its culture too deep,
to foster but a single reaction, a solitary emotion.

In China, I learned that madness—of the most delightful and
entertaining sort—can be as close as the hand in your pocket. That
things can happen in China that could not happen anywhere else in
the world. In China, I learned, the hard way, that airport tarmacs are
noisy, smelly places. And that the cargo holds of major airliners are
smaller than they look.

We were running late, the weather threatening, nerves tight,
fourteen families with new children preparing to depart Changsha
for Guangzhou, to begin the final leg of our journey. Inside the air-
port, the line to the security checkpoint seemed endless. Finally we
reached the front.

I stepped through the metal detector, which emitted a loud
screech. I let out a loud curse, realizing that my Swiss Army knife
was in my pocket and would now be confiscated. I slapped my knife
into the plastic basket atop the machine.

I hated to lose that knife. It was a gift from Christine's uncle in Bienne,
Switzerland, not just a useful tool but a reminder of a happy trip.

I heard Mary talking to Christine behind me.

"Why is Jeff upset?"

"He had to give up his knife, and it's special to him."

A second later, before I could consider what Mary might make of a guy who holds sentimental feelings for a pocketknife, she was beside me, speaking urgently to the security officer. I didn't know what Mary was saying, but I could guess the gist: *Can't you make an exception? For this foreigner and his new Chinese baby? Surely you don't think this American, with his Nike sneakers and EMS backpack, is some kind of terrorist?*

I could tell the guard's answer by the look on her face: rules are rules.

Mary kept talking. Finally the guard picked up my knife and began to walk away. I figured she was searching for a trash can, a big metal one, one that would produce a loud, echoing *thunk* when she slam-dunked my knife, making a proper example out of this pushy American and his fast-talking guide.

But no.

"C'mon," Mary said.

We followed the guard back behind the checkpoint to a row of glass offices, waiting as she ducked her head inside the one on the corner. A minute later, a large man in a blue police shirt emerged. A supervisor. He looked rumpled, as if we'd woken him. The guard handed him my knife. Mary renewed her argument. I stood there, trying to seem pathetic.

The supervisor didn't look at me or Mary. He looked at the knife, turning it over and over and over in his hands, as if the next time he turned it, it might change color. Finally he looked up, dismissed the guard with a word, and waved over a younger, male security officer. He handed my knife to the kid, who started off. I figured this little drama had reached its end, that my knife was headed into a disposal and I was headed back into line.

Instead, the officer motioned for us to follow.

"C'mon," Mary said again.

The guard led us deeper into the warren of halls and offices, all the way to the back of the airport, to a security door marked with big, bold Chinese characters that I'm pretty sure must have said, Do Not Open.

He pushed the door open.

I was hit by a rush of wind and rain. Two steps forward and I was outside, atop a steel-mesh platform, eye level with pilots seated at the controls of big jets. One of the pilots glanced up, looked at me, then returned to checking his dials and gauges. Apparently he was used to having Americans show up outside his airplane, staring at him in the cockpit. The guard led Mary and me down a flight of stairs and from there out onto the tarmac. The asphalt was greasy underfoot. It smelled of fuel. It wasn't a comfortable place to stroll, among the tires of giant airliners, staring up at the planes' bellies, hoping none of them started to move.

The guard hurried across the tarmac as Mary and I hop-stepped behind him. He led us to the base of a tall, stairlike stepladder that reached up and into the stomach of a plane—our plane. There he halted our procession and called over a baggage handler. A three-way conversation ensued in Chinese. The guard took my knife—he had it all the while—and dropped it into Mary's open palm.

"C'mon," she said to me, for a third time.

The three of us—Mary, me, and the luggage guy—hustled up the stairs. I had never been inside a cargo bay, although this seemed as good a time as any to go. At the top of the stairs was a small platform. One by one we squatted, then duck-walked through the hatch and into the hold. It was dark inside. And cramped, too small for us to stand.

Worse, from my perspective, was that the bay was packed floor to ceiling with suitcases of every color and shape.

"We'll never find my bag," I said.

Mary answered, "We don't need to."

She explained: We needed to find a bag that belonged to some-one in our travel group. We would slip the knife into *their* bag, then retrieve it after the plane landed in Guangzhou. Luckily, the hotel in Changsha had slapped an orange sticker onto every suitcase owned by someone in our group. That sticker was now our grail.

The baggage guy, crouched in the half-light, pulled a suitcase toward him and turned it over. No sticker. Mary reached for a bag. I grabbed another. Nothing. On his third try, the luggage handler flipped over a big navy blue suitcase—revealing a bright orange cir-cle. Mary checked the name tag. The bag belonged to Tom O'Dea, a travel companion from Kansas.

"Okay?" she said to the luggage handler.

He nodded.

Mary unzipped the outer compartment of Tom's bag, tucked the knife inside, and sealed the flap. The three of us crab-crawled back across the baggage hold, edged out onto the platform, and scurried down the stairs. The luggage guy went back to his work. The secu-rity guard, who had been waiting at the foot of the stairway, led Mary and me in a fast walk through the rain, back across the tarmac to the airport offices.

Ninety minutes later, I was standing in the baggage claim area of the Guangzhou airport, watching suitcases and duffle bags topple off the conveyer belt and onto the luggage carousel. Somehow I still wasn't sure that my knife would turn up. It seemed too weird an adventure. But after a few minutes I noticed a familiar blue bag winding its way toward me. I pulled it off the carousel, set it down, and zipped open the side pouch. Nestled beside a Civil War novel was my Swiss Army knife.

I slipped the knife into my pocket and resealed the bag.

Looking around, I picked out Tom, whose suitcase I'd just rifled,

standing on the far side of the luggage area. I carried his bag to him and explained what had happened, how his suitcase became the conduit for a peculiar little exercise in fulfilling airport regulations.

Tom's eyebrows rose behind his glasses. I'm not sure if he believed me. From the look on his face, I don't think he was entirely certain that somebody who tells such wild stories should be allowed to handle sharp objects.

IN CHINA, I learned that while anger and gratitude appear incompatible, even opposites, they can sit side by side as the bookends to experience.

I learned that people you've never met in a land you've never seen may be willing to consider what you most need and want—and what a child might need and want—and try to maneuver each of you into a position to help the other.

In China, I learned that wishes can come true, granted by the most unlikely of wizards.

Whatever I might think of China's birth-planning policies, its system of orphanages, or its general treatment of women, I recognize this reality: the people running the government did not have to let me have Jin Yu. They didn't. There is nothing in international law or nation-to-nation politics that compels or even encourages the People's Republic to allow me to have my daughter.

A lot of people think China does it for the money, that letting wannabe parents adopt its lost daughters is a way to bring in hard dollars. I don't try to argue, because I know it's bunk. The researcher Kay Johnson has shown that while the money that flows to the orphanages is substantial—$100 million during a decade, now $25 million a year—it's a pittance in the overall Chinese economy. In

2001 China's total exports totaled $133 billion. The fees from international adoption, Johnson determined, equaled less than two ten-thousandths of that.

As strange as it may sound, coming from a cynical journalist living in a cynical world, I think China allows me and others to adopt our children for two main reasons: First, because, at the end of the day, these children are worth little to them. Second, and more important, because the people running the government believe it's a good thing to do. That it's a right thing to do, a benefit for the kids and the parents, a logical way to create loving families from among groups of people in need of both love and family. I think they see foreign adoptions not only as a way to save a little cost and trouble, but as a means to build links between countries, to forge connections between cultures at the most basic level.

Obviously the people charged with matching parents and children take care in their work. Among the untold numbers of children in Chinese orphanages, among the thousands of people who ask if they can adopt a child, the government of the People's Republic decided that only Christine and I should be allowed to have Jin Yu. Only we would be granted the joy of her smile and the pleasure of her laugh. Only we would get to be parents to this phenomenal girl. I wish I knew who in the government made that decision. If I did, I would kowtow before him, knocking my head on the floor.

I wish I knew who in the bureaucracy looked at a stack of children's files on one side of the desk and a stack of American applications on the other, and decided that, among all the possible combinations, our lives belonged together. I don't think the choice was random. If you were you to take Jin Yu's referral photo and place it beside a picture of me as a toddler—me in a crew cut, she with her head shaved—you would see a resemblance that borders on the identical. Same mouth, same cheeks, same ears.

Somehow the government also matched our personalities.

Christine has long believed that I am the most stubborn person on earth. And I believe it's not me, it's her. But both of us agree that Jin Yu is a contender for the crown. The thing is, being who we are, Jin Yu's stubbornness doesn't bother us. To us, stubbornness is normal. In another family, Jin Yu's obstinacy might have driven her parents and siblings to distraction. In ours it's the opposite. If Jin Yu had proven to be pliant, quick to change her opinion and surrender her will to ours, we'd probably have thought something was wrong.

I wonder, who took the time to find likeness in our faces and in our hearts? How did this person know that Jin Yu was a good fit for us, and us for her? How did he or she create a family as similar as family could be, consistent and alike but for DNA?

I know many parents who grapple with those questions, but none who have the answers. Partly that's by design. The mechanics of the Chinese government's "matching room" are rarely glimpsed by outsiders. Technically the matching room is called Department 2. By the time an application arrives there, it has already been examined by officials in the Registration Department, and then passed through Department 1, the review room, to ensure that all the paperwork is in order.

The matching room staffers consider the age of the applicants, and as a result an older pair of parents may be matched with an "older" child. But not always. Photographs too are used as a rough guide, because many Chinese believe that a person's face reflects his personality.

But that doesn't explain the staff's skill in creating cohesive families.

Jin Yu's home province of Hunan is but one of China's thirty-four provinces, autonomous regions, and administrative zones. An

estimated ninety-some orphanages operate in Hunan, though probably fewer than one-third participate in international adoption. Among those orphanages that participate, only a percentage of children are adopted. Among those children who are adopted, only some go to the same country. Among those who go to the same country, only a few go at the same time.

And among those few going to the same country at the same time, only one would come to me.

From the outside, the bureaucracy of Chinese adoption can seem a perfect mechanism of arbitrariness. Yet this bureaucratized, seemingly random procedure produced a perfect match. The odds against Jin Yu coming to us were infinite. Yet somehow she found her way to Christine and me, weaving her way across time and distance.

Many adoptive parents credit the red thread, a fable repeated so often that it has almost become an axiom in the community. It's the belief that when a baby is born, invisible red threads stretch out to connect the child to everyone who will be important in her life, be they down the block or around the world. The thread can bend and twist but never break. It's a belief in destiny, in foreknown fate, in providence. Many parents believe the match between them and their child was meant to be, predetermined by the full and infinite power of the universe or even by the hand of God himself.

Me, I don't believe in invisible red threads.

And actually, in China, the red thread is less a legend than a custom. The tying together of marriage goblets with a single red cord is a means of symbolically binding a wife to her husband. Which is not exactly a concept I want to encourage. Moreover, if God, or a god, is floating in His heaven, I would hope that He spends His time worrying about the big problems—war, famine, disease—and not about me.

I think the matching process is not as mystical as it might appear.

I think the nannies and administrators at the orphanages pay closer attention to their charges than people in America might imagine. That these staffers come to know the moods and behaviors of the girls they tend, particularly those who end up spending significant parts of their early lives in an institution, as did my Jin Yu. I believe the orphanage staffs effectively communicate that information to the China Center of Adoption Affairs. And that the people at the CCAA are really good at their jobs.

I think the workers there, having matched a thousand children with a thousand sets of parents, based strictly on photos and short biographies, get a feel for which child might fit best in which household, that they become adept at building families out of paper and pictures.

They did it for me.

Among the people I long to meet is the woman or man who matched me with my daughter, because I want to tell them of the importance of their work, of the difference they made in my life, in the lives of thousands of others. Because I want to tell them of all I learned in China. How, in China, I learned it's okay to be a foreigner. That people who start out as strangers can become friends.

I learned it's good to have faith—in people, in governments, in gods unknown and unseen. That faith doesn't have to be blind or even total. That it's okay to ask. For medical help. For permission to keep your pocketknife. For heaven's fortune.

In China, I learned you can find yourself in debt to people you have never even met.

JIN YU is unhappy with her father.

I can tell by her expression. Her eyebrows are pinched, her lips pressed forward in a pout.

She is sitting in her high chair, mostly done with breakfast, toying with a sippy cup that's half full of warm strawberry Nesquik. She doesn't like the chocolate flavor. And she refuses to drink her milk plain. Or cold. Her Nesquik has been heated in the microwave oven for precisely forty-five seconds, which is exactly how she likes it. But this morning she wants something else, something different.

"What?" I ask. "What is it?"

"Ah Dai," she says.

"What? I don't speak Chinese, sweetie."

Jin Yu stares at me across the table, like an exasperated judge looking down at a lawyer. I lean forward, moving my face closer to hers, and Jin Yu repeats herself, carefully enunciating each word, as if she were speaking to a child.

"Ah. Dai."

Jin Yu exploring her new home in Pennsylvania

I still don't get it.

"I'm sorry, baby, Daddy doesn't know what you're saying."

Jin Yu looks away, disgusted, as if she's wondering, *How in the world did I get stuck with this dummy?*

Maybe she's right. Maybe I am a dummy. Definitely I'm a novice, new to this idea of being a parent, to this job of being a father.

We are home. Back in the country. Back in our house.

Christine and I are elated, madly, giddily in love with our new daughter, still not quite believing she is ours. We are exhausted, our internal clocks unwound, our bodies unsure whether it's time to get up or go to bed. We are groggily, foggily trying to comprehend the external experience of traveling in China, and connect that to the transforming internal passage of becoming parents.

Christine sits to Jin Yu's right, a bagel on her plate. My wife looks different. Tired, for sure. Perhaps with a couple more gray hairs than when we left this house for China, though those are mostly hidden within her tresses of brown and gold. She looks—it's hard to describe. Not satisfied. Not exactly fulfilled. She looks somehow whole. She looks finally, unexpectedly content. As if the addition of a second being has somehow converted her into a complete entity of one.

She could live this day forever, the three of us together, safe and content.

Looking at my daughter, watching her play with her sippy cup, I feel like I have pulled off the biggest caper of my life. Against all logic and likelihood, I have flown into China, convinced a totalitarian government that I am capable of raising a child, and gotten the three of us out of the country and home in one piece.

Twirls of pink crepe paper hang from the dining room chandelier next to dangling cardboard cutouts of grinning Powerpuff Girls, the trimmings the handiwork of friends who held our house key.

The foyer is draped floor to ceiling in ribbons and streamers and Chinese lanterns, topped by a banner that says, WELCOME HOME. Outside the front door is a pink paper rocking horse, and just beyond that, stuck in a cement planter, is a sturdy plastic sign that announces, IT'S A GIRL!

It's 9:00 A.M., the start of Jin Yu's third day in America. Copies of today's *Philadelphia Inquirer* and *New York Times* lie in the driveway. The morning rush hour has come and gone without us. On the tracks behind our house, a SEPTA commuter train rolls toward the Elkins Park station, its rumble drowning the throaty calls of songbirds.

Jin Yu seems small in her high chair, her head not reaching the top of the seat. Her insistence on feeding herself has left a streak of strawberry yogurt across her eyebrow and a smudge on her nose. A handful of Cheerios is scattered across her tray. She picks at the oats, finally placing one between her lips, then pushing it out with her tongue. The Cheerio stays stuck to her upper lip.

"Sorry, Jin Yu," I say. "This isn't the White Swan breakfast buffet."

She frowns, as if to agree, *It sure isn't*.

Given the pace and movement of our time together, Jin Yu must think all we do is fly from hotel to hotel, each one grander than the next. But here, in this newest destination, the stacks of steaming waffles, pitchers of fresh juice, and slices of fried ham have all disappeared. There are no maids to pick up after us, and each day is not a whirl of outings and activities.

Still, she seems happy. Or at least, happy enough, given the revolution in her world.

Jin Yu tests the operation of her voice box, emitting a high-pitched coo. Then she puts her lips together and blows, producing the high-rev sound of an airplane readying for takeoff.

"Ma-ma-ma-ma," Jin Yu says, offering a big smile to the video camera.

She is at once small and gigantic, weak and dominant. Her presence fills the house. Three weeks ago, before her arrival, I'd have spent this morning sprawled on the couch, folding the sports page, concerned only with whether the Phillies won or lost and if there might be a last cup of coffee in the carafe. I'd be thinking about checking the movie listings for matinees and waging an internal debate over whether to put off mowing the lawn for another week.

No more.

Jin Yu dictates the day's agenda, her welfare—whether she needs a nap or a snack or a hug—the consuming focus of the minute and the hour.

Watching her, I realize I know something new and different, something I didn't know the last time I sat in this seat: I know what it's like to love a child. I know what it means to place the happiness of a little girl far above your own. It's liberating, in a way. I don't have to worry about myself anymore. What happens with me is unimportant. I only have to worry about her.

At the same time, it's disorienting to discover that the thing I never wanted—a child—is actually what makes me happiest. That realization makes me question all the others. Maybe I was wrong about those too. Maybe I really do like France. Or cauliflower. Or even the Mets.

Jin Yu is finished eating. Even after such a short time together, I know when she's ready to get down from her seat. She makes no sound or announcement, doesn't shake her head at a last, proffered spoonful, or turn her body away. Instead she raises her arms over her head, palms forward, like a movie bad guy cornered by the cops.

Jin Yu pauses there, in stick-'em-up repose. I can picture children sitting on either side of her, a vision of a dozen girls in a row at

the Xiangtan orphanage, waiting for the nannies to wash their hands.

I grab a damp paper towel from the table, then wipe Jin Yu's hands and face. I slide her tray out of its locks, put it down, and unsnap the clasps of her safety harness. Our dog, an elderly chocolate Lab, watches attentively, hoping a stray Cheerio may fall. Jin Yu has shown no fear of Mersey, though the dog is three times her size. And Mersey has quickly ascertained that it's wise to stay close to this new, two-footed arrival, as she will freely distribute her leftovers. Jin Yu would like to get to know the cats—Bela, Binkey, and Tuxedo—but they are far more circumspect. When Jin Yu steps toward them they vanish, and when they move from one place to another they travel up high, from bookcase to table to hutch.

The only animals Jin Yu doesn't seem to like belong to the pack that has invaded our house during our absence: dust bunnies. As I lift Jin Yu down from her high chair, she spots one lurking in a dining room corner. She squats down and points at it, shouting, "Ooh! Ooh! Ooh!"

"It's just a dust bunny, Jin Yu," I say, a little defensive.

She turns her gaze and looks at me, as if to say, *It sure is. A big one*.

Then she totters off.

THE WAITING room is decorated in muted tones of blue, its tables stacked not with months-old magazines but with plastic tow trucks and wooden puzzles.

We made an appointment before we left for China, wanting to be sure that our daughter would be seen quickly if she came home sick. We've been seated only a few minutes when a nurse opens the door at the head of a long hallway.

"Gammage?" she says.

We're the only ones here.

She leads us to an examination room. A minute later, Dr. Sude knocks twice and walks in.

In the Philadelphia area, Leslie Sude is one of a very few go-to docs for adopted Chinese children and their parents. She is young and smart, knowledgeable not just about the broad issues of international adoption but also its minutiae, of the specific illnesses that can attach to children who live in China's orphanages. Most encouraging to parents, Dr. Sude has a Chinese daughter of her own, so she has been there and done that, knows from personal experience what the girls—and their mothers and fathers—are facing.

It's the second time we've seen her. The first time we were childless. Christine and I came here shortly before our departure to China to learn what medical supplies we should carry, and how to administer certain medicines if our child became ill.

"Hi, everybody," Dr. Sude says warmly, then turns to our daughter. "Hello, Jin Yu."

Jin Yu, sitting on her mom's lap, doesn't answer. I'm not surprised. Faced with new people or situations, her first reaction is to go silent and still, moving halfway into the void that enveloped her in China. And so far in this country, new people and new situations are pretty much all she's had.

Dr. Sude asks about our trip, our jet lag, our adjustment as a family. After three minutes of gathering background information, she looks to Jin Yu, appraising my daughter not with the eyes of a mother but with those of a scientist.

Without taking her eyes off my child, she asks, "What do you know about Jin Yu's health?"

The answer is the same as it was when our daughter was nudged forward and into our arms: Nothing. Nothing really.

Nothing beyond a few checked boxes on an orphanage form, telling us that in health she was "normal" and in personality "obstinate sometimes." That she could put blocks into a cup, take them out, and bang two of them together. That she liked toys and music, as if other children did not. That at night she slept deeply, and during the day she could be restless. That she preferred the company of her caretakers to that of the other children.

The absence of information about Jin Yu's health is more than an intellectual loss, more than a reminder of all she had to give up to come here. It's a concrete loss, with potentially lasting repercussions. I wonder if Jin Yu is predisposed to diabetes or high blood pressure, or even to cancer or Alzheimer's disease. Knowing her family background would give her—and us—some sense of what to expect.

When I was a boy, my grandmother had to have her gallbladder removed. One of her sons eventually underwent the same surgery, as did one of her daughters, my mother. Knowing that, I expect that someday it will be my turn. Jin Yu won't have that advantage, that early-warning system of family history.

Christine lifts Jin Yu up and onto the examining table. Dr. Sude looks in our daughter's ears, in her eyes, down her throat, listens to her heart through a stethoscope. Jin Yu offers neither resistance nor encouragement, enduring this poking and prodding with stoicism, as if it were happening to somebody else. Dr. Sude says that once the physical exam is complete, she'll need to take a sample of Jin Yu's blood, to mark the levels as a baseline and to recheck the results of tests done in China.

Watching her examine my child, I wonder if Dr. Sude will discover the scar on Jin Yu's head and what she will make of it if she does. I don't want to prejudice her examination by mentioning it at the start.

Yet I feel as if I'm keeping some terrible secret, saving the worst

for last. I believe my daughter is healthy. But still I hope that here, back on the Western side of the globe, in the office of an expert American doctor, I can get an explanation of what is likely to have happened to her.

Christine and I wait for our turn to speak, for the moment when the doctor, having concluded her examination, will turn to us and say, "Do you have any questions?" And we will say, "Yes. Yes we do."

Dr. Sude runs Jin Yu through a series of developmental tests, all triangles and blocks and squares. She hands our daughter a plastic baby doll and an equally tiny bottle filled with imitation milk. Jin Yu is supposed to pick up the bottle and put it to the baby's mouth, to reflexively offer nourishment and display a life-sustaining maternal impulse.

Our daughter ignores both doll and bottle, holding them absently. I don't think she recognizes what they are. The doctor might as well have handed her a chess set.

I can tell that Dr. Sude is a little disconcerted. But to me, this represents another small window onto Jin Yu's past. I figure my daughter spent all but the last few weeks of her life in an orphanage. I don't know if she ever saw a doll before she arrived in America. And if she did, pretending to feed fake milk to a fake baby couldn't have ranked high on her list of priorities.

Finally it is our turn to speak, to ask questions instead of trying to supply answers.

"There's one thing," I begin.

Dr. Sude listens to our tale, then turns back to Jin Yu. She parts Jin Yu's hair with her hands. The scar is not hard to find. Dr. Sude uses her thumbs to manipulate its edges.

She frowns.

"What did they say caused it?" she asks.

We tell her—how the orphanage officials said it was nothing, a scratch, how one nanny tried to tell us it had been there from the moment Jin Yu arrived at the institution at three days of age. We explain how a Chinese doctor thought this wound could have started as a bug bite and bloomed into a ruinous infection.

I ask, Could that be right? Is that the most likely explanation?

Dr. Sude returns to the scar, taking another long look. Her fingers probe and knead the side of Jin Yu's skull. After another minute, she steps away from our daughter and looks at Christine and me.

"Whatever it was," she says, "it's healed."

The words linger for a moment.

That's it?

She must not have understood.

I tell her our story again, repeating the details—louder, and more urgently, as if that will change the quality of the information. I tell her about our terrifying discovery of the damage to our child's head, of our fears for Jin Yu's life and health, our inability to get a straight answer from the people in charge.

Dr. Sude doesn't interrupt. She lets me go on, describing and recounting and clarifying, until I have run out of words. When I finally stop talking, sure that now she will understand, Dr. Sude looks at me with an expression I take for sympathy.

She says: Here's what you have to realize. Children can come out of the orphanages with all sorts of illnesses and injuries. This one is on the surface of the skin. There's no evidence of abnormality or damage to the bone underneath. Jin Yu displays no symptoms of brain trauma, no sign of any cognitive impairment. Could this wound have been caused by an infection? Yeah, it could have been. But it also could have been caused by something else. By a lot of things.

She says: Here's the reality, and it can be hard for parents. Sometimes, you're just never going to know. Sometimes, in Chinese

orphanages, things happen to children. And you never get an explanation. The information, the history, the background—it's just gone. Vanished. Unknown and unknowable.

Dr. Sude looks at me, awaiting an answer. But I have none to offer. She turns to her file, scribbling a couple of notes on Jin Yu's medical record.

Whatever it was, it's healed.

Those five words may have to be enough for me. But will they be enough for Jin Yu? This scar is not some neat, fading line, soon to disappear. It's a rough gouge of blistered skin. It will be there forever. A patch of flesh where her hair will never grow. The remnant of an injury that must have caused terrible pain.

The wound may have healed, but its impact lingers. For me. And, I worry, for my girl.

Someday Jin Yu will ask me about this scar, about how and when it got there, and what's more, she will be asked about it—by classmates, teammates, boyfriends, lovers. Her hair will grow long enough to allow her to cover the scar. She will be able to hide it when she wants. But anyone she allows near, close enough to touch her face, to kiss her cheek, will see it and wonder.

Whatever it was, it's healed.

I wonder if Jin Yu will as easily move beyond the ragged dimensions of this mark, if those few words of summation can suffice. I wonder if this scar will become a kind of mean, personal touchstone, forever poked and fingered, an indelible reminder of a missing past.

I PULL the front door closed, the lock setting with a loud click. Jin Yu and her mom are already waiting outside on the cement apron that passes for our front porch.

It's hot and muggy, typical August weather in a standard Phila-

delphia summer. The bushes are lush, the cars in the driveways coated with pollen. My picket fence still needs painting. Nothing has changed on our block. Nothing and everything.

The neighborhood looks different. The people too. America looks different. It looks newly, unimaginably rich. My house, like the one next door and the one beside that, is strictly middle-class by American standards. In parts of Hunan it would be a mansion. Down the street is a cluster of clothing and jewelry boutiques, places where women buy silver and gemstone bracelets, along with skirts and blouses of comfortable summer-weight linen. Nearby is a grocery store stocked with practically anything that anybody might want to eat, and an art store that sells expensive carvings and paintings. This morning it all seems excessive. Disproportionate. In China, with no more than a backpack on our shoulders and our daughter in our arms, Christine and I had all we needed.

The three of us step through our front gate and turn left on the sidewalk, starting a long, languid walk toward what we have already come to call "the Yellow Park," nicknamed for its giant yellow sliding board. Jin Yu holds tight to her mom's hand, for support and comfort.

After a few steps, Jin Yu tugs Christine sideways. Our girl has spied a tiny purple flower poking up from the strip of grass beside the curb, and she crouches down to examine the bud. I wonder what the people in the passing cars might make of this scene. A little Chinese girl squatting by the road, staring hard at a patch of lawn, two older white people crouched behind, staring hard at her, as if she were about to do something magical.

Jin Yu completes her inspection of the flower, retakes her mom's hand in hers, and grabs mine with the other. We start off again. It still feels odd to hold a little girl's hand. To walk bent in a partial stoop, as if my back were hurting, so that her arm doesn't stretch.

I find myself being preternaturally careful with Jin Yu, as if she were an egg, fragile and breakable.

I am still learning. We are still learning, Christine and I, trying to figure out how to function as a threesome after years of being two. Jin Yu seems to trust us. At meals she willingly opens her mouth, certain we would never feed her anything harsh or bitter. She lets us comb her hair, wash her face, dress her in bright new clothes. She doesn't push or kick when we lift her up, or balk at being strapped into her car seat to go out on an errand.

Day by day we are teaching her how to be a daughter, indeed, how to be a child, how to be not the constant seeker of attention and affection, but its recipient. As much as we are teaching her, she is teaching us more—how to be parents. How to hold her, speak to her, how to comfort her when she cries and laugh with her when she smiles. We are a new family—but what is that? In our house it is two people intensely focused on a third, newly obedient to schedules of feeding, sleeping, and waking. Overnight the house has filled with dolls of every size and color, and stuffed beasts that represent every order and class in the animal kingdom. Parts of games and puzzles are strewn through the house like field seed. I'm sure we will still be finding pieces under couches and seat cushions after Jin Yu has left for college.

Right now that seems light-years away. Right now Jin Yu is a child who is interested in everything. And a little afraid.

She is content to play in the sunroom, but the living room is an expanse of hostile territory, never to be dared. She likes Doritos. But not chocolate. Ice cream strikes her as a little cold. She won't eat it unless we heat it in the microwave. Television holds no attraction. But a walk up the stairs is a magical journey, each big step a triumph of exploration. She can go up, and then down—to a child two completely different journeys.

Here in a new land, Jin Yu struggles to make her wishes known to us. And we labor to make ours known to her. Mostly Christine and I have to point, or we lead her by the hand to whatever we want to show her. I hope Jin Yu doesn't think we are transitory caretakers, that her stay with us is temporary. But there's little we can do to tell her otherwise, our different languages a fence. We carry Jin Yu around the house, showing her each room, welcoming her to climb or sit wherever she likes. We tell her she is here forever, that we will always love her. She doesn't understand. Her room—with its fresh sea-foam-colored walls and built-in bookcases, crafted by her mom—must seem like little more than where she happens to live now. Next week it could be somewhere else, like the hotel where we stayed in Guangzhou, and the different place where we stayed the week before that.

Twenty minutes after we start out for the Yellow Park, a stop-and-go stroll during which Jin Yu halts to check out anthills, cracks in the sidewalk, and stray vegetation, we reach the main gate. The park—its real name is Ogontz Park—is a giant green rectangle encompassing soccer fields and a baseball diamond.

Jin Yu doesn't take off running for the jungle gym. She stops where the cement of the sidewalk meets the gravel of the jogging track, again where gravel changes to grass, and once more where grass switches to wood chips. Each time we come here, she waits to be reintroduced to the play equipment, wanting to be escorted up the steps of the faux castle and led across its fortlike drawbridge.

I lift Jin Yu and place her on the toddler's swing, her legs secure in a hard rubber bucket. A small push gets her going, another whisks her higher. Jin Yu loves the swings. On the swings she relaxes, happy to move like a pendulum from point to point, confident that her back-and-forth journey will end at the same place where it started, in my arms.

After half an hour on the swings, Jin Yu shows no sign of want-

ing to stop, but it's getting close to lunch time, and given her inclination to inspect each bud and bug, the walk back can be a crawl. I let the swing slow to a bob, then grab the chain. I pluck Jin Yu out of the bucket. She looks tired. She doesn't want to walk, and I'm happy to carry her.

At home Jin Yu demolishes a bowl of noodles and a wedge of cheese. A tangerine serves as dessert. Drowsy in her high chair, she accepts a last spoonful of broth. Christine wipes our daughter's hands and face and unsnaps her bib. I pick her up to carry her upstairs for her nap. In her room, we sit on the floor to read *Curious George*, who as usual is in big trouble. Then Christine and I set Jin Yu in her crib, kiss her goodnight, and quietly close the door behind us.

I love naptime. And bedtime. And not because they offer a respite from the demands of the day. But because when Jin Yu lies down to sleep, she reveals her secrets. Downstairs, I turn up the volume on the monitor as Jin Yu begins her sleeptime ritual, babbling to herself in baby-talk Chinese. Her voice rises and falls, changing tone and pitch. Sometimes she'll talk for half an hour before falling asleep. It's like she's explaining her new world to herself in words she can understand, offering herself the only piece of what remains of the past—her language.

I love to hear her speak in Chinese. It's beautiful. And it makes me realize how I must sound to her, a voice making sounds that have no meaning.

Jin Yu begins to sing, a song I can't make out, a melody I've never heard. Her voice is sweet and strong. To Jin Yu, the verse is soothing, helping her drift toward sleep. To me her song offers reassurance. I imagine the Xiangtan orphanage, a place where too-busy nannies have too few hands to tend too many children. But at night one woman stands beside a crib, and there in the darkness, for reasons of her own, she sings softly to my child.

IN CHINA, Jin Yu was afraid of the bathtub. It may have been the cold tile or the warm water, or the sound produced when one sloshed against the other.

In Hunan we washed Jin Yu in the sink, the small oval form a better fit for her thin body. That first time, the dirt came off her like a second skin. In her new home Jin Yu has overcome her aversion to the tub, come to relish bathtime as a chance to splash and laugh and taste soapy mouthfuls of suds.

Tonight, as every night, Christine is kneeling beside our daughter, leaning into the tub to gently swish a wet washcloth across her back.

My job is twofold: One is to make funny faces and the occasional odd noise, to keep Jin Yu amused and patient while Christine washes her body and lathers her hair. My second task, once Jin Yu is clean and rinsed, is to wrap her in a big powder-blue towel and lift her up, sparing Christine's back and giving me the chance to hold my fresh-scrubbed daughter close, to breathe in the scent of her skin.

I lift Jin Yu out of the tub, naked and shining. It's as close as I will ever get to the moment of her birth. She smells so good. She smells like rain. She smells like the earth in the minutes after a storm has passed, the sky caught between cloud and sun.

I take a seat on the commode, steadying Jin Yu on my lap while her mom rubs her from foot to forehead with moisturizing lotion. Jin Yu is all motion and sound, wriggling this way and that, calling out unintelligible orders to mom and dad. Christine cleans Jin Yu's ears with a Q-tip, tossing the used swab into a wicker trash basket. She trims Jin Yu's toenails and fingernails with a pair of safety clippers, then rubs antibiotic cream onto the palms of our daughter's hands, the site of a weird, bumpy infection.

Last, Christine turns to Jin Yu's head. The cleaning of the scar has become part of our daily ritual.

Christine takes another cotton swab, dabs it with antiseptic and gently begins to scrape the surface of the wound, pushing away bits of dead skin. The scar seems to be changing, becoming more defined and solidified. As it contracts it offers up bits of dirt and filth, the way slivers of metal will continue to work their way out of a soldier for years after the initial wound.

After she completes the cleansing, Christine coats the scar with the medicines we were given in China, the white cream and the green jelly. We still don't know what's in them. Or if they're helping. Whether we should stop applying them now or go and try to find more, for the day when we run out.

Christine assumed the job of bathing our child through unspoken mutual consent. And just as there was never any question she would be the one to bathe Jin Yu, there was no doubt she would be the one to clean Jin Yu's wound. As Christine paints the scar with medicine, I turn my head away.

I can't watch.

It's not that the treatment is painful for my girl. Most nights she barely seems to notice. It's that this scar is a visceral presence, an emblem of her suffering, a reminder of my absence.

To me, it's inconceivable that a massive wound could blossom on the side of my child's head, but neither the people at the orphanage nor doctors in two countries can say how it got there. Telling me it's healed doesn't tell me how it happened. Or how much pain my daughter endured.

I know that at one time, the nannies placed hot water bottles in the cribs to keep the babies warm at night. Sometimes the bottles leaked, burning the children. But Jin Yu's injury looks too linear to have been caused by a burn. On the other hand, if it was caused by a

cut, it surely would have required stitches to close. Yet her skin bears none of the pale, telltale dots typically left by sutures.

As Christine sets to her task, I turn my gaze out the window—and my mind to who is to blame. I know exactly who that is:

A careless orphanage staff. An indifferent welfare system. A government that consigns little girls to live in a place where a head injury can fester and boil without notice. From those people and those systems, I want more than an explanation. I want vengeance. I want someone to pay, in pain, in agony equal to that inflicted upon my child.

Jin Yu is wiggling on my lap, tired of being prodded.

As I look out across our front walkway, I imagine the three of us as guests at an official government function, visitors to the Chinese embassy, mingling with diplomats in tuxedos and foreign-service wives in long formal gowns. I see myself waiting patiently as the receiving line inches forward, toward the foreign minister, who is greeting guests a few feet ahead. Finally, when it is my turn, when I've drawn close enough to look into his eyes, to touch him, I ignore his outstretched hand—and grab hold of his necktie. I yank him forward, listening to the satisfying choke that emits from his throat as I shove his face next to the side of my child's head, where he can take a long, close look.

That thought is quickly followed by another. By a vision of a different circumstance and outcome. One based at least partly on fact. One that forces me to reconsider my studious assignment of fault.

A friend at a foreign charity told me how she had visited the Xiangtan orphanage not long after Jin Yu would have arrived. During her tour of the housing area she noticed a baby lying in a crib, the side of the girl's head covered with a thick bandage. My friend saw the child only for a moment. She never learned the baby's name.

It's impossible to know if that child was Jin Yu. Probably it

wasn't. It could have been any one among scores of children. But even if it wasn't my girl, it shows the orphanage was providing treatment to a sick baby, that the people there were doing what they could for an injured child. They hadn't abandoned her to the fates. They were trying to make her well.

There is something else too. Something specific to my daughter.

During the daily ritual of bathing Jin Yu, of cleaning and medicating her scar, Christine made a discovery: several additional scars on Jin Yu's head, each one a short, thin line, barely perceptible. They are as different from the scar on the side of her head as the sun is from the moon. They look like the scars left by intravenous needles. And in China, the common practice is to insert IV lines in the head, not the arm.

It makes me think: maybe I have it exactly backward. Maybe, far from ignoring Jin Yu's injury, the orphanage staff did everything possible to help her, including the provision of multiple IVs. Maybe it was only their intercession that saved my baby from serious, long-term injury. Maybe it was only their devoted intervention that kept my child alive.

I think back to that day when we visited the orphanage, those hours when the nannies gathered in the courtyard and surrounded us and our children. Friends who see the videotape sometimes ask: Was it an act? Had the nannies been told to smile and pose, to put on a show of warmth and love for the visiting Americans? Had the caretakers in street clothes been ordered in on their day off to make the pantomime complete?

I suppose it's possible. But I don't think so.

I've worked twenty-five years as a news reporter, an occupation that routinely puts me in contact with politicians, promoters, and public relations agents, people for whom the truth can be a malleable concept.

I have learned to trust my instincts. And I am sure the nannies'

affection for the children was real. The tears they shed that day were genuine. When Jin Yu was first injured, or took sick, could these same women have ignored her cries for help, her obvious distress?

No. They couldn't have.

Here, at home, granted a measure of space and distance, I have to believe it's as likely the staff did everything they could as it is they did nothing at all.

I will never know for sure.

My daughter's life in China is a mosaic of a thousand tiny tiles. I can infer some of the colors and guess at the broad outline, but I will never see the complete picture. As we go forward, father and daughter, I will have to piece together the story of her beginnings by choosing the parts that seem most logical to me, selecting the likely versions of possible realities. And as she grows, Jin Yu will conjure her own account, selecting and ordering the parts that seem most probable and believable to her.

Now dry and lotioned, Jin Yu is ready to get off of my lap and into her pajamas.

Many, many months from now, on an evening much like this one, after Jin Yu has acquired the language to ask and the interest to inquire, she will look up from my lap at her mother and pull back her lengthening black hair.

"Mommy," she asks, her finger upon the scar, "what is this?"

"It's an ow-ee, sweetheart."

"I had an accident?"

"We don't know, darling. It was there when you came to us from China."

"Do other girls have one?"

"No, darling, they don't."

Jin Yu falls silent.

That explanation is enough for her. At least for the time being.

MOST AMERICAN parents don't know anything about their daughter's Chinese mother and father. Not me. I know everything. Or at least, I like to pretend that I do.

The woman who gave birth to Jin Yu lives in a small town on the far eastern outskirts of Xiangtan, almost halfway to the city of Zhuzhou. She has a job in a Xiangtan bicycle factory, her working life spent fixing long steel spokes onto round chrome rims.

She's young, and pretty, and relentlessly optimistic, which makes her unusual among her neighbors, people for whom hardship is as certain as the rain.

She was twenty-two when she had her first child, a girl named Bao Tan, and a year later she became pregnant again. She had no government permit authorizing her to have a second child, and at first she didn't tell anyone, not even her husband. Later, after sharing the news with him, she hid her swelling stomach under billowy dresses and bulky shirts. Friends thought she was putting on weight and kidded her about her husband spending all his money to supply her with rich delicacies.

寻 亲 公 告

姓名	性别	年龄	捡拾日期	捡拾地点	外貌特征
社凌寒	女	约6个月	2000.7.22	岳塘区社建村	提花毛毯包裹
社艳阳	女	约6个月	2000.7.23	市计生委	红花布包裹
社宁亮	女	约6个月	2000.7.21	湘潭长途汽车站	紫色毛绒外衣
社乔莎	女	约6个月	2000.7.24	湘潭县茶恩寺镇	红色毛线外衣
社玉星	女	约6个月	2000.7.26	市机电高等专科学校	旧花毛衣裤
社金玉	女	约5个月	2000.8.5	雨湖区广新巷	旧绒布衣裤 A
社金芝	女	约5个月	2000.8.10	岳塘区板五路	红花衣裤
社金蓉	女	约5个月	2000.8.14	湘乡市新湘路	花棉布衣裤
社金芬	女	约5个月	2000.8.18	湘潭县中路铺镇	黄绒毯包裹
社金柚	女	约3个月	2000.11.10	岳塘区建设南路	紫色棉衣
社金娜	女	约2个月	2000.12.14	雨湖区贯阳路	红花棉袄包裹
社金波	女	约20天	2001.1.15	湘潭县中路铺镇政府	红色连衣裤
社辛进	女	约5天	2001.2.2	韶山火车站	蓝花毛毯包裹
社建萱	女	约1个月	2001.1.1	茶恩寺镇计生办	黄色棉衣裤
社清香	女	约11个月	2000.7.24	市儿童福利院	蓝花衣裤
社金үй	女	约一个月	2001.1.1	岳塘区安乐村	绿色毛线外衣
社阳红	女	约2个月	2000.10.20	白果镇街上	头带帽子,有纸条
社明亮	女	约2个月	2000.11.5	九观桥水库	放纸箱内
社晓洁	女	约2个月	2000.11.9	衡山县政府办	风衣包着
社文艺	女	约1个月	2000.11.27	福田乡镇门口	穿黄色棉衣
社寒雪	女	约10天	2001.1.1	南岳街上	用棉被包着
社兰兰	女	约5天	2001.1.3	福利院门口	放竹篮内
社岳云	女	约21天	2001.1.5	衡山岳云中学	有生日,身穿兰色衣
社樱花	女	约2天	2001.1.9	衡山县民政局	穿花棉袄
社冬平	女	约10天	2001.1.21	县交通局门口	头发少皮肤白,圆脸
社杜兰	女	约3天	2001.2.1	衡山县加油站门口	头大,眼睛大,身体小
社玉珍	女	约2天	2001.2.3	福利院门前	圆脸,稍胖,花棉衣

以上儿童系湘潭市儿童福利院、衡山县福利院取名。自公告之日起两个月内
无人与当地民政部门联系认领，将确定为弃婴，依法予以安置。湖南省民政厅

Our daughter's "finding ad." Jin Yu's name is sixth from the top

They had wed at twenty, their marriage a disappointment to their parents, who had hoped to steer each toward another they thought more suitable.

Her husband runs his own business in Xiangtan, a fruit-and-vegetable shop that he strategically located beside a big Western-style hotel popular with Canadian and American visitors. He sells them Coke imported from Hong Kong, oranges from Japan, and Granny Smith apples that come all the way from Washington State.

Husband and wife ride the bus to Xiangtan together every day.

The prospect of a new baby was greeted not with elation but apprehension. If they scrimped, if they saved everything, spent nothing, they could afford to raise a second child. But they could never afford to pay the fine for violating the provincial birth-quota regulations, a penalty amounting to several years' wages. Still, they decided that if the baby was a boy, they would somehow have to find the money to keep him. A son, by the mere fact of his gender, would redeem both of them in the eyes of their parents. A son would continue the ancestral lineage, carry out his filial duty to provide for them in their old age. Maybe they could borrow the money to pay the fine. Maybe friends would help. Maybe even their parents.

If the child was born female, they decided, they would do what others had done.

On a scorching summer day in August 2000, she gave birth in the bedroom of their small apartment, attended by her husband and the one friend they dared to trust with the truth.

"A girl," the friend said softly as the baby was born. "It's a girl."

She called in sick to work for the next three days. A virus, she said. She touched her baby's cheeks and nose. She traced the curve of the girl's mouth, so like her own. She gazed at her baby's eyes, beautiful dark pools of light. It was like looking into her own face.

She was sore and tired, exhausted physically and mentally. But on the third day she forced herself from bed, wrapped her baby in a blanket and walked the four blocks to the bus stop.

Her husband had offered to go with her, even to go himself, but she had said no. There would be less chance of attracting attention if she traveled alone.

The bus was nearly empty at that hour, the highway traffic light. None of the other passengers noticed her. She was just a woman with a baby, heading to the city. Twenty minutes later, the bus stopped at the first in-town station, and she climbed down the three stairs by the exit door and stepped onto the sidewalk. Her legs ached. She stood there for a moment, letting the other passengers move ahead, trailing as they walked toward the bus station and on up the street.

Her child felt heavy in her arms.

She came to the head of an alley, a local shortcut marked by a bench and a government billboard that read, ZHI SHENG YIGE HAIZI HAO. "It is good to have just one child." She had reached her destination. She watched the bus-station door swing closed behind the last of the other riders. She glanced left and right. Then, in a single, fluid motion, she set her baby down on the curved seat of the bench.

The girl, small even for a newborn, made not a sound.

The woman spoke no final words to her baby. She whispered no last "I love you" or "I'll never forget you" or "Always be a good girl." There was nothing she could say that she had not already said, and nothing at all she could say that the child might remember. She had given her baby what she could. Her mouth. Her eyes. Her chin. A chance.

She stepped back, pausing a moment to observe the tableau she had created—"Child Without Mother."

Then she took ten quick steps across the street to the eastbound

bus stop, taking up a pose as just another tired night-shift worker waiting to catch a ride out of Xiangtan. The front page of yesterday's newspaper lay on the ground. She picked it up and folded it in half, holding the paper in front of her as she kept her eyes focused just over the top of the page, on her child on the opposite sidewalk. Already they were farther apart than they'd ever been.

Now she could hear the rumble of an oncoming bus, precisely on schedule, the machine that would ferry her back to her home and forever away from her baby.

She thought, *This is not right*. And, *This is a mistake*. Her arms felt unnaturally empty. A second later the bus rolled to a stop in front of her. The passengers filed off and crossed the road toward the station. She was the only person waiting to board.

The driver tapped his horn, impatient. "Get aboard, get aboard," he called.

The bus doors stood open. She didn't move. She couldn't move.

Just then a man across the street cried out, "A baby!" She could see him bent over the bench, his back to her. He had gray hair and a blue shirt, torn at the shoulder.

"Staying or going?" the bus driver barked, his hand on the door switch.

She stepped up and the doors slapped shut. Through the window she could see that a ticket agent had come outside of the bus station to investigate. That was good. He would call the police. A crowd was forming on the sidewalk, encircling the gray-haired man and his tiny find. He was holding the child slightly away, his arms extended. She wanted to shout, "Not like that. She doesn't like to be held like that." The bus lurched forward. She couldn't see her baby. She never saw her baby again.

That's what happened.

How do I know all this? How do I know the most intimate

details of this woman's existence, of her husband, of how the two of them came to the most excruciating decision of their lives? How do I know the particulars of the strategy they devised to surrender the child they'd spent nine months nurturing?

I don't. How could I? It's a fantasy. A fable. An invention. A flashback to a war I never fought in. It's one of a dozen or more versions of the story I tell myself about my daughter's beginnings, about how she came to be, about how the people who gave life to her could plan and carry out their permanent separation and expect that all involved would somehow survive the experience.

The story always starts with a germ of real or imagined truth. For some reason I dwell on Jin Yu's mother, perhaps because the two share not just blood but gender. Was the woman young? Yes, she was young. And very much afraid. Did she love the father of her child? No, she met him only once. He didn't even know she was pregnant. What name did she give her baby? None. She knew if she named the child she could never let her go.

From those grains the tale expands, growing full and intricate, existing as the assumed truth for weeks or months until it is replaced by another elaborate web of daydream.

Sometimes, in my mind, my daughter's Chinese mother is older, about thirty-five, a peasant who labors shin-deep in mud, planting rice in the fertile fields around Xiangtan. She is known for her powerful intelligence. Sometimes she's a well-to-do college student, giving birth surrounded by girlfriends who swear they'll keep her secret. They rush to tell their boyfriends the moment the child is born. Sometimes she is a teenager, single and alone, her only companion her unbreakable determination. She gives birth in a neighbor's stable.

What do I truly know about this woman and her decision to give up her baby? Practically nothing. Officially, less than that.

I know this: the woman who gave birth to Jin Yu is physically beautiful, and her beauty is so artless and casual that she neither works at its maintenance nor notices its effect upon others. I know that a smile is her natural expression, empathy her natural response. I know she has a will of iron, that those who seek to move her from a core belief do so at their peril. She possesses a quick wit. And a willingness to tease and be teased. When she laughs, it is as if all humanity is her friend, and when she cries it is as if the world is ending. I know that whatever her education, employment, or station, whether she works designing computers or picking cucumbers, she is conspicuously, exceedingly smart.

I know because these are the qualities that define her child, my daughter.

The account provided by the Chinese government can be summed up in seven lines:

The girl who would become my daughter was found on August 5, 2000, at a place called Guangxin Alley, located in the Yuhu District of the city of Xiangtan. She was judged to be three days old. She was taken to the Yuntang police station and, later on that same day, to the city's social welfare institute. At the orphanage the administrators gave her the surname shared by all the children, She, pronounced "Shuh," which means "of society" or "socialism." For her first name they chose Jin Yu, meaning "Gold Jade," in hopes it would bring her luck and fortune.

Chinese officials offered no other information. No indication of whether Jin Yu was found early in the morning or late at night. Or whether it was raining or dry. No name or address of the person who found her. No description of Guangxin Alley itself.

The few details I've managed to add to that bare outline were gleaned slowly, over months, their discovery greeted with a celebration that far exceeded the scope of the information itself.

AFTER WE returned to the United States, I located a man who has created a small business by traveling to China and collecting what are known as "finding ads." These are small, classified ad–like notices published in Chinese newspapers to announce the discovery of an abandoned baby. In the late 1990s, the U.S. government began urging China to do more to try to locate the birth parents of abandoned children. There was a sense, at least among the American authorities, that the children were being offered for adoption too quickly, that a fuller attempt to locate their families needed to be undertaken. That doing so would make the adoption process more systematic and, I suppose, more legitimate. One of the ways China responded was by publishing ads in the local newspapers, notifying the public that a child had been found at a certain place on a certain day.

In theory, someone might come forward to claim the baby.

No one ever has.

The more recent ads include thumbnail-sized photographs, often a child's first picture, taken when they were but days old—an unimaginable find to the adoptive parents. The earlier ads contain only a few words, the orphanage equivalent of name, rank, and serial number. They're written with all the flowery imagery and heartfelt sentiment of an eviction notice.

Jin Yu's ad appeared at the bottom of page 11 in the *Jiating Dao Bao*, a sporadically published Hunan newspaper, on February 15, 2001, six months after she was abandoned. Her name was sixth on a list of twenty-seven children who had been found between July and February. Every one was a girl. Each was granted a single thin line of type.

But within those few words, for Christine and me, was an unexpected gift.

Beyond the routine recitation of the date and place of discovery, the ad contained a description of the clothes Jin Yu was wearing: a velour, two-piece outfit, shirt and pants, ragged and dirty. To learn the style of the clothes Jin Yu was wearing provided a new detail about the most significant day of her life. To grasp the extent to which her clothes were soiled was to understand the economic status of her birth parents, which is to say, they were probably as poor as could be. Most crucially, that line of type tells me my daughter almost certainly has a biological sister or brother living in China. Her parents didn't go next door and borrow a set of dirty baby clothes so they could abandon their child. They had children's clothes at hand. Clothes that had been worn by an earlier, older son or daughter.

The journalist in me can easily dismiss the publication of this ad—of all these ads—as little more than an exercise in bureaucratic compliance. A child's ad appears only once, in a small-circulation newspaper. The chance that anyone will notice is remote. No mother or father could recognize their child under a name bestowed in an orphanage, and there seems little point in publishing a notice so late—months after some of the girls were found. Surely if anyone was going to go looking, they'd have done so long before.

It's puzzling to me that, in Jin Yu's case, the ad contained no description of identifying marks on her body. How could the writer have missed the round black mole on the outside of her left heel? It stands out like a drop of ink on parchment. Why didn't they mention the pale, smile-shaped birthmark on the back of her calf? Both are signs by which I will always be able to identify my child. By which her birth mother could identify her now.

At the same time, the ad is proof, in black-and-white newspaper type, that Jin Yu was found where the authorities said she was found, on the day they said was the day. It shows that the Chinese government made an effort, however half-hearted, to locate her parents.

Perhaps most of all, the ad's existence is a tangible reminder that Jin Yu's life did not begin when she was urged forward and into our arms. She came to us with a past, from a different family, from people battered by law and circumstance.

Emboldened by the information in the ad, I started searching for details that might have been embedded in the public record, information that didn't require the luck of finding a Western businessman devoted to combing the back issues of obscure Chinese newspapers. I located an Internet website that gathers and stores weather data from cities around the world. I could search its archives for free, and by doing so I learned something extraordinary:

It rained on the day Jin Yu was born.

Not a lot. Just a trace. And that night, a sliver of moon shone in the sky.

Three days later, on the day Jin Yu was discovered in Guangxin Alley, a thunderstorm roared through the region. Knowing that bit of information allows me to more fully imagine that day, that moment when her mother set her down and walked away. The woman wouldn't have left her child out in the rain. Not on purpose. But what if the storm came up suddenly? What if my child was lying there alone, sopping wet, exposed to the pounding rain, terrified by explosions of thunder?

Maybe that's not how it happened. Maybe the storm was a good thing. Maybe Jin Yu cried out at the first distant crack of clouds, and that cry brought someone to her aid.

Why do I care whether it rained on the day Jin Yu was born? Why should it be of any importance that on the day she was found, local visibility was down to seven miles instead of the usual twelve? Or that the moon was one-third of the way toward fullness?

It matters because that is all I have.

The thick catalog of details that other parents take for granted—

place of birth, time of birth, attending family and friends—is lost to Christine and me, and more important they are lost to our daughter. Where American kids have birth certificates and baby pictures, my child has a blank space. She has lost the very foundation of her personal history, lost all connection to the timeless roll call of her ancestry.

I am frustrated by the dearth of information. Not because it's been lost. Because I believe it exists. I am certain that chunks of Jin Yu's story lie within state files in China.

The Chinese love bureaucracy. Perhaps only the Americans love it more. The discovery of a baby in a bus station or market square may not be an extraordinary event, but neither is it an everyday event. It creates disruption, attracts bystanders, interferes with the order of the day.

It involves the authorities. And in China the authorities document their work.

When Jin Yu was found in Guangxin Alley, I am sure that somebody called a police officer to the scene. And that this officer wrote up a report. He probably took down the names of witnesses, maybe sketched a description of the alley. He may have interviewed the person who found Jin Yu, jotting down that individual's fresh recollection of how he came to notice the baby. It's possible the officer or his supervisor might even have tried to locate the birth parents.

All of that would have been recorded on paper.

What would it be worth? To have a police diagram of the exact location where Jin Yu was found? To know the name of the person who plucked her from her alley bed? For the chance to try to find him, to say thank you, thank you for reaching down and taking my child into your arms, for offering her a gentle touch and soothing voice when she was scared and alone?

Everything. It would be worth everything.

Across the ocean, somewhere in the reaches of east-central Hunan, is a woman who lives her life in want of answers to the opposite questions. A woman cut off from the story of her daughter's future as completely as I am blocked from the story of her past. She wonders if her baby is cared for, healthy, loved, if she goes to school, has nice friends, pretty clothes. But in her anguish she's willing to settle for much less: To know that her baby is warm at night. To know she has enough to eat. To know she's alive.

What would she give, this woman? What would she give—not for the privilege of holding her child one more time, of kissing her face and hands, for these things are beyond her now. What would she give to know that her baby is safe and well? What would she give to know that, against all odds, her child has landed in a country where an abundance of food is taken for granted, in a home where two enthusiastic parents cater to her wishes, in a family where a loving swarm of grandmothers, aunts, uncles, and friends is devoted to her happiness? I know what she'd give:

Anything.

She'd give anything.

I SEARCHED for a map of Xiangtan, and then, after finding one, searched for a street called Guangxin Alley. It wasn't there. Either Guangxin Alley is too small and insignificant, or the map too broad and approximate.

In my mind, I am forever trying to envision this place, this alley beyond detection.

Sometimes, Guangxin Alley is bright and clean, a walkway that leads to a lively outdoor food market, a place where couples stroll and shop and children playfully dart between the stalls. Other times, it stands at the edge of a busy pearl market, where vendors shout out

the prices of their wares. I tell myself that, as Jin Yu lay there, newly alone and perplexed by her mother's absence, she could glimpse the translucent shimmer of the pearls, and it made her smile. Sometimes, in my mind, Guangxin Alley is dark and forlorn, a scary place, a dirty concrete path where few people venture.

Wherever it may be, whatever it may look like, Guangxin Alley was important to this woman. That I know. She didn't pick it at random. Not for the defining act of her life. She chose it for a reason. She ran options through her mind, adding or discounting possibilities according to her own rationale. She chose Guangxin Alley because it was close. Or because it was far. Because she knew someone who lived there or because she knew no one there at all. Perhaps it was the place where she first met the man who would become her husband. Or the spot where their love affair came to a hurtful end. Of the multitude of public places in China, of the scores or dozens within her reach, she chose this site to lay her child down.

Again and again I take that journey with her.

I walk beside her as she heads to the bus stop, take the seat behind for the ride to Xiangtan. I see her holding the child close, whispering prayers and promises to remember. I see her examining Jin Yu's hands, noting for the last time, as two years later I would note for the first, the delicate fold across the center of her palm.

I sense her fear of discovery as she walks toward the alley, her child in her arms. I see her trembling as she sets the baby on the bench, feel her legs go weak as she turns to walk away. I see the torment distorting her face, marking and changing her.

She is devastated. She will never recover.

From now on, whatever she does, wherever she goes, she will carry the pain and the guilt as an internal, invisible scar on her heart.

Today, at this moment, the child she left in that faraway alley is

upstairs, asleep in her bed, nestled under a down comforter and attended by enough stuffed animals to fill a forest. Jin Yu is not yet old enough to ask about the events of that day. I wonder if she dreams of it. If in her dreams she feels the splash of her mother's tears against her cheeks. I know that day inhabits the dreams and nightmares of a woman across the sea. I wonder if she saw the newspaper ad, the lone line of type that said her baby had been found and was under the guardianship of the authorities. Perhaps a friend pointed it out.

I wonder if somehow she knows that her baby was adopted. I wonder, does she imagine me, the way I imagine her? To her, am I a wealthy Spanish building contractor? Do I live in a mansion with a heated pool, snapping my fingers to summon servants? Am I a Canadian magazine magnate, commanding a staff of hundreds from a palatial office high within a glass skyscraper? Or are her hopes more modest? Merely that someone, somewhere, is doing what they can for her daughter?

Before I became a father, before Jin Yu appeared, I found reassurance in the anonymity of Chinese adoption. I took comfort in the cold fact that my child's birth mother and birth father would never be able to locate her, never even be able to try, not without endangering themselves. They would be way over there, blocked by distance and law and language, and I would be way over here, untouchable, hoarding my riches.

Jin Yu would have one set of parents. One mother. And one father. Me.

But now it is so plain—I was wrong. As wrong as I could be.

Now I know that her birth parents' physical absence has nothing to do with their ability to be present in her mind and in her heart. Now I know that this secrecy comes at high price, and worse, that it is my daughter who will be asked to pay the brunt of that cost. Now I see that this barrier will not settle questions, only raise them. That

it can do nothing to help my child figure out who she is, who she hopes to be, and where she might find her place in this world.

Now, I wish for the opposite. Now I wish that Jin Yu could meet her birth mother and her birth father, that each of them could say what they might want to say, have at least one chance in this life to ask their questions and get their answers.

Sometimes, I can almost see this woman. I glimpse her face in my child's expression, hear her voice when my daughter speaks. I worry that now, a little older, a little stronger, she wishes she'd made a different decision. That now, removed from the fear and fatigue, she would surrender all she owns and loves for the chance to take back that day, that moment in Guangxin Alley. I worry she lives her life in mourning.

Today a woman I've never met moves through my life like a ghost, her presence as obvious as it is unseen. Sometimes, as I watch Jin Yu chase after a friend, laughing as she runs, I can sense this woman standing beside me. In the evening, when I bend to kiss Jin Yu good night, I feel her eyes upon us.

Sometimes, in quiet moments, after Jin Yu has been put down for the night and the house is still, I wonder if I could possibly locate her in China. Maybe find a way to take out an advertisement in a Xiangtan newspaper, or in several Hunan Province papers, telling her where we are and how to contact us. I don't know if she has money to buy a newspaper. Or if she can read. And what if I were to hit those odds, and she happened to see that ad on that page of that paper on that day? If she were to reveal herself by responding, she could be severely punished. It might be wrong for me even to tempt her.

I don't want to add to her trouble or her pain. She already has enough of both. I want to tell her: Your child is alive. Your child is well. Your child is loved. She is healthy and strong and smart and

beautiful. She is all that anyone could want in a daughter. You would be so proud. I want to tell her: I know you suffer for the loss of your baby. That you will suffer always for her absence. I can't change that. But you mustn't torment yourself about your daughter's welfare. On that you must let your heart rest. You have done your part for Jin Yu. I promise that I will do mine.

That's what I would say to her. Not that it matters. The reality is there is nothing I can say to this woman, nothing I can do, that would ease her burden or lessen her sorrow. She made her choice. And now she lives with it. I know that for the rest of her life she will wonder about the fate of her child. And I expect that for the rest of mine I will wonder about her.

THE FIRST thing that strikes you is the heat.

Already, at mid-morning, the temperature is deep in the 80s. In a few hours it will hit 100.

And that's nothing.

Two days ago it was 108, the day before that 106.

The warmth rises off the ground in great shimmering waves, like a scene from a western movie, the humidity as close and dense as a wool jacket.

This place is different from others. It looks different and smells different, and when the summer wind kicks the grit and sand off the ground and into your face, it tastes different too. The grass is dry and hard and sharp, the rocks a singed and dusty brown. Even the hardwood trees look parched, as if they haven't had a drink of rain in ages.

But then, that's Texas for you.

The heat leaves me panting as I hustle to catch up to the rest of the group.

Jin Yu (center) among friends at the first Hunan reunion in Texas

I've been to Texas only a few times, and to its guitar-twanging capital of Austin only once, two decades ago. I was in my twenties then, and my eagerness to explore the city's arts and culture extended only as far as the bars and music halls of Sixth Street. Today I'm heading in the opposite direction, away from downtown, toward a patch of pampered property on the city's southeast edge.

Zilker Park is often described as the Austin equivalent of New York's Central Park, a vast collection of tended plants and sculpted waterways bordered by blocks and blocks of expensive homes. Stephen F. Austin Drive marks the northern boundary, Robert E. Lee Road the south. The park's northeast edge is bounded by the placid waters of Town Lake, which actually isn't a lake at all, but a narrow stretch of Texas's Colorado River, dammed half a century ago as part of a flood control project.

The park is named for Andrew Jackson Zilker, a transplanted Indianan who earned a fortune manufacturing a product that was as desirable a century ago as it is on this hot day: ice. Known as "Colonel" Zilker—though as near as anyone can tell he never suffered a day of military service—he started buying up the land between the Colorado River and Barton Creek in 1901, attracted to its abundance of local springs and its reliable supply of clear, clean water. The biggest of the springs fed a rock-encrusted pool, the water a constant, chilly 68 degrees. In 1917 Zilker donated Barton Springs to the city, and fifteen years later he threw in the land around it.

Today Zilker Park covers 347 acres, roughly twice the size of Disneyland. On weekends it's crowded with thousands of swimmers, soccer players, joggers, and cyclists. I'm headed for its showpiece—the Zilker Botanical Garden. The garden is actually a group of gardens, featuring specialized areas for herbs, cacti, and butterflies, for plants grown using the organic methods of early pioneers and for the preservation of what might be called dinosaur habitat.

In 1992, park volunteers discovered fossilized tracks that turned out to be about 100 million years old, most likely made by a beaky-looking creature called Ornithomimus, a distant cousin to the deadly Velociraptor. Today the area around the footprints has been turned into a grassy, watery stroll, marked by limestone cliffs and low, gar-stocked moats, to mimic the terrain that existed here during the Cretaceous period.

I follow an intricate stone pathway past a grove of ornamental bamboo, beyond small stone pagodas that guard ponds stocked with flashy orange and silver koi, arriving at the most popular spot in the park's most popular section. The Oriental Garden is the creation of a California bonsai farmer named Isamu Taniguchi, who carved a peaceful refuge out of rugged caliche hillside. He gave the garden to the people of Austin in gratitude, though these many years later it's hard to fathom why Taniguchi felt especially grateful. Perhaps he was thankful for the free room and board provided to him and his family during World War II, when the Taniguchis were among three thousand Japanese imprisoned at the Crystal City Internment Camp. Maybe he was just grateful they let him out at war's end.

After being freed, Taniguchi settled his family in the Rio Grande Valley, where he grew cotton and flowers. He sent his two sons to the University of Texas at Austin, and when he retired in the late 1960s he moved to Austin himself. Taniguchi toiled on his garden for eighteen months, aided only by the occasional laborer, working without equipment, blueprints, or pay.

I walk past a pond designed as a floral ship, its sail a large wisteria, its chain and anchor a series of stepping-stones. The ponds here are all different shapes and sizes. From above, they spell out A-U-S-T-I-N. The path leads to a short, humpbacked bridge, its log floor and rails spanning a shallow stream, set against a backdrop of dense green foliage. It's a replica of the bridge in the famous Monet paint-

ing, *The Japanese Bridge at Giverny*. The Austin bridge has a formal name too: the Togetsu-kyo Bridge, or "the Bridge to Walk over the Moon." Taniguchi positioned his span so that on nights when the moon is high and full, the lunar reflection follows as you walk across the water.

Today there is only the withering sun. And the bridge is anything but tranquil.

Nine little girls bounce on its narrow bulge, dressed in outfits sewn from the luminous silks of their homeland. All share the same dark hair and dark eyes. All but one share the same hometown, and, for a time at least, shared the same surname. A couple look so alike that they could be sisters.

A year ago, these girls posed for a different picture at a different place, a place where silk dresses were reserved for others. Where the kindest assistance their caretakers could offer was to help to propel them out and into the unknown. A year ago, on a different continent, these girls posed in similar drenching heat and humidity, surrounded by this same small group of adults.

Now, at the one-year reunion, the girls on the bridge seem to recognize one another, but vaguely. They remember one another the way you might remember a childhood friend glimpsed in a dream. After a while, you're not sure whether it was the dream or the memory that was real. These girls spent their first two years—for some it was almost three—on the same small patch of land within the same stone walls. Now they live with new families in homes across the United States. They have gone from getting whatever attention could be spared to getting all the attention they can take.

"Stand still!" one of the grown-ups calls.

The girls pay no attention.

Two are elbowing each other. One is crying. Three are belting out a loud, off-key chorus of "Twinkle, Twinkle, Little Star." Most

of them are facing in different directions, and all seem to believe that the particular direction they happen to be facing is the correct one.

The formal group reunion picture—the purpose of coming to this place in this park, the full-color proof of all that these girls have accomplished in a year—is fast becoming a shambles. The kids have lost interest in posing. They want to play and chase.

One girl, dressed in a weave of pink and red, waits until most of the other children have pushed to the front of the bridge. Then she makes her escape at the back, using the crowd as camouflage. She moves quickly yet cautiously, her legs still not fully trustworthy, traversing log after log until she reaches the bottom of the bridge and steps onto the dirt-and-stone path. Then she pads forward in white sandals, the hitch in her step at once familiar. She approaches me with the confident stride of someone who is headed for known territory, who takes my constant presence and undivided attention for granted.

She stops half a step in front of me. She is sweating, her coal-black hair wet at the bangs, revealing underlying streaks of hard-to-spot mahogany. She lifts her arms without a word, and I reach down and pull her up into mine.

People say she looks like me.

TODAY, AT three, Jin Yu is no longer the thin, impassive child we met in Changsha, but a girl who is steadily gaining strength and stamina.

Her arms and legs are pudgy, and if anything her cheeks have grown more round and full. She's not fat, but carries the padded body of a child a year younger. Her hair, once a few rough locks mostly confined to the top of her head, now falls over her ears.

Her transformation includes not only her looks but her tastes and interests.

Jin Yu loves Apple Jacks. The furry blue creature she calls "Cookie Monsher." And frozen vegetables eaten cold and hard from the bag. She loves when we read stories to her, particularly *If You Give a Mouse a Cookie,* and watching endless replays of *Big Bird in China.* She likes to try to walk backward. To Jin Yu, Christine's lap is a comfortable easy chair, and a picnic on the living room floor a favorite outing. She's a tease—grabbing my car keys and running away through the house, laughing as if she had just pulled off the Brinks bank job. If she can manage to find the button that sets off the car alarm, so much the better. During the day she tolerates her father's musical preference for the singer she calls "Bringsteen," and at night she lies down to the ethereal tones of Enya, who paints the sky with stars.

She is strikingly attractive, so much so that other people, parents met at a playground or supermarket, will comment on it to me.

"I know," I answer, then quickly add, "not that I had anything to do with it."

Jin Yu no longer babbles in Chinese. She doesn't babble at all. Every day her language grows more sophisticated.

She says "Hole you" when she wants to be picked up, "Wadder peese" when she's thirsty, and "May toe" when she wants a taste of the bright red fruit on my plate. When she thinks it's time for us to jump up and down to music, she shouts, "Dans, dans!"

For a long time she called me "Da-ding," as if to pronounce my name in Chinese. Later on, when I would come downstairs in the morning—Christine and Jin Yu finishing breakfast and me freshly dressed to go to work—Jin Yu would say, "Hi," or maybe, "Daddy," but not dare to see how the two words might fit together. Now when I appear she says, "Morning, Daddy," without stumble or lag, as if she'd been saying it all her life.

She is a girl who keeps her guard up, even after a year, still learning to trust her environs, still learning to trust us, her parents. Week

by week I watch her uncoil, become accustomed to her life. When I think she can relax no further, that her level of trust and confidence is at its final level, she relaxes a little more, revealing the previous point as a plateau. For a long time, whenever I held her, she would keep one hand poised against my chest, at the ready, it seemed, to push me away. Now she loops her arms around my shoulders, content to ride where I take her.

Jin Yu is sturdy, inside and out. Her will is unyielding. I think that's why she survived. Some people are too tough to die, and my daughter is one of them.

One night as we snuggled on the couch, I quietly asked Jin Yu if she remembered that night in Changsha. The night we returned from visiting the orphanage, when she broke down, weeping until she could weep no more.

She responded with silence.

But I think she remembers. She is just not ready to talk about it. Or doesn't yet have the language to communicate the enormity of the experience.

I've asked other parents if they had heard of a child suffering a similar breakdown. Some had. Though no one, not even our doctor, could offer a definitive explanation. It doesn't matter. I've made my own diagnosis: That night in Changsha, Jin Yu was indeed sick. Not physically. Emotionally.

She was sick with despair and grief and loss. She was sick with the realization that she had been abandoned a second time, that those who had saved her from the streets had delivered her into the arms of strangers. That the very direction of her life had been altered, again, without anyone so much as asking her opinion. On the day she came to us, her world, along with the places and people who made it a living existence, disappeared without a trace. That night in Changsha, her world shrank to sound and solid—her cries, her

tears, her little body, undersized and under-exercised, flat against mine.

From a distance of a year, I can see how terrible that time must have been for her. To have the people she knew and trusted suddenly vanish. To be unable to communicate her fears to these new, strange-looking beings who now held sway. To be torn from everything, and all at once. Other people living other lives are granted the grace of slowly surrendering the things they love: a neighborhood changes as people move on, a family business withers over generations, a parent ages into infirmity. All these things, in their leisurely cruelty, afford a chance to settle debts, to reconcile wrongs, to make peace. They offer a chance to say good-bye.

Jin Yu was not allowed that privilege.

That night in Changsha, it was as if she had been holding back her rage and sorrow, wanting to see how this interlude would end, waiting to find out if this latest, greatest change would prove passing or permanent. After our visit to the orphanage, when she returned to the hotel with us, she had her answer. Only then did she allow her anguish to burst from within.

Before she could begin to accept her new life, she needed to mourn the old. She needed to say good-bye, to those she loved and to friends she knew, even if they were not there to hear her farewell. I don't think she was unwilling to receive Christine and me, to give us a fair chance to show we could be good parents. She had that strength, the ability to close one door and open another, however painful the parting. But before she could accept what was being offered, she had to honor what was being lost.

Today, a year later, I think about the things that happened in China, about gain and loss, present and past. I think about how far-away events in a distant land will ricochet through my life and that of my daughter, perhaps forever.

You think the impact of her years in the orphanage will quickly fade, become less of her life. But grief is deep and abiding, whatever its cause. Grief is not a sudden plunge into darkness, followed by a slow upward incline to the light. Grief moves forward and back, up and sideways. At times it jerks to a stop, and any progress toward healing seems fully and permanently stalled.

Jin Yu has not forgotten her life in China.

Sometimes, at night, as Christine and I are putting her to bed, she'll tell us stories, tales that begin nowhere and end in the same place, fragments of memories about another child, a missing toy, or a woman who tucked her beneath the covers. The names and faces are lost to her. Only the ghosts remain.

Almost every night, Jin Yu will awake three or four times, disconsolate. She doesn't seem to know why she's upset. Sometimes she will go to sleep only if Christine or I lie on the floor of her room. Some nights, it is Jin Yu who insists on sleeping on the floor, the rug as her mattress.

One night, at bedtime, she and I are turning the pages of a favorite book. Once again Curious George has lost track of his pet baby bunny.

Jin Yu points to George's face.

"Sad," she says.

"Wait," I say. "George has an idea for how to find the bunny."

"Crying," she says.

I try to turn the page. I want to show Jin Yu that in the end things will be fine, that she doesn't have to worry, George will find his bunny as he always does. She slaps her palm onto the center of the book, blocking my hand.

"Tears," she says.

She seems to be on the verge of tears herself.

I move her hand and force the page, showing her that George

has enlisted the mother rabbit to help search. Now George is sure to find his little bunny and bring her safely home. Sure enough, a few pages later, George has tracked down his pet and put the world right.

That happy resolution doesn't do much for my girl. Jin Yu goes to bed glum.

Later on, I awake to hear her crying. She doesn't call out for Christine or me. She just cries. I haven't completely opened the door to her room when she springs out of bed, clawing her way into my arms, climbing my legs and torso as if I were a tree. She won't let go. Sobbing, she pulls me so close it's as if she's trying to push herself through me. She refuses to let me set her down. So we stand there in the dark. I don't know what to do, how to comfort her. I begin to recite the list of all the people who love her.

Mommy loves Jin Yu. Daddy loves Jin Yu. Grandma-ma loves Jin Yu. Jack loves Jin Yu. Tanya loves Jin Yu.

She stops crying. I go on.

Zumu loves Jin Yu. Noa loves Jin Yu. Arielle loves Jin Yu. Rena loves Jin Yu.

Her grip loosens. I can feel her body unclench. A few more minutes, another six or eight names of the roll call, and she pulls back and looks at me.

"Hi," she says softly. As if she'd just noticed I was there.

I ask her if she's ready to get back into bed.

She nods.

I lay her down and pull the sheet up and over her, turning off the light as I leave.

THE GUILT does not settle on you immediately. Nor does it come all at once.

It builds slowly, like a small black dot on your skin, unnoticeable at first, an odd blemish that slowly grows wide and deep and cancerous.

At first you're not even sure it's guilt. You think it's fatigue. Or stress. Not until it begins to wake you in the night, to leave you staring into space during the day, do you fully realize its presence. I am always surprised that people do not seem to notice. Sometimes I feel they must be blind, not to see my blame, not to recognize my chains, as long and ponderous as those that bound Marley's ghost.

It never keeps me from getting out of bed in the morning, doesn't stop me from going to work during the week or doing what needs to be done around the house on weekends. On good days it is merely present, silent and stabbing. On good days it's a shrunken thing, and I feel I can almost hold it in my hand, examine its weight and texture. I resolve to toss it away, like a stone into a lake, to hear the satisfying *ker-plop* as it hits the surface, to imagine it drifting down, deep under water, passing through cool shades of green and blue until it strikes bottom, where no light can reach.

On bad days it's neither small nor separate. On bad days I can almost see it, a living piece of me, like a gruesome photo in a medical-school textbook, a portrait of a man with a partial, malformed twin growing out of his side.

The experts say guilt can be a good thing. That it can function as a warning, a reminder not to repeat your mistakes, to do better next time. But for my daughter there is no next time. There is only then and now. And for me there is only this reality: my baby needed me, and I was not there to help her.

She was alone, waiting, hurting, wanting. And I was fiddling in doctors' offices and fertility clinics. Wasting my time. Wasting her life. She needed warmth and food and medicine. She needed laughter and love. She needed just a little of what I had in abundance, and

I did not offer it. More appalling, it never occurred to me to do so. Not until I needed something from her, not until I wanted something from China, did I even think to ask.

I wonder if she will ever be able to forgive me.

Sometimes I think we will talk when she is older, that we will sit down and discuss the reasons why she spent the first two years of her life in an orphanage, and I will try to explain what I did and didn't do, and why I was thinking what I thought. I will not have much to offer in my defense.

No matter how many times I zip her coat closed on cold winter days, no matter how often I rise in the night when she cries, nothing can overcome the fact that when she needed me most, I was absent. At night, I lie down beside that simple truth. And I know that, seven thousand miles away, the people who gave birth to her lie down beside theirs. They and I are alike in that way.

Of course, right now that conversation between Jin Yu and me is years off. And I am glad to keep it there. Right now Jin Yu loves her daddy. To her I am a source of warmth and light, a sun in her universe. It's wonderful. But even as I bask in that affection, I wonder how she can love me so. How she can so casually blink away the pain of her first two years, a sentence served for no crime committed.

The other night she was restless in bed, talking to herself at 1:30 A.M. Most nights Jin Yu is up so often and for so long that Christine and I answer her cries in shifts. On this night I listened to Jin Yu on the monitor for a minute, then went to check on her.

When I stepped into her room, Jin Yu was wide awake, her thumb in her mouth.

"Are you okay, sweetheart?" I whispered.

She didn't answer. She simply looked at me, her expression one of intense bemusement, as if she couldn't imagine why I felt the need to get up and come visit at this hour of the night. She looked at me

with such focused curiosity that I started to smile, and then to chuckle. The more I tried to keep from laughing, the more she stared, until finally I could no longer contain myself and I laughed out loud. At that moment, there in the darkness in the middle of the night, Jin Yu took her hand from her mouth, holding her thumb aloft as if it were a favorite cigar, and said, "Daddy funny."

I told her she was the one who was funny, then bent and kissed her on the cheek.

Back in my own bed, I could hear her steady breathing on the monitor. Already she had fallen back to sleep. Mine would be longer in coming.

Jin Yu's fate makes me wonder about the nature of luck and chance, the reality of good and evil. It makes me wonder how a loving God could deliberately put a small girl through two years of privation, and leave me to live with the blame. It makes me wonder if this God who people worship is a weakling. Or a coward, unwilling to intervene in the life of a helpless child. Sometimes, I wonder if Jin Yu's fate is the ultimate proof that God is a figment of our imagination, a false celestial comfort born from the minds of primitive, frightened men.

I AM searching.

In my dream I am searching.

Someone has told me the exact address where my daughter was left as a baby. Not merely Guangxin Alley, vague and elusive, but 7 Guangxin Alley, a precise address. Now I can find the exact spot where Jin Yu was abandoned. And by finding it, I will achieve a sense of acceptance, of peace. I locate Guangxin Alley quickly, then move down its center at a half-trot, checking the numbers affixed to the buildings on either side. The digits on the stores and offices keep

changing, spinning like the drums of slot machines. But that can't stop me.

Then I see it—set back from the road, a plain brick building with small twin doors. I am so happy I almost weep. I rush across a dirt courtyard and push through the doors. Inside, the space is a single room, huge, as big as a concert hall. The walls are covered with Eastern religious symbols and statues, smiling Buddhas and tranquil Kuan Yins, and drawings of the sacred Hindu symbol that means "Om."

A dozen people mill about, carefully examining the drawings and carvings. They are searching too, absorbed by their own need. They pay me no mind. Somehow they don't see what I see, in the middle of the floor. The head of a giant flower is set out like a floral rug, its tuliplike petals laid flat. Two paths of stepping-stones lie across its center, meeting at right angles to form a giant plus sign. I rush to the nearest stone and start forward, across the outstretched arms of petals toward the heart of the flower.

That's where the dream ends.

I don't know whether I ever reach the center. Or if I learn anything new once I get there. It's just a dream. But it feels like a message.

In the months after we returned from China, my child's lost family and missing history preyed on me. I didn't fret. I brooded. I felt my daughter's loss of ancestry as if it were my own. I feared she would grow up plagued by an inner sense of rootlessness. I worried that by the time she was old enough to search for answers on her own, whatever records might exist would be gone. That whatever people might be living would be useless, their memories faded, and others would be dead, their lips forever sealed. On Father's Day and Christmas, on my birthday and hers, her absent home and lineage seemed to hover not as a neutral piece of her story, part of the series

of events that led her to us and us to her, but as a lasting sadness.

No note from her parents? No record of her discovery in Guangxin Alley? What cop would take custody of a baby found on the street, transport her to the station house, and not write up a report? There had to be more information.

I needed to try to find it. I needed to be able to show something to Jin Yu—in five years, or ten, or twenty—and say, Here's what I found. Here's how I applied myself to this problem, my time not wasted in the callow pursuits that once formed the construct of my life, but spent dutifully seeking to excavate whatever information could be located.

I needed to look, for her sake and for mine. And I wanted the government in China to know I was looking.

I WRITE out the text for a classified ad. Nine lines. Fifty-three words. Simple phrases, basic instructions. Meaning can be lost in translation, and I can't risk that blunder. The Chinese authorities place ads for children who have been lost. I will place one for a child who has been found. At the top of the ad I write, "Seeking Mother and Father."

And underneath, "To the parents of the baby girl found in Guangxin Alley, Xiangtan City, Hunan Province, on August 5, 2000. Your baby is safe and well. She is living in the United States with us, her parents. We offer our most humble and eternal thanks for giving us this perfect daughter. Please contact us."

I list our names and address.

I'll have to find someone to translate the ad into Chinese, and figure out how and where to publish it in China. Probably I'll need to place it in newspapers in several cities, in Xiangtan and Changsha and other places. Then I'll wait. I think: One of Jin Yu's birth par-

ents might actually contact me. Might write to me. If not one of them, then maybe one of their friends. Someone who knows them, or of them. Someone who could at least let me know that the birth parents saw my ad, who could assure me that although Jin Yu's Chinese parents may choose to remain in shadow, they do so in the knowledge that their daughter is healthy and loved.

Next, I call a friend at the *Inquirer*, a reporter named Jennifer Lin, a former Beijing bureau chief who maintains impressive connections in China. I ask her: do you know anyone there who might be willing to tackle a difficult freelance project? It probably would have to be a reporter, or maybe a detective, someone deft and nimble, comfortable dealing with the authorities. Someone who could probe and ask questions without inadvertently stepping into target range.

Jennifer can't think of anyone offhand. But she knows someone who might know someone—Guo Hui, her former assistant in Beijing. Guo Hui, she says, is smart and experienced, bilingual, a solid reporter, and a person of sound judgment. Jennifer gives me Guo Hui's e-mail address.

In the meantime, I start to write letters, a task that quickly proves complicated and time-consuming. I need the phrasing in every letter to be just right, inquiring but not demanding, hopeful but not pleading. Then I have to find a person who can translate the letters into Chinese. Make sure I have the right address on the envelope, in English and Chinese. And be certain to enclose a self-addressed envelope, and a prepaid international mailer, so that anyone who wants to respond can easily do so.

I write to the orphanage in Xiangtan and the Hunan Civil Affairs Office in Changsha, and send e-mails to friends in the United States and to friends of friends in China, asking for the names of others who have pursued similar searches, that I might seek their advice.

Then I wait. For weeks. And here's what comes back from offi-

cials in China: nothing. It doesn't bother me, not at first. As a news-
paper reporter, I'm used to dealing with government bureaucracies.
An answer of no, or no answer at all, is no reason to stop pressing.

But as time goes by, I begin to run out of people to ask and places
to look. The secrecy that once made Chinese adoption seem attrac-
tive now works against me.

Having run out of good options, I decide to write to the Chinese
consulate in New York. I turn on my computer and type the name of
Consul General Liu Biwei at the top of a letter. Then I tell him more
than one should tell a stranger: Of my daughter's intellect and beauty.
Of her delightful sense of humor. Of her grace. I tell him I am the
luckiest father on the face of the earth—and that I cannot sleep at
night. That I need to be able to tell my child about the circumstances
under which she was found, that even the smallest details would be
of tremendous value. I tell him I need his help. And I ask, can he
please search the government files and send me a copy of whatever
he finds?

I know the consuls in New York attend to diplomatic matters
more important than digging out the history of a single child, par-
ticularly one who, by Chinese standards, has found her way to a
richer life. I don't expect much of an answer. In fact, I expect no
more than the polite form letter that is sure to come back in reply.

At least that will be something. Someday Jin Yu will see that let-
ter, with its bright red consulate seal, and she will know I tried.

Not long after I mail that letter, I send an e-mail to Jennifer Lin's
former assistant, Guo Hui, in Beijing. Guo Hui responds quickly,
recalling the time we met during her visit to the United States. She
says she will try to find someone in South China to take on the quest
to uncover Jin Yu's past.

A couple of days later, Guo Hui e-mails from China. She says she
is still looking for a reporter in Hunan to handle this task. I've

already sent Guo Hui the handful of facts I have about Jin Yu's discovery in Guangxin Alley.

More than a month passes.

Guo Hui writes to say she has successfully enlisted the help of a journalist in the city of Xiangtan, and that the reporter has been searching for information about my daughter. So far, Guo Hui says, there is nothing to report.

Two more weeks pass, with no further word. I hope that means progress, that this is taking time because new and important details of my child's life are being unearthed.

I don't expect the people running the Chinese government to open Jin Yu's file and shake it out. I don't expect everything—I just hope for something. A bit of fresh detail to build on, a little evidence that could suggest a new line of inquiry, a few facts I could use as a wedge to pry others loose. If nothing else, perhaps the next time one of my letters shows up in a government office, the people there will recognize my name. Or at least they'll see that the same person has written again. They might surrender some scraps just to be rid of me.

Nearly two months after I first wrote to Guo Hui, as I'm starting to lose hope of hearing any news, I log on to my computer to find that she has sent me an e-mail. I click on "open."

Guo Hui says she is very sorry.

She says the reporter did the best she could. She didn't make a couple of quick phone calls and give up. She traveled to Xiangtan to try to find answers. At the police station, where Jin Yu had been taken after her discovery, the reporter asked the officers if they retained any records, or if someone there might remember the baby or the events of that day.

The cops told her, in so many words, to get lost.

She didn't stop there.

She went to the door of the orphanage itself—where officials gave her the same response as the police, presumably in kinder terms.

At the end of Guo Hui's e-mail, she apologizes, needlessly, for not having discovered any new information. She says there is one thing that might be encouraging. When the reporter talked to the police officers and orphanage administrators, they already knew that somebody in America was trying to find out more about this child. They told her the Hunan Civil Affairs Office was looking into the matter.

THERE IS only one thing to do, one option left. I see that now.

I'll have to go there myself.

To China. To Hunan. To Xiangtan. To Guangxin Alley, wherever and whatever it may be.

Finding places and people, gathering information, that's what I do for a living. I know I can find Guangxin Alley. That's where I'll start. I'll put up signs. I'll hand out flyers bearing my daughter's picture, let my foreignness do the work of attracting a crowd. Maybe I'll set up a tent and camp out, force the police to come and move me. Basically I will create a small public spectacle, and word will get around about the American who has taken roost in Guangxin Alley. Maybe the local newspaper will write about the crazy man who has come looking for his daughter's past. Maybe a television news crew will shoot some footage, spreading word of my presence far and wide.

I am happy to play the fool, if that is what it is going to take.

Of course, I'll be getting there late, more than three years after Jin Yu was found.

But this is Xiangtan, not Shanghai. Smaller cities in China don't change that fast.

There's every chance that the people who walk past Guangxin Alley today are the same people who have been walking past it for years, a routine part of their trek to work or to the market. There's every chance they were there the day the baby was discovered. And that they'll be there when I show up.

Jin Yu picking out a pumpkin

EVERY ONCE in a while, I think about that family. About that couple.

I wonder how they're doing. If they're still together. If they managed to construct a protective layer of scar tissue around their broken hearts and keep on, or if eventually just looking at each other became too painful and they went their separate ways.

Their baby boy had slipped through the belts of his car seat and strangled to death on a strap.

A couple of days after that, I called them up, introduced myself as a news reporter, and asked if they would be willing to speak to me about the loss of their child and their decision to donate his tiny organs for transplant. The father mostly managed to keep from weeping when we talked.

They're not the only ones who come back to me now. There are others, too numerous to count. I thought I'd forgotten them. But I find that now, a decade or more later, now that I'm a parent myself, they come floating into my consciousness, recalled with a detail and clarity that's both complete and terrible.

The mother whose vivacious twenty-five-year-old daughter didn't come home from an evening of dancing at a local nightclub. A month later a man walking his dog found her body, by then mostly bones, lying in the tall grass of a field near the airport. The father whose twenty-one-year-old son was shot through the head when a cop's gun misfired. The bullet exited just above the young man's right ear.

In twenty-five years as a reporter, I've covered the stories of sons and daughters who have been shot, stabbed, strangled, beaten, burned, drowned, bludgeoned, and run over. I have written more stories about more children killed in more house fires than I can remember or count.

It never bothered me.

In the early and mid-1990s, I covered the police department in the city of Philadelphia. That meant that on many days, of the neighborhoods I visited, I went there because someone was bleeding. Usually by the time I arrived the victim had been taken to a hospital, lifted into the back of an ambulance for the mad dash to the nearest trauma unit. But sometimes they were still there, their prone bodies being jabbed and pounded by paramedics frantically trying to restart their hearts or force air into their lungs. Or, other times, when I got there, the person had finished bleeding. Nobody was hurrying then. All that awaited then was a slow ride to the city morgue in the back of a medical examiner's van, trailed by a carload of wailing relatives.

I remember arriving at the scene of an accident in South Philadelphia where a four-year-old boy had been crushed beneath the wheels of a school bus. Ribbons of yellow police tape created a sort of three-dimensional frame for a weird, Edvard Munchian still life. A front wheel of the bus had flattened the boy's head like it was an overripe pumpkin. His little body lay without a scratch, untouched,

unblemished, a perfect child's torso, incongruously set beside the mash that was his head. Twenty feet away the child's grandfather sat at the front window of his small brick rowhouse, staring out at the wreckage of his grandson.

It was the grandfather who had helped the boy off the bus and then turned away—just for a second—to assist another grandchild.

I watched as the police investigators interviewed the witnesses and the accident technicians took their markings, waiting for a ranking officer to come over and brief the gathering crowd of reporters. When the cops finished their work, an ambulance crew loaded the dead boy into a van, lifting him with an unnecessary tenderness. A firefighter took a hose and washed the blood and gore off the street, the high-pressure stream chasing a small piece of brain tissue down the block and into a storm drain.

After watching a scene like that, I'd go back to the bureau and file a story, writing an account of a tragedy that had taken but seconds to destroy the lives of a family.

Then, if it was afternoon, I'd invariably do the same thing:

I'd go to lunch.

It's true. I'm ashamed to say it. But it's true.

It's not that I felt no sorrow for the dead or the bereaved. I felt each individual death was a loss and a shame. But I felt no more than that, because from me nothing more was required. The loss of these children was part of the daily mayhem of the city, and documenting that mayhem was my job. I viewed the trauma the way a medic might view the carnage of a battlefield: I would do all I could. I would do my best. That meant I would tell the stories of the dead— or at least, how their stories ended—as honestly and as completely as possible. I would describe their lives and their last moments fully, offering whatever sympathy might be practicable.

But there were many things I could not do. I could not bring

back the dead, of course. In fact on many days I could barely keep up with their numbers. In the mid-1990s, people in the city of Philadelphia were murdering one another at the rate of once every nineteen hours. That meant there was usually a homicide waiting for me when I got to work, and often another one by the time I left. And the homicides were only the peak of the body count. Car crashes, drownings, falls, and suicides increased the daily toll, often without garnering more than a couple of paragraphs in the next day's newspaper.

Today, looking back at that time, and at the reporter who so earnestly went to interview anguished families, I see things differently. Now, I know what it means to love a child. Now I know what it would do to me, to my wife, to my family, if that child were to be lost. If that child were to be taken. Now I understand why newspapers send young reporters to knock on the doors of grief-stricken parents. It's the same reason governments send young men to fight their wars: they're the only ones who would do it. Young people don't know any better. They haven't had the life experience. They haven't grown old enough to bear a direct personal loss, or to suffer the graze wound of a near-miss.

Now, I wish I had the chance to go back. I wish I could return to see all of those parents and talk to them again, to sit with them as my older, wiser self, listening as they recite the details of their baby's death, their son's shooting, their daughter's disappearance. Because now, with a daughter of my own, I know different. A joy—and curse—of having a child is that you are newly able to imagine every child as your own. Now, given the chance to go back in time, I would ask these parents the most obvious question, the one that years of schooling and on-the-job training had not taught me to ask, the one I now see was the most obvious and important: how did you survive?

You whose child was here one moment and gone the next. How is it that you manage to stand upright, to draw air in and breathe it

out? And after that first day, when you awoke and realized it had not been some terrible dream, how did you manage to get out of bed? And on the next day? And the next? And all those that followed?

Tell me.

Because I know I couldn't do it. I look at my daughter and I know that the continuation of my existence is bound to the continuation of hers. That were her heartbeat to cease, mine would surely follow.

I NEVER had the right words for love.

Not even to describe my love for my wife.

There were times early in our life together, as a young couple in our twenties, when money was tight. It's not that we were living on the streets. We had an apartment, a table, chairs to sit in. But there were plenty of times when we had to choose between having more groceries or more heat, or to make do with less of both. Christine never once grumbled, never demanded that I forget about the newspaper business and find a job that paid real money. Instead she wrapped a blanket around her shoulders while she worked over the stove, cooking the week's third serving of beanie-weenie.

I have never had the words to thank her.

So how do I express my love for my daughter? How does a father quantify his caring, collate his feelings, enumerate his emotions? Do I say that what I feel for Jin Yu is a love of depth and dimension, full and solid? Do I say that I love her with all intensity, that there's nothing I wouldn't do for her, that were I called upon to trade my life for hers I would instantly agree and consider it a bargain?

That's a starting point. But it is so much more than that. Jin Yu makes me comfortable in my soul.

I delight in the way her eyebrows dance when she's thinking up

a new way to tease me. I laugh at how, at breakfast, she'll reach out and give me a hard poke on the side of my face and shout, "Cheeky!" I marvel at the way she insists on stopping at the entrance of every store in the shopping mall, to dance to the music flowing from the doorway speakers.

Me, I'm always thinking about the long term—next week, next month, next year. Jin Yu finds rapture in the moment. And in doing so, she gives me a happy heart.

I'm astonished that Jin Yu, a child for whom food was once precious, is always willing to share her Froot Loops and Frosted Flakes with our dog, doling out a portion with a fair-minded "One for Mersey." At breakfast she'll often insist on setting a couple of Loops aside "for the people," a notion that strikes me as vaguely, amusingly communist. I'm staggered by the way a child whose daily existence was once dull and repetitive has embraced a rich and elaborate fantasy life, a world where Mary Poppins, Tinker Bell, and Princess Jasmine are constant visitors.

She refuses to be bound by the past.

Is my love for her different now than at the moment I first saw her?

Yes, definitely.

But it's different in the way that turning the tube of a kaleidoscope presents a new and striking montage, sparkling gems falling into place as others slide out, all reworking their order to form a new and remarkable montage.

I didn't expect that. Actually there were a lot of things I didn't expect. Becoming a father is like growing a new skin. It makes you aware and sensitive to all kind of new sensations, to experiences heretofore unnoticed and unimagined. My dad must have felt the same way. Fatherhood came late to him, too. He must have been surprised by its influence, by its demands. To see his weekend golf

outings and spur-of-the moment get-togethers with friends disap-
pear, relinquished to the needs of a little boy.

Before Jin Yu came to us, I knew that once she started preschool
I would have to get up extra early to make her breakfast. I dreaded
the idea. I've never been a morning person, and the thought of forc-
ing myself out of bed at 6:30 A.M.—when I was used to sleeping until
8:00—did not fill me with enthusiasm. But our household schedule
dictated that I prepare breakfast while Christine got Jin Yu dressed.
And I learned something: while I would never get up early to make
breakfast for myself, I didn't—and don't—mind getting up for Jin
Yu. In fact, I enjoy it. I like mixing her cinnamon oatmeal. I like
pouring her milk into her favorite pink sippy cup. I like listening to
the muffled conversation upstairs as Christine gets Jin Yu into her
clothes, anticipating the moment when I will hear my daughter's
feet on the steps. Then I know I'm about to get to see her again after
a too-long, overnight separation.

Loving my daughter is recognizing that what is trivial to me—
the fact that her parrot doll is missing, when a dozen other stuffed
animals compete for room on her bed—may mean the utmost to her.
That knowledge makes my trip back downstairs to search for the
parrot less of a chore. Loving Jin Yu is being sure to save the acorn
tops she gathers in fall, tucking them into my winter parka pocket
for safekeeping, knowing the delight they'll spark when they're
rediscovered in a couple of months. It's noticing the way her fingers
get chubby before a growth spurt. And how she gets quiet in the
days before having a language explosion.

Having a daughter has taught me to live at low altitude, close to
the ground, where children live, a world where a smooth flat rock is
a treasure and a straight piece of stick is a find. It's taught me to set
my body clock—at least on weekends—to child standard time, a
time zone where there's always an extra minute to examine the stem

of a dandelion, imitate the goggle-eyed stare of a goldfish, or stroke the softness of a duck feather found by a pond. It's taught me the essential, secret truth known to parents everywhere: if you've seen one dirty diaper, you've seen them all.

I've discovered that children actually perform very few daily activities that do anyone any measurable good. Their actions have no utility. People say that their play is their work, but that's not true. Their play is their play. Nothing that children do meets any deadline or adds any value.

It puts the lie to everything we think is important.

Because nothing is more fun or more important than spending time with Jin Yu.

I know that I view my daughter from a specific vantage point, different from the perspective other parents may have on their children. Other parents look at their kid running on the playground and they see the smiling face of an angel, come all the way across the blacktop to present them with a bouquet of purple wildflowers. I see that too. But when I see Jin Yu running toward me, I also see the losses she has borne to reach this point. I see all she has had to sacrifice. When I watch Jin Yu dash across the playground, behind her I see the trailing outlines of children left behind, of friends still in China, of brothers and sisters unknown.

Those ghosts don't seem to torment her. Not yet. For Jin Yu, life's challenges are immediate.

For some reason, she is scared to cross the living room, which divides her play area from the kitchen. She'll stand in the sunroom entrance, her tiny feet moving up and down, like a track star settling into the starting blocks, her arms turning at a slow pump, as if helping her build up an electric charge of courage. Then she takes off— arms flying, knees swinging, not stopping until she emerges, safe at last, on the far side of the living room.

There, a smile bursts onto her lips. Another challenge conquered.

Jin Yu is terrified of loud noises, and particularly of thunderstorms. Some nights, when the crash of clouds rattles the windows, she will run crying into our room. But on others, the noise just as loud, she steels herself, refusing to flee. When I go into her room to check on her, she is sitting up in bed, fingers plugged in her ears, trying to block out the rumbling.

I love Jin Yu because she confronts her fears. And because I know there was a time when she didn't have a choice.

Not long ago, I attended a seminar where the speaker asked us to name a person who inspires us. Not someone we admire, or might wish to emulate. But someone who by the power of their living example encourages us to be more than we are, to do more than we can, to persist longer than we think we are able. In my life, that person is Jin Yu. In her short existence she has suffered more hardship and endured greater losses than most of us will experience in a lifetime. Yet she insists on living in the present, not the past, certain that wherever music is playing—on the radio or stereo, in the doorway of a store in a mega-mall—it's best to take a moment to dance.

I THOUGHT that when I became a father I would know things.

Not everything. But some things.

I thought that being placed in charge of a child would instill in me the knowledge that other parents—my own—seemed always to possess. That by becoming a father, the best choice, the logical selection, would now be obvious.

Instead, those right, rational choices remain as elusive as ever.

I have a whole new appreciation for my parents. Or rather, a new interpretation of them. It's not that I didn't appreciate them. I did.

But as a boy I had no idea what they were up against, this business of making one's way in the world, this endeavor of raising a child. Now I find myself looking at life's challenges through their eyes. I look at my child and imagine how my parents looked at me.

I think that being a parent is a little like being a chemist. Or maybe an engineer. Everybody brings similar tools to the table. But nobody has a guaranteed plan. So everybody is left to do what he thinks might work, to pay attention to what others are doing and try to build on that progress.

But when I was growing up, my mother and father, I was sure, always knew exactly the right thing to do in every situation, whether it was a child slipping into the deep end of a pool or a washing machine overflowing in the kitchen. My mom and dad knew the answers to every question. They divided light from darkness. If, as a child, I asked my dad, "Right or left?" he said, "Left." If I asked, "Now?" he said, "Not yet." If I asked, "Is there a God?" he said, "Yes."

I remember once, when I was five or six, my dad was driving me to visit my grandmother, so I could show her my new dog. This was in the days before seat belts were widely used, and no one saw any danger in having a child ride standing up in the passenger seat. We were heading north on route 130, near Burlington, New Jersey, and had just passed a gas station where the sign on the pump read 39 CENTS/GALLON.

"What's that noise?" I asked.

My dad didn't know. But he heard it too.

We'd gone maybe a half-mile farther when I looked out the passenger-side window to see the strangest sight—a lone car tire rolling beside us, almost even with my door. Even now, some forty years later, I remember being struck by how funny it seemed. A wheel on the loose, racing the traffic. I turned to tell my dad to look,

that someone's tire had come off the axle, but the words never left my mouth. At that moment the rear right side of our car crashed down into the road, jerking us from fifty miles per hour to twenty or ten. It was like we had dropped anchor on the highway.

I remember falling forward as if I'd been shoved, the interior of the windshield filling my field of vision. And I remember my dad's arm materializing in front of my chest, blocking my fall into the glass. I remember thinking, in the strange way that an emergency can bring tiny details into perfect focus, that he had the biggest hands.

After pushing me back into the seat, my dad guided the car to the breakdown lane. He got out and flagged down a cop. Decided we would walk back to the gas station and locate a tow truck. And that we could use my belt as a leash for my dog.

I remember thinking he must lose a tire off his car pretty often, because he knew exactly what to do when it happened.

Now that I'm a father, now that I'm the age my parents were when they were raising me, I know: they were making it up. They were doing their best to apply their knowledge and experience in a way that seemed appropriate to the situation. Now I know how little anyone raising a child can be sure of.

Because kids change, not just year to year but day to day and at times, it can seem, hour to hour. As a parent you struggle to keep pace. Parents get weary, or annoyed. They're uncertain. They're in the wrong mood at the wrong time, or they miss the moment entirely. Even if they're sure where to draw the line, they might not be able to hold it once it's drawn.

The only thing I know about raising a child is that no amount of preparation can suffice.

Not that I'd had any.

By the time Jin Yu arrived, I had attended hundreds of Phillies

baseball games, a score of Eagles football contests, and a dozen Bruce Springsteen concerts. But I'd never once babysat. Or changed a diaper. I'd never held a little girl's hand as she walked, never buckled the straps of her patent leather party shoes or sat up all night taking her temperature when she was sick.

I thought that raising a child would be like taking an ocean journey, sailing steadily from Port A to Port B aboard the sturdy ship of my knowledge and understanding. It's not like that. It's more like trying to body-surf on a giant wave. At moments you're safely tucked in the curl, feeling the speed, the force of the water propelling you toward shore. You think you have mastered the art. Then, without warning, the wave pulls you under, drags you across the broken-shell bed of the shallows, and throws you to the surface, where you gulp air.

I worry about disciplining Jin Yu. That I will be too harsh, because I'm fearful of leaving her spoiled. That I will be soft when what she needs is firm guidance. That she will see me, not as weak, or even stern, but as unfair. I worry that I will be the opposite example for my daughter. And that she will remember. That when Jin Yu is older, she will look back at how she was raised and silently swear that for her kids, things will be different.

And of course, when I worry, about a high fever or her future estimation of my parenting skills, I can never let it show. When you're a father, a portrayal of confidence is mandatory.

Some days, sitting with Jin Yu at the breakfast table, I feel I can see the future stretching out. Sometimes I'm sure she is headed for the stage, where she can act out her fantasies and dramas before a broader audience. Other days I think she's headed into politics, a natural leader, or maybe into a courtroom, an advocate for those in need.

Before Jin Yu arrived, I would hear people talk about molding

their children, as if the kids were brightly colored pieces of Play-Doh. And I would figure, well, that must be how it works. I thought raising my child would be an exercise in exactitude, her life order and direction set by me and her mom, like a slot car on a track: the pin and groove neatly fitted, the car unalterably locked on course, speeding toward the finish line.

In real life, it's much different. It's like rolling a marble down a sliding board, the tiny, fragile piece of glass veering wildly from side to side. And as that delicate orb hurtles downward, you get to wait at the top, watching, hoping it will stay within the boundaries of the chute and not spin out into disaster.

The lack of control is terrifying. Maybe that's why parents reduce the experience to banalities. *They grow up so fast. You turn around and they're grown. Where does the time go?* Then again, the clichés are clichés because they're true.

Already I can feel Jin Yu moving forward—and away. I hear the clock ticking. I notice the continuous, minute changes in her looks and size and demeanor. Some days I almost want to shout, Don't go! Please, don't go. Don't leave. Stay here. Stay my little girl, my baby, my darling. Stay the child who adores me always, the one who on Monday mornings wraps her arms around my legs and shouts, "Dading no go work!" And who, eight hours later, jumps into my arms and kisses me as if I'd been gone for a month.

My fatherhood will be too short. That I know. How long before she is off with her friends? Seven years? Eight? Ten at the most. Still, being a father has already delivered more laughter than anyone has a right to enjoy, and greater satisfaction than anyone has a right to expect. It has taught me—forced me—to become my better, stronger self. And left me in fear that, on too many days, I have not been the person I'd hoped to be, but the one who is too tired, irritable, and removed. The person who fails to understand that every day with

Jin Yu is a gift, that these moments and days will pass like a summer wind. That too soon I'll be waving good-bye to my grown-up girl and wondering how it all went so quickly.

My dad must have felt the same as I grew. I can picture him now—the new father in his forties who lay beside me at night, so I could fall asleep on his arm, my favorite pillow. Who took time off from work to follow my soccer and hockey teams up and down the East Coast. Who swept me into his arms for hugs and kisses when I was eight and who, when I was eighteen, too grown and manly to kiss him, accepted my handshake without complaint.

I miss him. Now most of all.

I miss that I don't get to talk to him, to tell him of all I'm experiencing, of this child who has changed my life, of the granddaughter he would adore. Because I don't get to talk to him, I try to listen. Sometimes I think if I'm quiet, I might be able to hear him. If I can shut out the noises of the world, just for a little while, I might be able to hear his voice, telling me how I'm doing raising this girl, and how I might do it better.

My father did so many things for me, took me so many places, sacrificed so much, asked so little. Yet even he could not be perfect. And that holds a lesson too.

One time when I was a boy, maybe nine, the circus came to town. It was a traveling circus with wild animals in cages, and a canvas big top that was pulled into spire-castle majesty by the labor of man and beast. The moment the big top went up, on a field two blocks from my house, I desperately wanted to see the show. My mother promised to ask my dad to take me.

That evening, after my dad got home from work, he and my mom were having drinks in the kitchen. My father was still dressed in his work clothes—dark pants, white shirt, striped tie. I stood outside in the driveway, trying to nonchalantly eavesdrop on the discus-

sion that would determine whether or not I went to the circus. For whatever reason, a long day at the office or a lifetime of aversion to the mistreatment of animals, my dad didn't want to go.

The discussion escalated into an argument, the voices loud. A couple of minutes later, my dad walked outside.

He said, "Let's go." And nothing more.

Did I enjoy the circus that night? I don't know. I can't remember.

My memories are snippets—a trapeze artist in a white-and-silver jumpsuit, bouncing into a net. A spotlight focused on a center ring. But what I remember vividly is how my dad complained to the ticket-seller about the entrance price. And then to the ticket-taker about the seat location. My dad's anger practically radiated off him, a force so potent that during the show I hesitated even to applaud. As we sat there, high in the bleachers in our overpriced seats, I wished we had just stayed home.

It is of course the smallest of paternal transgressions, insignificant in the course of a lifetime. Today, when I look back at that disappointed boy, his evening at the circus a bust, I want to tell him: Spare me. Just spare me your complaint. It was one bad day. No father deserves to be judged by that—not by one sour evening against decades of sweetness.

At the same time, that episode has stuck in my mind for decades. It alerts me that children are always watching, that we teach them more with our actions than with our words. It reminds me that with my girl I must try to think before I act. Even if she doesn't seem to be paying attention. Because some mistakes have a future all their own.

MY CHALLENGES will be different from those faced by my father. More external, and potentially more confrontational. There's a scene

in *Back to the Future*, the Michael J. Fox movie, that has become a personal reminder.

Nerdy George McFly is trying to profess his love to a girl. "I'm George," he says, nervously glancing at the notes he's scribbled on a pad. "I'm your density . . . I mean, destiny."

At a New Year's dinner at a Chinese restaurant, a group of friends and family gathered close, a woman I've never met stops at our table, intrigued and insistent, wanting to know who among our kids are the "real" children.

"All of them," I say.

"You know what I mean," she says.

Yes, I know what you mean.

Because lady, you are my density.

The ignorance can be cutting.

The friend who, upon learning we plan to adopt, asks, "Is that like picking a puppy from the pound?" The young woman by the swings at the park, who says she's surprised by Jin Yu's good health because she knows that children in Chinese orphanages are abused. The older health-care worker who decries the "cruel methods" used by the Chinese to secure children to potties, apparently unaware that Americans strap their kids into high chairs and car seats as if they were tiny astronauts. The preschool worker who gives up trying to call us when Jin Yu gets sick, because in checking the class roster she becomes confused about our child's name. She explains: "I thought that was the name of her mother—her real mother."

The litany of insults is lengthy, and for a long time I cataloged every one, storing them up as if they were coins or stamps, keeping them as proof of—of what I don't know. I've stopped doing that. I'm saving my strength, in case the world into which Jin Yu emerges is not much changed from this one.

Once I was the world's personal tutor, responding to the most

personal questions with a smile and a cheerful explanation. No, the Chinese don't hate their girls, but there's a birth-planning law called the one-child policy. No, we didn't "buy" our daughter, we paid the fees for the documents and certifications demanded by both governments. And do doctors and nurses who deliver babies work for free?

I stopped doing that too. For a while I went in the opposite direction.

Faced with a prying question, I would throw up my hand like a stop sign and let out a loud "Ugh!" Then I'd walk away. I wanted the person to know that they had crossed a line, and that I was offended—and make them think about why that might be.

Other parents of children from China told me to knock it off.

They told me to remember that I, more than any ballplayer or ballerina, am my child's role model. That I had to think about what I was teaching Jin Yu when I responded with scorn. I thought I was teaching her that she doesn't have to put up with idiots. But Jin Yu watches so closely. I didn't want her to think I was somehow embarrassed by her adoption, that it was something we couldn't talk about, a secret. Responding to people so coarsely was a mistake. A big, parental mistake, made by me. A mistake much more serious than, say, being grouchy about taking your kid to the circus.

So I stopped doing that too. I've fashioned a new response and a new behavior.

Now when someone inquires about why Jin Yu and I look different from each other, I make an on-the-spot decision about whether to answer, groan, or simply turn away. Some of the people who approach me in the line at the grocery store have the best intentions. Some are getting ready to adopt from China themselves. Some are thinking about adopting. Some are just nosy. I almost welcome the rude ones. My girl, I'll protect her against anything. Against all America. Against stupidity.

Defending her is my pleasure and my pride.

I'm less interested in defending myself.

Sometimes, when parents gather off to the side at a birthday party, or stand watching the kids play on a jungle gym, the conversation turns to our love for our children. How we're shocked by the intensity of our feelings, surprised by the depth of our devotion. How we never thought it possible that we would care so much for another human being.

Sometimes, as we talk, people whose sons and daughters arrived through the birth canal will nod at me sympathetically. Sometimes they'll even reach out and touch me on the arm, as if to offer some unspoken encouragement, their recognition that I've managed to craft a satisfying family life despite being denied the fulfillment of what they would describe as children of my own.

I used to rush in with words, with rising declarations of love for my girl, advancing a point-by-point argument to try to make them understand that, honestly, I wouldn't have it any other way.

Now I just stand there, silent. I'm already tired of trying to prove that my family is as authentic, as loving, and as permanent as families formed by birth. And I haven't even been at it that long.

Christine, my compass, reminds me that I can't change the world.

The truth is, I thank the heavens for our barrenness. The truth is that every day of my life I am grateful for our defective physicalities. What other people regard as misfortune or even tragedy—the inability to have biological children—I see as the luckiest break of my life. Without that grace, I would not have Jin Yu.

I know how fortunate I am. I try to remember, even—especially—when I am not the father I want to be.

Because I know that Jin Yu will remember those days, the times when I was less than my best self. When she is grown, when she

looks at me, she will see my failures and my failings, too numerous to count. She will see my cynicism. My quick temper. My slim patience.

She will see all that and more. But there will never be a day when she will not see my love.

Jin Yu running on the Great Wall, on her return trip to China

IT'S DARK, the dawn still forty-five minutes away, and cool, the chill of spring a buffer against the coming heat of summer.

No one else is here, so early on this first of June. Just our four-some, waiting beside the railroad track at the Elkins Park station, next to a small fortress of suitcases and duffel bags. The nearby houses are gloomy and still, their outlines visible in the glow of street lamps.

Christine looks down the track, searching for the gray silhouette of a train in the distance, fretting that we will fall behind schedule before we even begin. Our friend Ellen stands beside us, lost in her own thoughts, in her plans or imaginings of the journey ahead.

Jin Yu is awake and for the most part alert, content to study the glimmer of the early morning stars from a post in my arms. Like her parents, she was up with the 4:00 A.M. bleat of the alarm. I had expected a battle to rouse her from her bed. Instead she rose easily, moving on instinct and adrenaline, as if she too was eager to embark on this expedition.

Far along the track, a single headlight blinks into being, its beam turning the trees on the east side of the rails a ghostly shade of green. The light strengthens as it rounds the bend and heads toward us, illuminating the way for the 5:00 A.M. SEPTA train to Philadelphia. Seconds later the train wheezes to a stop at our side. It takes the four of us only a minute to board. The passenger car is practically empty, the few occupied seats taken by chefs in white smocks and waiters in black bow ties, headed to jobs cooking eggs and scrapple at the downtown hotels.

The train glides forward, then picks up speed.

It's quiet. We join in the silence.

The four of us won't be getting off with the others in Center City, or even at a point beyond. We're going to the end of the line, to the airport, to a plane that will carry us north and then west, trying to outrace the sun. Hours from now, at our first stop, in Chicago, the pilot will advise us to settle back, because it's going to be a long flight.

Again we are headed to China.

This time Christine and I are traveling as a full-fledged family, with our daughter and with our friend and helper, Ellen. We're traveling lighter, leaving behind the weight of doubt we carried the last time.

We'll land in Hong Kong, then catch a flight to Beijing. Of course, flying to Hong Kong to get to Beijing is like flying to Miami to get to New York. It adds time and distance and fatigue. But it was this flight or no flight. And given all that awaits, thirty hours of travel is a small inconvenience.

We'll stay in Beijing for a few days, letting our heads and stomachs settle, exploring the city, girding our nerve. Then we'll board another plane that will take us deep into the country, to a particular place at an appointed hour. She will be meeting us there. This person I don't know but long to see. This soul who I'm certain will play a

pivotal role in my daughter's life, forever connecting Jin Yu to her homeland, her family, and her future.

No, not her birth mother. Or an aunt, or a cousin, or a biological relative of any sort.

Her new sister.

A tiny beauty, born in the year of the sheep, not yet one.

I don't know what I will say to her first. Not that she'll be able to understand. I wonder what she will make of me, of my wife, of her new big sister, now nearly four. In two years Jin Yu has grown tall and strong, her intelligence shifting from the consistently impressive to the occasionally frightening. At lunch a few days before, Jin Yu was trying to solve some puzzle. And I was trying to help by leading her through a logical system of resolution, step one, step two—at which point Jin Yu jumped to step five. It scared me. If she already has more raw brainpower than me, how ever will I keep pace when she's a teenager?

But intelligence is different from maturity. Jin Yu is too young to comprehend the momentousness of this voyage, too small to under-stand how it will turn the direction of her life like a twig bent from a tree. She is too young to be excited about its possibility and prom-ise, but old enough to perceive its anxiety and angst.

When her mom and I explained to Jin Yu where we were going and what we would do, she responded with a wounding question: would she be coming back with us, or would we be leaving her in China?

Every day, you tell your child you love her. Every day you tell her that she is yours and you hers, a family forever. Every day you tell her that you will always love and care for her. Yet when faced with the first challenge to your promise, she asks: do you mean it? Chris-tine and I tried to reassure Jin Yu, again, that we would love and provide for her for as long as we drew breath.

In a way, what Jin Yu thinks or feels, what any of us thinks or feels, is beside the point now. We are on our way, and this journey will be what it will be.

The vinyl upholstery of the train seat is cold against my back. The air-conditioning is running despite the coolness of the dawn. Jin Yu stares out the window, watching bedroom lights pop on inside the houses, the passing rumble of our train providing a gravelly wake-up call. I lean back and close my eyes. I need to stockpile as much rest and energy as possible during the next twenty-four hours because the time after that will be long and testing. And of course, I can't sleep, my mind racing.

People say the second child is the parents' gift to the first. That the second is confirmation that the first child made them happy. Otherwise they wouldn't have another baby. But I think a second offers the first more than encouragement. The second is an ally in disputes with Mom and Dad, a co-conspirator in childhood schemes, company on a stormy night.

Christine and I are not returning to China solely so that Jin Yu can have a sister. Adoption is the ultimate selfish act—all about the parents getting what they want—and Christine and I have our own reasons for going. We like the idea of having two children. It seems to offer a certain balance, a precise sort of stability. Of course we worry: That a second child will prove more than we can handle, beyond our parenting skills. That the happy triad we have established with Jin Yu will be ruined. That the girls may not merely bear no love for each other but be openly resentful. We worry that in asking for another daughter, in asking for even greater love and happiness, we have asked for too much.

I believe this trip to China is the right thing to do. But in a way, that doesn't matter either. Once you set these things in motion, you go where fate leads you and you take what it delivers.

She is waiting for us now. I wonder what she will do when she sees us, how she will react, whether she will smile or cry, in joy or sadness, or perhaps offer a face masked by stoicism. I have seen her only in photographs, taken when she was younger. She is older now. But I am certain I will know her at first glance, and that, somehow, she will know me.

I CAN'T see her. She is here, in the same room of the same building in the same smoggy Chinese city, but it's so crowded I can't see her.

I'm standing on tiptoes, bobbing left and right as Jin Yu, her arms tight around my neck, bobs right and left, each of us trying to peer over the heads and shoulders of people in front of us. Ellen is behind us, aiming a video camera.

"There she is!" Christine calls. "Do you see her?"

No, I don't.

More people step in front of me. I can't see anything. Christine says she can see her sitting against the wall on the far side of the room, perhaps fifty feet away, and that she's beautiful, with fine, delicate features. That she seems relaxed, peaceful amid the commotion.

Today she has traveled more than three hours to meet us, leaving her home in an orphanage in the city of Wuwei to come to the J. J. Sun hotel in Lanzhou, on the banks of the silty Yellow River. Lanzhou is the capital of Gansu Province, a snaking spit of land in western China pinched between the Tibetan Plateau and the Gobi Desert.

I edge my way to the right, trying to see. A man at my shoulder steps back—and there she is.

I can't keep from waving, trying to draw her attention. She doesn't notice. She seems unaffected, by so many people, by all the

noise and movement. Her lips are drawn together in a tight little smile, as if she alone knows the answer to an odd riddle.

I step to the left, creating an aisle so Christine and I can move ahead together.

Now she is up and coming toward us, carried forward in the arms of a nanny. I can see her full on.

She's dressed in a cotton two-piece, colored pale blue with yellow sleeves. It looks new, undoubtedly purchased for this occasion. She looks different from her photographs. Thinner perhaps. Her hair is short. Not black, but a shade of sun-bleached brown.

We're five feet apart, separated now by only a few bodies, each able to appraise the other. She's small. Her skin is pale, her eyelashes curled. She has the longest fingers of anyone I've ever seen.

We are two feet from each other. I notice she is no longer smiling.

Jin Yu is trying to jump up and down in my arms.

"It's me! It's me!" she shouts.

As if she would be recognized. Then again, why not? These two are family.

Jin Yu, determined to be first to greet her, is leaning so far forward that she almost falls out of my arms. I push one step ahead—and they are together, their faces inches apart, close enough to breathe the same air.

Jin Yu's face is illuminated in the brightest smile I have ever seen. "It's me!" she insists once more, peeved at the baby's lack of response. She acts as if they are old friends, separated long ago and now miraculously brought together, time having made one unrecognizable to the other.

Christine has her arms out to receive the child. The baby, snug in the grasp of her nanny, stares quizzically, as if to ask, "Whatever do you think you're doing?" not realizing how little she will care for the answer.

The nanny bends slightly to hand over the child. In that moment, the girl not quite ours, no longer fully theirs, a freeze frame: the baby is the portrait of serenity, calm and at ease. I think, *This one will be our quiet child*. Our easy baby. Not the daughter who insists her way is the only way, but the one willing to go with the flow, to submerge her own opinion in the interest of compromise. Her name is Wu Zhao Gu. She was found outside the door of a health clinic in Wuwei, a Silk Road encampment best known as the discovery site of a prized bronze relic, the Flying Horse, its image seen everywhere in China.

A woman steps in front of me, and I lose sight of Zhao Gu. I can only see Christine's back, and over her shoulder, the face of the nanny.

Then Christine turns around, our new daughter in her arms. Zhao Gu—my quiet child, my peacemaker, my diplomat—begins to scream at the top of her lungs. She is not crying, not even frowning. She's screaming, registering her dissent at a level that pushes the noise in the room, where a dozen families are receiving Chinese children, to a new and impressive volume.

It would actually be funny if she wasn't so upset. And if she wasn't so loud.

A man I recognize as the director of the Wuwei orphanage tries to calm her, patting our girl's hand and whispering soft assurances. Zhao Gu will have none of it. After a minute he turns toward me and shrugs his shoulders.

I want to hug him. But that seems presumptuous. I tell him in Chinese, "Thank you, thank you." In English I tell him all I cannot say in Mandarin: That I am so grateful, that Christine and I appreciate all he has done, all that China has done, in allowing us to have this baby, in permitting us to build a family. That we will always love and nurture this child, now our daughter.

The words spill out, one after the other. He doesn't answer.

Instead, he pats me on the shoulder, a gesture I take to mean, "I understand. And you're welcome."

I'VE HAD no word from Jin Yu's Chinese parents, nor from anyone who knows them. I've not heard from a soul in response to my meticulously crafted classified ad alerting the birth parents to their child's whereabouts and asking them to contact me. That was to be expected. I never published the ad. Not in Xiangtan or Changsha. Not in China or anywhere else. In the end, I left my message, my script for trans-world reunion, lying on top of my bedroom dresser, stuck between an old copy of *Newsweek* and a Phillies ticket stub.

My plans for a trip to Guangxin Alley, to conduct an on-scene inquiry and search, I likewise put off.

It's not that I've shed my desire to learn about Jin Yu's past, to know more about the people who gave life to her, more about the events of the days that preceded her abandonment and the hours that immediately followed. Nor have I lost the hope of somehow alerting Jin Yu's Chinese mother and father to the fact that she is alive and well and very much loved. But the more I thought, the more I came to the realization that it was not my place to undertake such a search, to try to make that contact or pass on that information. That odyssey belongs to Jin Yu, and Jin Yu alone, should she someday wish to pursue it. If she wants me to help, I will. If she doesn't, I won't.

The paper trail was a different matter. Trying to locate documents and records, papers that could help provide a basis for Jin Yu's own search later on, that was within my parental purview. To me, it made sense to try to find any surviving written accounts now, before paperwork and people disappeared, to at least establish a record of

having made the request. Not that it did any good. My effort to unearth some tangible tie to Jin Yu's past proved nothing more than a waste of stamps.

OUR GUIDES don't believe in long first meetings.

Forty-five minutes after Zhao Gu is placed in our arms, the five of us—Christine and I, our two daughters, and Ellen—head out of the hotel, due to meet the other families outside.

Zhao Gu has not stopped screaming. It doesn't bother us, except of course for her distress. It's perfectly natural that she should be upset. Zhao Gu's loud protest triggers none of the dread provoked two years ago by Jin Yu's deep, still silence. To Christine and me, Zhao Gu's loud, continuous shriek is music. This baby is healthy and secure enough to let us know what she thinks, to voice her displeasure, to take full advantage of her first opportunity to give us her opinion.

We step outside the hotel and onto the sidewalk, the summer heat instantly dabbing our skin with sweat. Zhao Gu decides it's time to save her voice. Her screaming ebbs, replaced by grunts of disagreement and, finally, by the occasional murmur of interest.

We join the other American families, happy with their new Chinese babies, lining up outside a photography studio that's set up in what looks like an open garage. A couple of passersby stop and stare, intrigued by the sight of so many foreigners holding native girls. Five or eight people surround us, then a dozen, then two dozen. The sidewalk quickly becomes impassable. People press close, touching us on the arms, shaking our hands, stroking the faces of the babies, eager to make sense of these curious pairings.

We're being mobbed, for the moment the most popular people in Lanzhou. It's like being the Beatles, but without the torn clothes.

The people closest to me seem to be offering plenty of advice about raising a child—and I can't understand a word. Some of them want to hold the babies, not quite sure what we're doing with them. Others understand perfectly, raising their hands to give us smiling thumbs-up signs. I crane my neck to try to judge the size of the crowd. At the back of the throng I see people standing on their tiptoes, trying to see what's going on up front.

A cop shows up, waving his arms and ordering people to move on.

Strapped across her mom's chest in a Baby Bjorn, Zhao Gu is unperturbed by all the attention and to-do, glancing around to see what she can see. She reaches out and grabs Jin Yu's hair. Jin Yu protests as if she's been stung by a bee. Zhao Gu responds with a grin. Already she is interested in this other, older child. In our room, the only time Zhao Gu paused in her wailing was when Jin Yu approached, wanting to rub her nose against that of her new little sister.

We don't know it yet, but Zhao Gu's grieving is over. An hour of shouting, screaming protest—then acceptance. Her transition to us will be remarkable only for its lack of complication. Feedings will be easy, her sleep sound. She will cry when she needs something—a fresh diaper, a snack, a hug. But she has no interest in recreational crying. She will take to Christine and me as two big, personal servants and playmates, and to her sister as her guide and role model.

As of now, Jin Yu is no longer an only child. And Zhao Gu is no longer alone.

They will be rivals in some ways, to be sure. Jin Yu will have to share the spotlight, and she so loves its shine. But now each will have a friend, and most of all, each will have a sibling with whom to grow old. Years from now, all their lives, after Christine and I are gone, each of my daughters will be able to look at the other and say, "Do

you remember the time when . . ." As an only child, I recognize the value of such a connection, because I don't have one.

Of course Zhao Gu comes to us with her own life and history, a baby with her own story, mostly unknown, attended by her own collection of ghosts. Her time in the Wuwei orphanage was relatively short at eleven months. Later this week, Chinese officials will surprise us by offering a wealth of information about Zhao Gu's background, including an almost blow-by-blow account of her discovery outside the Wei'an health center in Wuwei.

In fact, the level of detail provided about Zhao Gu's discovery is so substantial that, a little over a year from now, with the help of a Chinese journalist, I will be able to locate and interview the man who found her on the street.

"Oh, you don't want me, you want my husband," his wife will say when we call from Philadelphia. "He always talks about the day he found the baby."

On the sidewalk near our hotel, most of the locals have moved on with their business, leaving a happily tired pack of Americans to tend to their children. Our guide, Cindy, calls out our last name. It is our turn to be photographed. We step inside the makeshift studio. Only Zhao Gu, Christine, and I are permitted to be in the picture. Jin Yu, a bit put out at being excluded, waits on the sidewalk with Ellen.

"Smile!" somebody shouts.

The photographer is waving some sort of stuffed toy bird at Zhao Gu, trying to get her to look at the lens. Zhao Gu casts her glance everywhere but straight ahead. Finally—of her own accord, surely not because she's been told to do so—she raises her chin.

The flash pops. The resulting photo shows Christine and me leaning toward each other, as if to form an A-frame roof over our new daughter. My eyes are lidded, my mouth half open. I look worn out. By contrast, Christine is beautiful, her hair combed and in place,

her glee evident in her smile. Zhao Gu is facing the camera—but her eyes look off to the side, I know not at whom or at what. She holds a rattle up near her ear, as if to show it off. On her lips is the beginning of what may be a smirk. She looks like someone who has just received some bit of good news, and is thinking about how sweet it will be to share it with friends.

"Next, next," somebody calls.

I lift Zhao Gu and ease her back into the child carrier, facing forward, safe and comfortable against her mom. We walk out of the studio and join Ellen and Jin Yu, turning back toward the hotel with plans for an early dinner and bedtime. Zhao Gu is content to bob along as we stroll, watching the faces of the people who pass.

I pull open the hotel door to let Christine step inside. My wife is playing with Zhao Gu's dangling feet. Our daughter cackles in delight. At that moment, halfway through the door, my new daughter turns and looks up at me, her little face alight.

I do not know what has become of Zhao Gu's Chinese mother and father. I hope they are well—and that someday our lives will be such that we may meet. I hope that, somehow, they will learn their baby is safe in the arms of people who love her.

But those are just wishes.

What I know for sure is that, once again, officials in the Chinese government have examined the nature of my character and the content of my heart, and compared what they found there to the needs and dispositions of the children in their care. They believe Zhao Gu and I will make a fine match. And I am willing to trust their judgment.

SINCE WE landed back in the United States, we have spent our time adjusting to life as a foursome, settling into new routines and adapt-

ing old ones to new schedules. On Saturdays, I'm the one who gets the mail from the box near our front door.

I find the letter at the back of the mailbox, dropped there without ceremony or announcement, hidden behind a couple of bills and a catalog offering half-price on summer footwear. I take it inside with the rest. At first, standing there in the foyer, I don't realize who sent it.

I'd given up hope of help from the Chinese government in unearthing Jin Yu's history, concluding that whatever records might exist would, for now, remain beyond my reach. To see them I might have to wait a very long time, for a day when the relationship between the United States and China shifts to something more open and comfortable, or perhaps even for a cataclysmic event like the fall of the ruling party. In the former Soviet Union, archives opened to reveal decades-old secrets only after the top cadres were expelled.

The envelope is thin. If this were a reply to a college application, I'd already know I'd been rejected. The letter bears the return address of the Chinese consulate in New York.

It's been five months since I wrote.

I slide my finger under the flap and tear open the envelope, glad to have received some reply, interested to see the wording of the response, the explanation for why the information is unavailable, or why I must write to some other branch of the government.

There's a cover letter. It says the government of the People's Republic understands my desire to obtain more information concerning the birth and discovery of my daughter. That my request is being answered by Consul Shuangming Dai, who received my letter from Consul General Liu Biwei. Consul Dai heads the unit that authenticates American documents regarding adoptions.

In the letter, Dai says he contacted the relevant authorities at the Ministry of Civil Affairs in China, and received this information

about my daughter: the child was female, found in Guangxin Alley, within the Yuhu District of the city of Xiangtan, on August 5, 2000. She was wearing cotton clothes. The name of the person who found her was not recorded. The police transferred the baby to the Xiangtan orphanage. Efforts to locate her Chinese parents were unsuccessful, and after two months she was legally declared to be eligible for adoption.

All of this I knew. All of this I'd been told before.

The letter continues.

It says a search of the record by the relevant authorities located a particular document, and a copy is included herein: a note that was found tucked inside Jin Yu's clothing on the day she was discovered in Guangxin Alley.

My forearm thumps against the entryway radiator as I slump sideways.

I flip the page. I see it. But I can't believe what I'm looking at.

The note. What adoptive parents call the birth note. Jin Yu's birth note. The last testament of my child's Chinese parents. Their final words on the subject of their daughter.

Of all the records I imagined might exist, of all I hoped might be found or surrendered, this I didn't expect. I wished for a copy of some official record compiled by the authorities in the hours after Jin Yu was found, something that might provide a name or a location, a new place to look. From the consulate I anticipated a polite, formulaic note thanking me for my interest. I never imagined I would be given the note that was left with Jin Yu. When we were in China to adopt her, I'd been told that no such note existed.

"Christine!" I call.

She walks out of the kitchen, her hair pushed back, wiping her hands on a dish towel. My hands are shaking.

"You won't believe this."

We look at the paper together.

The note is short. Three lines. Written on a torn Hong Bao, in this country known as a "lucky money envelope." The envelopes are invariably red, typically adorned with pictures of dragons or deities. During the Lunar New Year, grown-ups place a few coins inside the envelopes, to give to children as goodwill gifts.

This red envelope bears neither dragons nor gods. On its cover, beneath Chinese characters that say, "Good luck," is a cartoon draw-ing of two children. One is a boy, the other a girl.

On the reverse side, the dark lines vivid against a white back-ground, are twenty-three Chinese characters. The handwriting is neat but not elaborate. The characters look as if they were written by someone who was concentrating very hard, someone taking care with their writing and their words.

The consulate has included a translation. The words say: "Daugh-ter, born at 5:13 P.M., August 2, 2000."

I practically want to shout: Success! Success. From the depths of the Chinese bureaucracy I have managed to mine a previously unknown artifact, a new piece of information, a fresh portion of Jin Yu's past.

The note is proof of Jin Yu's birthday—and a silent explanation of why the officials we met in China seemed sure of her date of birth, while those of so many other children are estimated. It adds an important detail to her story: the time she was born. It provides my daughter with a sample of the handwriting of one of her Chinese parents, a physical, tangible tie between them. This note is some-thing they created for her.

To me the value of this small bit of paper lies not only in what it says, but in its mere existence. My daughter didn't drop to the earth from the moon. She came from real and living people, people who, however briefly, clothed and fed and cared for her. People who kept

their child for three days before letting her go forever. People who thought to write out some semblance of a good-bye.

This is it then—her Chinese parents' farewell. Their last comment on their child, the girl who would become my daughter. Their note had been sitting in the files the whole time we were in China. In fact, it had been there much longer, since before our adoption application arrived in Beijing.

I bet it was Jin Yu's Chinese mother who wrote out these spare lines. The toughest jobs fall to women.

I wonder, did she want to say more? Did she long to pour her heart onto this piece of paper, to tell her child all she had done and tolerated just to be able to give birth? Did she want to write volumes of detail—the place of birth, the baby's weight, the familial name—but dared not, fearing it would lead to her own identification and punishment? Did she want to tell her daughter she was sorry? That she was caught between want and reality? That despite this act of abandonment, despite their distance and anonymity, the two of them would be bound for as long as both should live?

Maybe she spoke words like those aloud, a conversation kept between herself, her daughter, and the gods.

Of course it's possible that Jin Yu's birth mother didn't write the note. Maybe her husband or boyfriend wrote it. Maybe she wanted to write it—but couldn't bear the pain. Maybe she was unable to read or write, forced to ask a friend for help. And then, faced with having to dictate her words, to describe the scale of her loss and the depth of her grief, to express in a few lines all she had expected to be able to say to her child over long years, she could manage to speak only the bare details: "Daughter, born at 5:13 P.M., August 2, 2000."

Who was she writing to? Certainly not to me. She could not have expected Jin Yu to maintain possession of the note, and indeed it was taken from her, along with the clothes on her back. Plainly this

woman wanted her daughter's birth date known—identifying the child as a dragon, the only magical animal of the Chinese zodiac, the luckiest and most powerful of symbols.

Yet it is also true that had Jin Yu been born a male, her Chinese parents probably would have kept her. Her parents were under pressure to give up their baby, compelled by situation and society, but they were not forced, not in the literal sense of the word. They could have made a different choice. They could have kept their child and suffered whatever penalty was to follow, however unfair and injurious. But they didn't. My daughter will have to live with that knowledge, as her Chinese parents live with it now.

At this moment, as Christine and I pore over this note, Jin Yu is in the sunroom, determined to protect her toys from the clutches of her baby sister. Christine hugs me and says, "Ya done good." The exploration of Jin Yu's past has always been more my obsession than hers. Christine, like her eldest daughter, directs her energy toward discovering a brighter tomorrow, not recovering a darker yesterday.

Standing there, in the doorway of my house, I imagine the entrance to another home, far across the sea, a household too poor to feed an additional child, its elders too weak and beaten to face the wrath of their government. I can hear the baby, crying in her makeshift crib on the floor, hungry for her mother's touch. I see the child's father standing by, impassive, not daring to embarrass himself by revealing his sorrow, as the woman sits on a stool, writing a farewell.

I imagine that she slips a few precious coins into the red envelope, hoping that whoever discovers it will use the money to feed the baby. She doesn't know that the first person to see the child will tuck the money into his own pocket and walk away, leaving the note and the baby for others to find.

Standing there, holding a copy of the birth parents' last missive

in my hand, I am sure that these people loved their child. I can't explain it. It's just my own certainty, a sureness that Christine and I are not the only parents in the world who love this child. I don't think they would have gone to the trouble of noting Jin Yu's date and time of birth if it wasn't important to them. They wanted to communicate—with someone, with a police officer or a passerby, with whoever might be next in their daughter's life.

I fold the note and letter and slide it back into the envelope.

I think, *The woman who wrote this note doesn't know I have a copy.*

But someday, if my eldest daughter permits, she will. Someday I will bring it to her. I will track her down. I will take this note in my hand and place it in hers, a piece of paper with the power of a talisman, the coded evidence that reveals each of us to the other, marking us as kin. When she sees this note, she will know by the evidence of her own handwriting that I have her child. And she will know by the look in my eyes that I worship my daughter.

THE LAST thing I do, a few minutes before the guests are scheduled to arrive, is the same thing I've done on or about this date for the last four years: tie a shiny Mylar balloon to the fence beside our front gate, to help people find the house.

I tug the knot and let go. The late-afternoon, late July sun bounces off the curved surface of the balloon, which jerks to a stop on the tether of a gold-and-purple ribbon. The balloon revolves in the breeze, as if impatient to display its confetti-colored message, HAPPY 6TH BIRTHDAY.

Christine's brother Yves and his partner James are already here, in from their home in Oklahoma. My mom arrived fifteen minutes ago. This will be Jin Yu's first birthday without her other grandmother, Christine's mom Hannelore, who died last winter.

Only family and close friends attended the first parties. But now Jin Yu is old enough to invite friends her own age—from her preschool program, from the neighborhood, from the lion dancing class she attends each week in Chinatown. Her circle of friends grows by

Jin Yu on her sixth birthday

the month—sometimes it feels like by the hour—pushing our guest list beyond forty, half of them children.

"Daddy, what are you doing?" Jin Yu calls from the front door. I turn to explain, noticing how pretty she looks. As she chose many of the guests, she also chose her birthday outfit, a pale orange plaid dress. It's practically brand-new, and already a little short.

Jin Yu will start kindergarten in a few weeks. She is not just growing but maturing. Her tastes are shifting. Elmo, her friend from her first days in this country and the theme of a previous party, is being left behind. Today the theme is unicorns, the cups, plates and tablecloth bright with the spectrums of color and bent light that accompany magical animals. And magical children.

There will come a time when Jin Yu will regard a birthday party, particularly one thrown by her parents, as decidedly uncool. But not today. Today she is thrilled.

Nathan arrives with his mom, Florence. Then Phoebe and her mom, Ellen. Helen and Bret and their three children. The house begins to fill with people. I lose sight of Jin Yu. That's okay. She is no longer at an age where I must wander the house and yard behind her, keeping her constantly in view, worried she might meander out the gate or down the basement steps. Now the best way to check on her is to stay fixed in place and wait for her to pass.

I'm dumping a bag of ice into the cooler when Jin Yu flashes by, newly decked out in a sparkling pink-and-gold dress-up gown, leading a pack of kids wearing an array of tiaras and tutus. Their plastic high heels clomp against the wood floor as they rush past. Trailing behind the bigger kids, determined to be part of the group, or at least near it, is Zhao Gu. She is not much for dress-up, though today, perhaps in honor of her sister, she has donned a stylish set of oversize plastic pearls.

Jin Yu begins to organize the other kids, setting them in line as a makeshift wedding party, best men and ushers and bridesmaids. Of

course Jin Yu is the bride. I can't tell who is the groom. Maybe she sees that job as superfluous. She turns her back to the wedding attendants, swinging her arm in an underhand motion from hip to shoulder, perfecting the movement she'll use to toss her bouquet. She's much more interested in refining the arc of her throw than in learning who will catch the flowers.

A minute later, the wedding is over and the kids move on.

The grown-ups stand chatting in groups of three or four, relaxing on soft leather sofas or sitting on the hard concrete steps of our back patio. Children follow one another through the house in twos and threes, head out and around the yard and then come inside again, stopping only long enough to pick up a juice box or another slice of pizza.

It's almost time to cut the cake. Christine and I know our roles by now. She is in charge of arranging the candles and carrying the cake from the kitchen to the dining room table. My job is to summon all of our guests and ready the video camera.

There's no need to call Jin Yu. She materializes at her mom's side at the head of the table. She is hot and sweaty. It's hard work being a bride. And a hostess. Christine lights the candles, the cue for everyone to begin singing "Happy Birthday." When the song ends, a smaller chorus of guests repeats the tune in Chinese.

Jin Yu leans forward to blow out the candles, six this year, plus the usual one extra, for her birth mother. Christine steadies Jin Yu. I can see the two of them, captured in the rectangle of my viewfinder: Christine, caught in half-smile, her arms around her eldest daughter. No longer a woman hoping to be a mother, or even a new mother, but the woman other moms approach when they have questions about raising their kids. Jin Yu, her cheeks puffed like the belly of a blowfish, so happy, and so accepting of happiness as the normal state of her existence.

She doesn't know how far she's come. She doesn't know how much she means. How much she matters. She doesn't know how close a thing it was. We could have missed each other. What would have happened to her if she had stayed in Xiangtan? That part of my imagination is not a place I like to visit. What a waste it would have been, for Jin Yu most of all, but also for the people gathered around her now, who love her and who bask in her love for them. For others, not yet known, who will love her in the future, and for people who will enjoy and benefit from the things she will do and accomplish in her life.

That day in China, when we were allowed to visit the orphanage, the administrators told us that most of the older kids go to school in the city. They learn to read and write, and that is not an insignificant skill in Hunan Province. But to me the older children looked sad. They looked dulled, as if the nourishment that helps children grow—not merely food, but music, art, sports, intellectual challenge—had been denied to them. They looked as if they knew that, and could not understand why they had been relinquished to that fate.

Jin Yu blows a long gust of air that extinguishes most of the candles. A second blast puts out the rest. People applaud. Her pals push their way in from the sides of the table to stand close beside her, each announcing whether they want a slice of cake with an icing flower, or no flower, or a butterfly or part of the rainbow or the unicorn.

Later that night, an hour after the last slice of pepperoni pizza has been snatched from its box, after the hum of conversation has slipped from the house, it is just the four of us again, parents and daughters. Jin Yu is sitting at the kitchen counter, trying to decide which of her new bracelets to wear tomorrow. Her forehead is streaked with violet icing. Nearby is the stack of videos she received as gifts, *Mickey Loves Minnie*, *Lassie*, and *Barbie as Rapunzel*.

As we head up the stairs to bed, I ask Jin Yu: What did you like best? What was your favorite part of the party? Another kid might say, "The presents," or, "The games," or, "The ice cream."

Jin Yu answers, "Laughing with my friends."

That is just like her.

For all of the lovely gifts, and there were many, Jin Yu has always been a girl who prefers experience to souvenir. Given the choice, she would rather take a trip than have a toy, would sooner meet someone than have something. As this birthday approached, she didn't ask her mom and me for a new Barbie doll or a Dora the Explorer nightgown or some other character-driven children's product.

She asked if as a special treat we could go and visit what she calls "the dinosaur bones."

So a few days after the party, on her actual birthday, August 2, I take the day off from work and Christine packs our backpack. The four of us head into Philadelphia, stepping past the bronze statue of the Velociraptor that guards the door of the Academy of Natural Sciences on the Benjamin Franklin Parkway, ready to spend the afternoon among the skeletal remains of a T-Rex, an Avaceratops, and a Giganotosaurus, the last the size of a bus. Jin Yu is as usual full of questions about the animals, children's questions like, "What color were their eyes?" and "Where did they keep their blood?"

Today, as we ride the elevator to the third floor, Jin Yu takes both my hands in hers and poses a question that has nothing to do with fossils:

"Daddy," she asks, "how do you spell 'love'?"

TODAY, AT six, Jin Yu is thoroughly American. And Chinese at the core.

Here, in this country, her intelligence and creativity are con-

firmed by her achievement in preschool and kindergarten. Her teachers love her. Her friends do too. Jin Yu is the kid with whom all the other kids want to play, the child every boy and girl recognizes on sight, the one whom half the class considers their personal best friend.

Her success was preordained. Jin Yu was born in the year of the dragon. More, she was born in a year ending in double zeros, a turn of the calendar that occurs once in a hundred years. That makes her a golden dragon, supremely blessed, destined for greatness.

And in fact, she already has a career goal: to become a princess and live in a castle.

When Jin Yu gets home after school, and first thing on weekend mornings, she slithers into a frilly gown. Her favorite is a bright yellow dress, the color of sunshine, with highlights of small pink roses. She adds a plastic-jeweled crown and a pair of elbow-length white gloves. Once properly attired, she commences to recite entire scenes from *Beauty and the Beast*, complete with sound effects and selections from the musical score. Naturally, Jin Yu casts herself in the lead role of Belle, the heroine, while her baby sister, incongruously, plays the muscle-bound bully Gaston.

Their first months together were rough.

One night, not long after we got home from China, the four of us were sitting at the dinner table, Zhao Gu at the head in her high chair. Jin Yu pointed her finger at the little girl who had taken roost in our home.

"Where are her mommy and daddy?" she asked.

I thought she was kidding. She wasn't.

"Jin Yu," I said, nodding toward Christine, "*we* are her mommy and daddy."

Jin Yu didn't say anything. But she must have thought I'd misspoken, because a couple of weeks later she came back with another

question, posed not in anger, but as if wanting to be sure of the time-table: "When is she going back?"

Today, after two years together, Jin Yu may never accept having to share the limelight, but she has more than accepted her sister. She has come to love her. The realization that Zhao Gu would be stay-ing, that she was not a temporary houseguest but a permanent part of our family, took root slowly but deeply. One evening after dinner, offered ice cream for dessert, Jin Yu swept her arm across the table as if welcoming us to a grand banquet, then inquired, "Do you have some for my good friend Zhao Gu?"

The other night, as usual, Christine and I put the girls down, each in her own bed in the room that they share. After an hour of silence, with only the purr of the fan coming over the monitor, I thought for sure they were asleep.

Then I heard Jin Yu:

"Zhao Gu? Zhao Gu? Zhao Gu?" She paused. "I love you."

And Zhao Gu replied in her tiny, three-year-old voice: "I nuff loo too."

Jin Yu has learned that her sister will for the most part graciously accept second billing in their dramatic productions, that she doesn't mind taking the smaller piece or the later turn. She's begun to see how her little sister adores her and looks up to her. That Zhao Gu is happy to cheer her on.

On Saturdays, Jin Yu puts aside her Disney gowns and faux jew-els, donning a pair of loose-fitting nylon pants and a red T-shirt, traveling into the city to a class where she learns the ancient art of lion dancing. Supposedly the dance began, some four hundred years before Christ, as a way for defenseless farmers to scare off invaders, or to at least scare away the elephants the raiders rode on.

Jin Yu loves learning the steps, and playing the drum, and figur-ing out how to position herself for the Kung Fu stances. Christine

and I like her to take the class not just for the skills she learns, or even for the joy she derives from the public performances, though those are important, but because Jin Yu's participation gives her a chance, at least for a couple of hours each week, to be part of the majority. Perhaps equally as essential, it affords Mom and Dad a regular dose of what it feels like to be in the minority, to be the people who look different.

Our family is now half Chinese. In fact if our household was a democracy instead of a dictatorship, the Chinese contingent would hold the ruling majority—two votes, against one for Ireland and one for Switzerland. Christine and I try to recognize that the ethnic makeup of our family has changed. Jin Yu already sees that. About a year ago she began to comment on the fact that she looks different from her parents. The first time, we were having lunch at a favorite eatery, Vietnam Restaurant. Christine had taken Jin Yu to the bathroom. There, next to the commode, our daughter placed her arm beside that of her mother's.

"You have white skin," she said. "I have brown skin. I wish I had white skin."

Christine told Jin Yu that her brown skin was beautiful. That her skin helps make her who she is. That many, many people have different shades of skin color—and it doesn't matter, that what matters is what they have in their hearts and their heads.

Jin Yu responded, "I wish I had white skin."

After that she seemed to put the issue aside, not mentioning it again until a morning shortly before her sixth birthday. At breakfast she announced to her mom, "I wish I had a pointy nose like you." One of her friends had told Jin Yu that she had an "ugly flat nose."

Which hurt. Me more than her.

I understand that children will notice difference and comment

on it freely. What I don't understand is why one distinction or another must be defined as good or bad.

That morning I told Jin Yu she has the most beautiful nose I've ever seen. That her nose—her eyes, her mouth, every part of her—is stunning. But my words don't carry much weight. From me she expects complete support, or preferably, fawning admiration. She usually gets it. And that renders my opinion biased.

Jin Yu has also begun to construct an understanding of how she came to be with us. About a year ago, she began telling everyone we met that she had come here from China. Jin Yu would politely intro-duce herself by name, then brightly add, "I'm from China!" I didn't know what to make of it. I was glad she understood the rudiments of her origins, and that she considered her homeland worth brag-ging about. But I wondered why she felt it so important to share that information immediately.

The roles reversed when a friend from Shanghai, a woman named Hu Yan, came to our house to visit.

"Jin Yu," she asked, "do you know where I'm from? I'm from China."

Jin Yu paused, astonished. Then she blurted, "I'm from China too!"

She was so pleased. As if they belonged to the same sorority.

Today Jin Yu no longer informs everyone we bump into that she came here from China. Perhaps the psychic need that spurred that introduction has been met. Maybe she just wanted to hear how it would sound to say it out loud.

Now that she's six, I tend to think that her earlier declaration of origin was a means to lay a base for larger, harder questions.

Even as a toddler, Jin Yu was interested in the swollen bellies of pregnant women, amazed to hear that a baby was growing inside. She would tell Christine and me that she grew in the belly of one of

her nannies in Xiangtan. And we would gently correct her, saying that, no, while her nannies took care of her, she developed within the body of a different woman who gave birth to her in China.

For a long time Jin Yu never asked the logical follow-up question: where is she?

Then, the other day, Jin Yu was riding in the back of Christine's car, looking out of the window as they rolled past a neighbor's house adorned in blue ribbons and banners.

"They had a baby?" Jin Yu asked.

Yes, Christine told her, a son.

"He grew in his mommy's tummy?"

Yes.

"I grew in my nanny's belly?"

With this she was teasing.

But in her next question she took a step forward.

"Where is the woman who gave birth to me?"

And a few days later, she asked the toughest question of all:

"Why didn't she keep me?"

When it comes to China, to the orphanage, to her birth parents, Christine and I tell Jin Yu the truth, in digestible bits and appropriate language. When Jin Yu asks, "Where is she?" and "Why didn't she keep me?" I know she is not asking for a political dissertation on the nature and scope of the one-child policy. But at the same time, too often, when it comes to even the most basic details of her life story, the truthful answer is, "I don't know."

I don't know where to find your birth mother.

I don't know her name.

I don't know if you will ever get to meet her.

Jin Yu got quiet after hearing Christine's answers to her first questions. I'm sure more queries will be coming. And I know Jin Yu will be able to handle the answers.

She is so strong. So firmly planted. So proud to be Chinese and so comfortable being American. On Saturdays, as I watch her maneuver her shoulders under the furry, pink-and-silver lion head, her feet sketching the movements of a rite that connects her to the children around her and to ancestors unknown, I doubt she will grow up suspended between two cultures. I think she will live her life as a link between them.

Lately she's begun telling Christine and me that she wants to visit China.

I wonder what she expects to find there. It has been four years since she left Hunan, more than two since she last set foot in the country.

She has taken to watching repeated screenings of Disney's *Mulan*, with its bold, courageous heroine, a woman brave enough to take her ailing father's place in war. A woman who brings glory to her family, not by marrying well, but by employing her brains and strength to save all of China from the Hun hordes. Miss Fa Mulan, as Disney princesses go, is not a bad role model at all. Jin Yu pays attention to how Mulan talks with her father, to their debates over the meanings of responsibility and duty.

Not long ago, Jin Yu and I were walking up Eleventh Street in Philadelphia after a lion dancing performance, her one hand holding the flap-jawed head, the other nestled in mine. She seemed a little somber, as if something was on her mind. Finally she looked up at me and asked, "Did I bring honor to my family?"

I had to look away. I couldn't answer.

A moment later, I recovered enough to tell her: Yes, yes, my dear one, you have brought honor to your family. To all your family, everywhere.

WE FOLLOW our usual route to Chinatown, driving directly south down Broad Street, almost to City Hall, then turning left onto Vine Street, going east for five blocks, toward the Delaware River. It's Sunday morning and traffic is light.

We park in the lot on Ninth Street. I take Zhao Gu in my arms. Christine takes Jin Yu's hand. It's a glorious day, bright and breezy, the August sunlight just beginning to assume the quality of fall, casting the shadows just-so-much darker and longer.

We cross the street, stepping onto the sidewalk outside the Ocean City Restaurant. This place holds memories. Christine and I had lunch there a day after we received our first pictures of Jin Yu. I can still remember what I ordered. As a threesome, and now as a foursome, we go there for dim sum. In one restaurant picture window hangs a row of glazed ducks, their heads and feet still attached, their mouths open in silent protest. The other window displays tanks brimming with live lobsters and crabs.

Today we're not stopping to eat.

We continue down Ninth Street, past Amazing Jewelry, with its rows of jade bracelets in the window. Everything at Amazing Jewelry is expensive, but the wares are first-quality, and the husband-and-wife owners have incorporated an appealing Chinese tradition into their business: they'll bargain with you on the price.

We pass neighborhood families carrying sleeping babies and pushing babes in strollers. Seeing children so young always makes me wonder what Jin Yu looked like at that age. If as a baby she possessed the same feisty temperament she has now. The Chinese say that girls from Hunan are as spicy as the food, and they're absolutely right.

At the corner of Ninth and Race Streets looms the concrete edifice of the Verizon phone building. It seems incongruous, a tall block of cement and white brick dropped among older, lower, red brick

buildings. Around the turn of the century this corner was the site not of a telecommunications company but of a mysterious structure known as the House of a Hundred Rooms. Supposedly it was a brothel and a hideout for gangsters, sheltering lucrative Chinatown trades in opium, gambling, and smuggling. But nobody knows for sure. It was torn down to make way for a gas station, which later gave way to the phone building.

For most of its 135-year existence, and to a lesser extent today, Chinatown served as a gateway for immigrants, a first stop on their trek toward the American dream. Yet there is little in the way of recorded Chinatown histories to explain the way people lived here or how they felt about it. The residents were too busy trying to survive to worry about documenting the activities of their day-to-day routines. So the job of describing and defining Chinatown fell largely to local journalists, who saw the neighborhood as a foreign place, full of foreign people, worth noting only for some bit of entertaining exotica, or a Tong war, or perhaps at Chinese New Year, when the noise and smoke of firecrackers filled the streets.

Or when the city fathers needed part of Chinatown's land.

The four of us turn west on Race Street, our backs to the majestic Benjamin Franklin Bridge, its pale blue span soaring across the Delaware River and linking Pennsylvania to New Jersey. We walk past bakeries selling delicious cheese-and-corn buns, pharmacies offering herbs to cure every ailment, and shops trading in imported clay teapots. Halfway down the block we come to the H. K. Golden Phoenix Restaurant.

When I'm in Chinatown by myself, I always like to stop here for a minute.

This spot, with its cracked sidewalk and pile of construction debris across the street, is more than what it seems. It marks the heart of Chinatown, the place where the neighborhood began, the

spot where a man named Lee Fong established a hand laundry in 1870.

Chinese people had been living in Philadelphia for years by then, since at least 1845, operating laundries in scattered neighborhoods. But sometime after Lee Fong started his laundry, a restaurant opened on the second floor, the Mei-Hsiang Lou, a place where Chinese living far from home could find a familiar-tasting meal. With the convergence of those businesses, laundry and restaurant, Chinatown was born. More small stores and eateries settled nearby, drawing more Chinese, who drew more businesses.

Today two big plaques hang on the brown tile facade of the Golden Phoenix, marking the importance of 913 Race Street.

The plaques, one in English, the other in Chinese, recognize the sacrifice of all who came to the United States to seek the Gim San, the Gold Mountain. During the mid-1800s, more than a quarter of a million Chinese arrived in this country, attracted to jobs building the transcontinental railroad and the prospect of striking it rich mining gold in California. Very few became wealthy. Most lived out their lives in the bachelor societies that grew up in places like Philadelphia, New York, and Baltimore, the Chinese Exclusion Act having banned the men from bringing in wives.

Jin Yu is too young to read the words on the plaques, to know the hardship of the immigrants who came here from southern China. I hope that as she grows she will claim that history as part of her own, come to see herself as part of a continuous chain. After all she too is an immigrant, one who also left everything and everyone in China to find her future in this country.

Half a block on, the four of us reach the corner of Tenth and Race Streets, where we stop for a traffic light. If we kept walking we'd come to the Chung May Food Market. In the front of the store, twenty-five-pound bags of rice are stocked chest-high. In the back,

hundreds of hand-painted bowls and cups are stacked one atop the other. Search the nooks of Chung May and riches emerge—like 1950s-era tableware from the China Village Restaurant, which burned down in 1973. For a few dollars you can outfit your table with its dishes.

Chung May stands near Chinatown's western boundary. The physical size of the neighborhood has been shrinking for decades, pieces claimed for one public development project after another. The Vine Expressway sliced through the north end, sparing Holy Redeemer Chinese Catholic Church and School, a local institution, only after Chinatown residents laid down in front of the bulldozers. The Galleria shopping mall and the Market East train station took parts of the south side, while the Temple University podiatry school and the city Police Administration Building blocked expansion to the east.

Across the street from the Chung May Food Market stands part of Chinatown's newest challenge, and to local activists it represents a trend more ominous than any land grab.

The tall brick building at 1010 Race Street started out as a rocking chair factory, but today it's the TenTen condominiums. To the north, on Vine Street, the Grandview condominium project casts its lengthy shadow, and to the east the old Metropolitan Hospital has also been converted to expensive housing, penthouse apartments selling for $855,000. More condos are planned for other buildings.

The Center City housing boom is sweeping east, into places never before considered as sites for luxury housing. Chinatown activists fear the new developments will raise housing prices, rents, and taxes so high that the neighborhood's traditional working-class families will no longer be able to afford to live here. Chinatown, they worry, could be reduced from a living, breathing neighborhood to a touristy collection of restaurants.

We turn down Tenth Street, away from the new condos, past the Imperial Inn Restaurant, past the stands of plums and melons outside the King Market, past the fire station that's home to Engine Company 20 and Ladder 23, the House of Dragons. We turn right on Cherry Street—which appears to end at a brick wall. Actually the barricade is the east wall of the Pennsylvania Convention Center, another huge public development.

Jin Yu knows the way from here.

Halfway down the block, under a yellow awning, is a doorway marked by an elaborate painting of a Chinese dragon, its claws at the ready. Every Saturday morning Jin Yu goes through that door and up three flights of stairs, to the plank-floor studio of Cheung's Hung Gar Kung Fu Academy. Her teacher, always formally addressed as Sifu, is big and strong and stern and loves Jin Yu to death.

Today our destination is not the kung fu school but the building directly across the street. A few months ago, it was a plain brick storefront with a jutting picture window. Today it's as elaborate a building as can be found in Chinatown, its doorway protected by four fierce gold dragons that twist around tall red columns. Delicate portraits of Buddha and Kuan Yin frame the entrance, and overhead is a curved roof made of glazed ceramic tile, each block painted the color of sunset, a shade typically reserved for nobility.

The black-and-gold sign over the door is written in English though hardly anyone inside speaks a word. It says: FO SHOU TEMPLE.

The four of us step inside. Among strangers. Strangers and friends. There's a woman here who seems to be one of the organizers. She speaks decent English. I don't know her name, nor she mine. We recognize each other only by sight. As the renovations to the temple progressed, I would wander across the street to watch the workers while Jin Yu practiced her lion dancing. This woman and I

would chat about Buddhism and China, and how one connects to the other.

She wanted me to bring my children to visit. On a Sunday, when the monks would be here.

A LITTLE more than four years ago, upon boarding a flight that would carry us across the sea and into the arms of our first child, Christine and I were assigned to sit in row 59, an aisle number that matched the year of our births. At our first stop in Beijing, we were initially booked into the Taiwan Hotel, which happens to be located on Jinyu Road. In Changsha, our efforts to seek medical treatment for Jin Yu caused our paperwork to be filed a day behind that of everyone else in our group. That meant Jin Yu officially became our daughter on August 13—the anniversary of my father's death. When the three of us moved on to Guangzhou, to the ornate White Swan Hotel, we were assigned to room 1101—the number of the first house that Christine and I shared in Philadelphia.

Call those alignments whatever they may be—meaningless, coincidental minutiae, or signs that prove the existence of a greater, helping power. For me those matching dates and numbers were omens that offered assurance and continuity in a time of upheaval. That sense of connection followed me home. It's not that I'm superstitious or religious. My last visit to anything resembling a church was two years ago, in Guangzhou, when Christine and I held Zhao Gu as the monks bestowed their blessing.

Now, Christine and I have brought our girls here, to this small temple in Chinatown, to renew that baptism, that consecration. Today, two weeks after Jin Yu's sixth birthday, feels like the right time to be here, to offer our prayers. Mine is not a prayer of want but a prayer of gratitude.

Inside the temple, we are enveloped by a warm wave of scent and sound.

The smell is of incense, and freshly cut flowers, of oranges and pears and apples, set in bowls on the altar before three large golden statues of Buddha. The aroma is sweet but not cloying, not like a perfume, strong and artificial, but a bouquet produced by nature.

Twenty-five voices move together as one, the rhythmic hum of the chant rising and falling but never stopping. Christine can pick out some of the words. Earth. Moon. Sky. The song will go on for another hour, like a church hymn of endless verses.

Two nuns stand near the altar. One noticed us come in. She walks down the aisle to where we stand at the back. Her head is shaved, making it hard to tell her age. Maybe thirty, maybe fifty. Her robe is a rich chocolate brown. It matches her eyes. She welcomes us in broken English, then takes Jin Yu by the hand and leads her forward. Zhao Gu automatically follows.

At the altar, the nun hands each of my girls a lighted stick of incense—not a choice I would have made. But the girls hold the incense carefully and respectfully. Then the nun kneels down, showing them how to bow before Buddha.

Zhao Gu is a little confused. Why should she lie down here, in this strange place, when it's not even naptime? Jin Yu takes to it immediately. A dramatic role, with all eyes on her—what could be better?

Watching the three of them, nun and daughters, gathered under Buddha's munificent gaze, I think: Thank you. Thank you, Buddha. Thank you, God, thank you, Jesus. Thank you, Allah, Jehovah, Krishna, Yahweh, Vishnu. Whoever you are, whatever name you prefer, if you are out there, listening, then thank you. Thank you for leading Jin Yu and then Zhao Gu to us, and we to them. Thank you for the woman beside me. And for the people here, willing to wel-

come us into their place of worship. I ask your blessings not for me but for them and others: for the people in China who gave birth to my children, for the workers in the government who matched us one to the other.

The chant is soothing, a song unbroken. One woman has her faced clenched in prayer. Another stifles a yawn. A third is lost in the moment, her eyes dreamily unfocused. One young woman is half slumped on a kneeling pad, her hand against her forehead. She doesn't look well.

Jin Yu and Zhao Gu come back down the aisle, practically skipping. Jin Yu climbs into her mother's lap, Zhao Gu into mine. For the next hour they sit still, content to listen to the continuous purr of the chant. It moves like a musical ocean, one wave after another.

It is nearly noon when the service breaks. Jin Yu commences to making introductions all around, sharing her words and phrases of Chinese with the women who gather around her. We're invited to share the day's meal, to fill a plate with rice and dumplings. But we can't stay. The nun helps our girls make a final bow to Buddha, then walks us to the door. From a shelf she selects a porcelain-bead mala. She draws Jin Yu close, speaking words I can't hear. Jin Yu nods her head. The nun kisses the mala, then slips it onto Jin Yu's wrist.

My daughter has a question: "Can I have one for my sister?"

"Yes, yes," the woman laughs. She chooses a second mala for Zhao Gu.

Jin Yu is thrilled with her new treasure, not sure of its meaning but mesmerized by its beauty.

The nun opens the door, telling us to be sure to come back. We are always welcome here, she says. Our girls are always welcome here.

EPILOGUE

I CAN'T remember the first time Jin Yu smiled at me.

Those early days together were all fear and crisis.

And of course, I have no idea when it was that she took her first steps, spoke her first words, learned to eat with a spoon. These things, the milestones of parents' lives, she did with other people in another land, long before we met.

The first words she ever heard were in Chinese—in the time before she was born, still floating in the womb, a voice come down to her through a hundred generations. I wonder what those words were, how they helped to shape her. I wonder if even now, in some way, she misses the timbre of her birth mother's voice, misses its tones and inflections.

I know a part of Jin Yu misses China. Even if she doesn't know exactly what part that is, or what it is that she misses. Maybe it's the smells, or the sounds, or the color of the sky, things she would have sensed and seen even before she had the language to name them. For a long time after she came to us, Jin Yu would tell us dreamy, half-

Our family in Lanzhou, with our second daughter, Zhao Gu

remembered stories, shards of recollections of people or places in Xiangtan. She related these things matter-of-factly, granting them no greater significance, at least on the surface, than that of a cartoon she'd seen earlier in the afternoon.

In our first months together, Jin Yu's expression did not switch from frown to smile. Of course there were hours and even days when she giggled and laughed, periods when she happily, pluckily threw herself into the moment. But generally her outlook changed only little by little, the corners of her mouth creeping up, until her frown turned to neutrality, her neutrality to approval, her approval finally advancing into excitement.

Initially she was traumatized, a child forced through another jarring change in a life that had already seen too many.

Someday I will answer for that.

I came home from China expecting that Jin Yu's memories of the orphanage would wane, that its influence on her life would decrease as time went on. Now I'm not so sure. In a hundred ways on a hundred days I see the needs it created for my daughter—and the emotions it stirs in me.

Sometimes, when Jin Yu leaps into my arms and wraps her legs around my waist, I can feel her hip joint pop. So far the doctors have not been impressed. And it doesn't seem to cause her discomfort, though at times it ever-so-slightly throws off her gait when she runs. I suppose the catch in her hip could have been there from birth. But it also could have developed when she was living in Xiangtan, the result of a lack of exercise.

The scar on the side of her head remains a constant, enigmatic reminder of her missing past. Jin Yu never tries to hide the scar. She pulls her hair back or up in whatever style she fancies, scar be damned. She still occasionally raises the topic of how the wound got there, and of course we have little better answer to offer her than we did on the day she came to us.

Jin Yu periodically raises the topic of her life in the orphanage, usually to tell us that the nannies there took care of her. She says she misses them, and wonders if they miss her too. Christine and I tell Jin Yu we are sure they miss her very much. We try to keep in touch with the staff in Xiangtan, and with the people who tended to Zhao Gu at the orphanage in Wuwei. We write every year on the girls' birthdays, enclosing pictures, recapping the highlights of their lives during the past twelve months, trying to put into words all that our daughters mean to us.

Sometimes we get a letter back, sometimes not. It's impossible to know if our mail even reaches its destination.

The psychic impact of Jin Yu's two years without parents is hard to discern. For a long time, when Christine and I left the girls' room at night, Jin Yu would call for us to lock the door, saying, "I need the lock to stay safe!" It made me wonder: does she truly understand what it means to be safe? Did anyone in her former life take care to ensure not just that she was safe, but that she *felt* safe? When Jin Yu called out at bedtime, was she simply repeating a phrase she'd heard on television or telling us what she needed most?

At the same time, I know this: Jin Yu may have had tragic beginnings, but she is not a tragic figure. She is a girl who delights in the possibilities of each new day and in the potential of each new encounter—with a flower, a butterfly, or a friend about to be made.

At the park we stop to chat with a grandmother, who leans down to put her face even with that of my daughter.

"And what's your name, darlin'?" the woman asks.

"Um, Snow White," Jin Yu replies.

She's not being a smart-aleck. She just likes to be called that.

Her humor is so funny because it's so sincere. One time Jin Yu was being difficult—I can no longer remember the details. But I was lecturing her about how this behavior was going to stop, how her

conduct was going to change, going on and on in my parental admonitions, finally concluding, "What do you think?"

Jin Yu answered, solemnly: "I think there's something wrong with you."

I couldn't help but crack up. Heck, she's probably right.

Yet she'll turn serious at the most unexpected moments. On a recent Sunday, Christine and I were late getting the girls to bed. It had been a hectic day. Both Jin Yu and Zhao Gu were wound up, each trying to claim the same storybook. My back was aching, the house was a mess, and I was due at work especially early the next morning. I was turning out the light in their room, glad to close this portion of the day, when Jin Yu spoke up.

"Dad," she said, "I'm really glad you're my father."

What more could I ever need to hear?

FOR ME Chinese adoption is a continent of contradiction, a place where elation is paired with regret and hope stands as companion to sorrow. Adopting a child from China puts you through a transformation, gathering you up from one place, spinning you around, then setting you down somewhere else, facing backward. It changes your life in ways you never could have foreseen.

Joy? Certainly. Love? Absolutely.

But the process also generates a virulent strain of remorse, for actions taken or not, and enough guilt to fill a courthouse.

I have not set down my anger. Four years later, I carry it like a touchstone. In fact, instead of seeing my anger diminish, I have noticed the opposite, that it grows stronger and harder as time passes. The Chinese government left Jin Yu in a rundown orphanage for thirteen months *after* they received our adoption request. That I can't understand. Or forgive. Jin Yu could have gotten sick. Or even

died. Many children do. My daughter, my darling girl, could have died, right there in Xiangtan. I think about that a lot. About the faceless government pen-pusher who sent her there. About beating him bloody. But of course, it is not a man who sent my child to Xiangtan, not a person who kept her at the orphanage but a system, a set of laws and beliefs and mores. And conversely there is more to the story than anger, so much more to the tale than fury and blame and revenge.

My debt to the People's Republic, my gratitude, my appreciation, is endless and eternal. I could never repay what I owe or fully express my thanks. The people who run the government decided to let me have a daughter. And then to have a second. They allowed me to become a father. They trusted me. Here, in the land of my birth, edging into my forties, I would have been considered too old to adopt a child. In China, with a culture that venerates age, I wasn't seen as tired and worn—I was mature and settled, ready for parenthood's challenges.

I went to China thankful that no birth mother or father could ever hope to come searching for Jin Yu or to contact me. I came back certain that my child and her birth parents should meet. Soon. Or that at the least they should be in touch. So sure was I of my judgment, I nearly tried to find Jin Yu's birth parents on my own. Now, four years on, I believe it might benefit Jin Yu and her Chinese parents if they were to see one another—but not today. And not tomorrow. Some day, when Jin Yu is older, and then only if she so desires.

Sometimes I get mad at her Chinese parents, furious at these phantoms who have moved into my house. I get angry at them for deserting Jin Yu, for putting her at such risk. Newborn babies are fragile things, and leaving one outside is a good way to kill it. I get angry with them for delivering Jin Yu into the hands of an under-funded welfare system that didn't need another mouth to feed. I get

mad because I know in my heart that whatever penalty a govern-
ment might impose on me—halve my salary, take my job, knock
down my house, cut off an arm—I would never surrender Jin Yu. I
get mad and I think: *They had their chance. In fact they had the first
chance, and they blew it.*

But that bitterness rises only once in a while. Mostly, overwhelm-
ingly, I am grateful to these people, unnamed and unknown. They
carried Jin Yu to term and then put her in a place where they knew
she would be found. I judge them by the standards of the middle-
class, middle-aged American man that I am. But I know nothing of
their situation. The truth is they gave life to Jin Yu, the person who
has come to define my existence, and they suffered for it.

I know they suffer still. That on every August 2, Jin Yu's birth-
day, and every August 5, the anniversary of the day they set her down
in Guangxin Alley, they look to the heavens and wonder what has
become of their girl.

There is never a day I don't think about them. Never a day I
don't consider the paradox of our situations, don't ponder the cold
truth that my life's happiness springs from their life's anguish. A
Chinese acquaintance calls it "the burden of good fortune"—the
price that must be paid for having benefited so greatly from the mis-
fortune of another.

Someday I would like to go and find Guangxin Alley, to see the
place where Jin Yu's birth parents chose to leave her. Right now that
alley exists only in my head, forever changing shape and dimension.
I want to see the actual location. I think if I could see Guangxin
Alley, I would feel better. That to see Guangxin Alley, to walk its
length, tread its footfalls, would evoke a healing sense of union. That
for me, seeing Guangxin Alley would be similar to what others expe-
rience upon visiting the fields of great and decisive battles: here is the
place where everything changed.

I don't know if Jin Yu would want to see Guangxin Alley or not. During the last few months she has started asking Christine and me to take her to visit China. Other adopted Chinese girls, older, are beginning to make their first exploratory trips to their homeland. In a few years the eldest among them will begin to tell us what they think of their own experience, not just in conversation, but in essay, memoir, and film, in painting and sculpture. I am eager to hear what they will have to say. It is a pale conceit—one frequently expressed in this country—to believe that in all that these girls were forced to leave behind, they somehow traded up.

When Jin Yu asks to visit China, I tell her we will try to go in a few years, when she is old enough to carry some of her luggage, or at least keep track of her backpack, and when Zhao Gu doesn't require quite so much attention.

But even as I promise I wonder: who will welcome her back to China?

On that future day when Jin Yu returns, stepping off the plane and walking bleary-eyed into the arrival lounge in Beijing or Shanghai, who will be there to greet her? In America, Jin Yu's appearance was celebrated with balloons and ribbons and rainbow-colored banners that stretched the length of a room, proclaiming, WELCOME HOME. She was pulled into the arms of friends and family, smothered by their hugs and kisses, dampened by their tears.

Who will be there to meet her when she returns to China? Who will be there to say, Welcome. Welcome to the land of your birth, to the place of your ancestors, to the people who gave you your tastes, your looks, your first language?

No one.

The answer is, no one.

DURING OUR second trip to China, we renewed old friendships and forged new ones.

Inside the Forbidden City, its thick red walls the very emblem of governmental authority, a group of gangly, stubble-chinned teenagers timidly edged their way into our family picture. We wrapped our arms around their shoulders and welcomed them as distant cousins.

At a noodle house in Gansu, I forced down a bowl of yak-meat soup and thanked the waitress when she brought me more. It was that or go hungry. And she had no way of knowing I wasn't partial to yak.

On a lost, misguided trek to a Lanzhou art gallery, I met a young Tibetan who walked far out of his way to lead me back to a main road. And at a small restaurant near the ancient Drum and Bell Towers in Beijing, I sat with a friend, a Chinese woman who knows well her nation's complicated interactions with its daughters. She told me that I am a good man and my daughter is lucky. I told her it is the opposite. My daughter is good and I am lucky.

From this shore, relations with friends in China are carried forward by e-mail, letter, and phone call, by cards and packages that are sent there or arrive here. In this country, Christine and I make friends with Chinese expatriates based, at least initially, on nothing more than the fact that they and our children come from the same place.

These interactions no longer surprise me.

For you see, I have a relationship with China.

I have opinions about its leaders, its courts, its news media, and its military, about its governmental policies on everything from energy to flood relief. I feel that China and I are in touch, that we share common aims and interests, that what began as an obligatory exchange of paperwork has developed into a bona fide and ongoing rapport.

There's only one problem.

China has no relationship with me.

China doesn't know I exist. Or if it knows—the fact of my existence noted somewhere in a state file—it certainly doesn't care. For more than four years, I have been planning to travel to China, traveling in China, or returning from traveling in China. Yet I have passed through that land leaving no more trace, in the words of Pearl Buck, than a finger drawn through water.

I hold no stronger opinion about China than on the malevolence of its one-child policy, an evil from which I have most certainly and greatly benefited. To me, it's an outrage that a government—any government—would seek to dictate the size of its citizens' families. I think it's scandalous that a government would coerce women into mandatory abortion and sterilization, and a crime that a national network of orphanages teeming with little girls could somehow be regarded as normal.

I think the government needs to change its policy. I think it needs to encourage its citizens to keep, raise, and honor their daughters. I think it needs to create a plan—and set a deadline—for emptying the orphanages and finding homes with foster or adoptive parents for all the children who live there.

And I know China doesn't care what I think. Or what other people like me think.

But it may not enjoy that luxury much longer.

The United States is now home to nearly 62,000 adopted Chinese children, and that figure is increasing at a rate of more than 6,000 a year. In essence these girls have left the countryside for the city, shedding the confines and limitations of state orphanages for homes that, by American standards, are solidly middle-class and even upper-class. The eldest girls are now entering adolescence. They are smart, confident, assertive, fully Chinese by birth, fully American in their concepts of fairness and justice.

Here's one possible future:

That these girls, as they grow into their twenties and thirties, will turn toward China, not with open arms, but with raised fists. That they will demand answers—about their births and blood families, about the governmental regulations that drove them to America and across the world in this Asian diaspora. That they'll be abetted at every step by a second, larger army composed of their American parents, siblings, and friends.

American mothers and fathers know of their daughters what I know of my own: these girls are fierce. Determination is their common trait, intelligence their shared asset.

I wonder if the ruling party thinks about that. If it ever considers that, by allowing us our girls, it may actually be building a monster, lugging each part to service, tightening each bolt into place.

What might these girls want from China?

Much.

Maybe the creation of a DNA database, where their birth mothers and birth fathers could register without fear of reprisal. Where Chinese parents who have abandoned a child would be *encouraged* to register. The construction of a databank, a common area where children and parents could look for one another, would be complicated but hardly impossible. In the six months surrounding the date when Jin Yu was found in Guangxin Alley, at least twenty-six other babies were abandoned in the same area. That's too many. But not too many to check.

DNA already is being used in this country to locate the blood siblings of Chinese daughters—girls born into the same family in China, abandoned, then adopted into different homes in the United States. Even without the aid of a central registry, several sets of matches have been made.

What else might these girls want? Perhaps an end to the one-child policy, or at the least, an end to the life-altering punishments

meted out to its violators. They may want reparations paid to the families who have been torn asunder. Real changes in the way China treats women. A dismantling of the orphanage system that holds untold thousands of their peers. At a minimum, or more likely as a starting point, they may want an apology—to the women and men who were compelled to surrender children of their own flesh and blood, to the thousands of girls taken from their homeland and spirited across the seas.

For the Chinese government to congratulate itself that these girls are better off in foreign homes than in state orphanages—and for American parents to do the same—misses the point.

These girls could be aided by internal pressures within China. Today, ultrasound technology is being used, not to check the health of fetuses but to identify females, who are then aborted. So many girls have been lost that China now suffers from a "gender gap" in which births of boys far outnumber those of girls—by 117 to 100, when the natural ratio should be about 106 to 100. That means many men in many parts of the country can forget about getting married. There just won't be enough women.

Of course, none of these changes, even if sought, would come easily. The government insists the restraints of its birth-planning policy have prevented disastrous famine, and famine is a powerful word in China, a land where death by starvation dwells within living memory.

Trying to introduce lasting changes in the way Chinese society values women could be, if anything, more difficult.

It's also possible the adopted girls will have no interest in any of this. It's possible they will grow to regard China as an evening moon—pretty to look at from a distance. I think of my own life: my paternal grandmother spoke Gaelic to her children. But a mere two generations later, only a few members of her family can speak more

than a few words, and those as a curiosity. For my grandmother's grandchildren, myself included, Ireland is not the great mother country, missed and longed for, but just another place we might someday like to visit, like Wales.

But China is not Ireland. These girls are pulled toward China by more than tourism. These children are big in number—one out of three international adoptions now comes from China. And they're already more organized and unified than previous groups of adoptees, brought together under the umbrella of Families with Children from China, a national support-and-education organization with a chapter or chapters in nearly every state.

In the Philadelphia area, FCC–Delaware Valley has grown from a handful of people gathered around a kitchen table to an active nonprofit organization of more than two hundred families. Across the Delaware River in New Jersey is another chapter with another two hundred families. FCC-sponsored speakers, seminars, discussion groups, and banquets help bring China into the children's lives.

My local chapter, like others elsewhere, finds itself struggling to hold the interest of the older girls. As they hit ten, eleven, twelve, school events and sports begin to take precedence. The girls have friends outside of FCC and want to spend time with them. But there's no reason to think they won't regroup later, as they examine and explore their own experience. Perhaps they'll even organize under their own banner, separate from that of their parents. Maybe CFC? Children with Families in China?

SOME PARENTS have it all planned out: their daughter will go to Harvard, earn a degree in Asian studies, then get a high-paying job in international finance that allows her to work in Beijing for six months of the year.

Me, I try to resist the urge to chart Jin Yu's life. Doubtless she will have a plan of her own. And it probably will be different from anything I might have selected.

It's true that I hold out for China more than she does, that I consciously try to connect her to a sense of the place and its people. I resist the Americanization of my daughter. But Jin Yu lives in the present and the future, not the past. She told me the other night that she wants to be a lifeguard, "because I like blowing the whistle." So she'll have that to fall back on, in case the job as a princess doesn't work out.

Some parents also think it's wrong to share the story of an adoption, wrong to share any details at all, that the story belongs to the child. That's fair enough—this is Jin Yu's story. But it is my story too. As her life has been altered, so has mine, in ways I never could have anticipated and, where she is directly concerned, all for the better.

Having a daughter from China makes you more a citizen of the world. It makes you live in several places at once. News of a flood that kills dozens in southern Hunan is no longer a far-off event, an item to be skimmed in the world-roundup column of the newspaper, but a real and proximate disaster.

When you're young and single, or half of a young married couple, you wish for things: a bigger apartment, a better car, concert tickets. When you are an older parent, like me, the thing you want most is the one that money can't buy: time. Time to see your children grow, to see the arc of their lives take direction. Jin Yu is already six, and Zhao Gu has grown from one to three in what seems like the space of a day. When my youngest is twenty, in the middle of college, I'll be past retirement age. When she turns thirty-five, the point at which many people first begin to understand some of what their parents went through and how it shaped their lives, I'll be close on eighty, if I'm here at all.

I don't want Harvard. I want time.

When I was younger, and vaguely considering some future day when children might arrive, I thought, *Give me a son and I will know how to raise him*. Give me a son, because I will know how to take him to ball games, how to wrestle and roughhouse, when to leave him alone with his thoughts, and when to come down hard before he does something stupid. I never lost touch with my inner sixteen-year-old, and that is a useful tool in raising a child of the same gender.

But it turns out that having a daughter is easier in so many ways. Fathers and sons, they're too much alike. Even in the best relationships—and I'd put that of my father and me in that category—it can be hard to state what you need and say how you feel. I can remember the day my dad dropped me off at college, six hours from home. I knew what he wanted to say: "You'll be fine. I'm proud of you. I love you." Instead, he looked off into the distance and said softly, "Well, kick you out of the nest . . ."

It's not that I didn't know how he felt. I knew. He didn't have to say it. If he had, I'd probably have been embarrassed.

But now, as a father myself, I don't leave my feelings for my daughters to their intuition. They hear that I love them at breakfast and at dinner and all through the day. They are probably bored to death of hearing it.

I can remember the precise moment when Jin Yu first spoke the word *love*. It was nearly a year after she'd left China. She was still learning English, figuring out what these new words meant and how they fit together. The three of us were in a rental car in Texas, cruising along an interstate on the outskirts of downtown Austin, heading to dinner at a restaurant called Manuel's. It was near the end of the first Hunan reunion, and most of the other families were already heading back to homes across the state and country.

Our friends Jim and Nina were traveling in the car ahead of us with their daughter, Eliza, who like Jin Yu had spent her first two years in Xiangtan. Without preamble, Jin Yu, then three, reached out her arms and hollered, "Eliza! Eliza!" She yelled so loud it was as if she were trying to shout through the windshield. Then she wrapped her arms around her shoulders, gave herself a big hug, and said, "Love Eliza!"

Christine and I had been waiting to see when Jin Yu would employ this word, how she would measure its meaning. If she would view the phrase "I love you" as a rare gift to be bestowed or nothing more than a common expression, the three words she heard every night at bedtime.

Plainly, she understood. And how appropriate that in staking her claim to love she would name one of her Xiangtan sisters. After all, at that point she had known them twice as long as she'd known us.

I think about what I will tell Jin Yu about her time in Xiangtan, now that she's getting older and asking questions. Most kids in America come to their families from hospitals, not orphanages. She's different from her friends in that way. At some point they'll ask her about it. On the other hand, in our home *orphanage* is not a scary word, a synonym for desertion. I'm fortunate to be able to tell Jin Yu that her mom and I met the orphanage director, Peng Liang, and he seemed to be a man of infinite patience. That he knew each of the children by name, and that he appeared happiest when one or another of them was climbing in or out of his lap. I can honestly tell Jin Yu that Peng and his staff seemed to be doing the best they could under difficult conditions.

In the summer of 2006, our family journeyed to Austin for the annual Hunan travel-group reunion. The eldest among our girls is now nearly seven. Five of the families have welcomed new sisters from China. We parents are no longer busy adopting children, we

are busy raising them. And busy doesn't begin to describe it. These days the conversation is more about lost teeth than lost cultures. We talk less about what the girls remember of China and more about their impressions of kindergarten and first grade.

Nine of the fourteen families attended the first reunion. Five made it this time. I suppose that for some, as China recedes, the allure of flying across the country for a few days of what amounts to an elaborate playdate may lose its appeal. Already some have fallen to once-a-year contact with a Christmas card, others less than that. I understand. Our girls demand a lot of attention.

Their lives are constantly changing. Jin Yu's life is changing. And not always for the better. In the brief time she has been with us, she has lost a grandmother she knew and loved. She has suffered other, lesser losses as well—her dog Mersey, and Bela, the one cat that would tolerate her affections. Our beloved pediatrician, Leslie Sude, has moved from the area.

Chinese adoption is changing too, in ways big and small.

Since the time when Christine and I first began the process to adopt a daughter, the Chinese government has established, and then eliminated, a cap on the total permissible number of foreign adoptions. It instituted a quota on adoptions by single parents, a group that previously constituted about 30 percent of the total. In early 2007, new regulations barred all adoptions by single parents—and by people who were over fifty, obese, or taking medication for anxiety or depression.

The process continues to require a healthy dose of pre-parental humiliation, like being fingerprinted, and having to ask friends to write letters attesting to your fitness. The waiting period, near a peak of fifteen months when Christine and I adopted Jin Yu, dropped to a relatively speedy seven months, then crept back up to a year and, as of this writing, stands at fourteen months. The facilities and care

provided in many Chinese orphanages have improved dramatically, assisted by new initiatives from within the People's Republic and by money, staff, and resources delivered from outside by charitable organizations like Half the Sky. The fact of child abandonment endures.

In Guangzhou, the final stop and point of departure for new American parents, the section of the U.S. consulate that handles adoptions has moved off of Shamian Island and into new offices in the Tian He District. People still love to stay at the White Swan, though.

These days I hear more about parents being given the tokens that were once routinely withheld—the clothing their child was wearing the day she was found, a photo taken by an orphanage staffer, the blanket their daughter slept with at night. When Zhao Gu was found outside the gate of the Wei'an health center, a note of good-bye was tucked into her wrap. I didn't learn of that by writing to the Chinese government and begging for a copy. The original was turned over to Christine and me in Lanzhou, a great and generous gift, presented as a matter of course along with the standard adoption paperwork. They gave us Zhao Gu's "finding ad" too.

It's almost like all of us are learning, getting better at this as we go along.

It will be fascinating to see what the years bring, how the adoption program will change as China continues its rush to modernization. And to see how the daughters of China living in this country react to those changes, and maybe even help propel some of them into being.

Right now, of course, most of the girls are busy being children. Mine certainly are.

Jin Yu likes her *Leapster Animal Genus* game, adores Angelina Ballerina and Mickey Mouse Clubhouse, is discovering *The Wizard*

of Oz. She takes equal delight in watching Chinese-language videos like *Follow Jade* and *Ni Hao Little Friends* and in surprising people we meet in Chinatown by speaking a few phrases in Mandarin. She loves lion dancing too, maybe even most of all. It has become not just part of her routine but part of her identity.

Early on, Christine and I decided that Jin Yu—and then her sister—would keep her Chinese name. We felt she had been given a lovely name, one chosen with care, and that by retaining it we would show our respect to China and encourage our daughter to do the same.

I wonder how those elements will blend within Jin Yu, the pull of the past and the push to the future. I wonder, years from now, when Jin Yu examines her heart, will she feel Chinese? Or American? Or both?

I wonder, but I do not worry.

I look at her now, and I can tell: she will be just fine. And that knowledge provides real comfort.

Watching her, fully six, my concern is not that Jin Yu will be unable to make her way in this world, but the opposite—that her brains and beauty will bring her too much, too easily. I know that whatever I do or don't do for her, Jin Yu will be able to navigate her way through life, to find her place in the changing landscape of America, and possibly even in China.

ON MY desk at the newspaper is a family photo, taken not long after our second daughter was placed in our arms. We are standing in front of a Buddhist temple in Lanzhou, in western China, our first time back in the country since adopting Jin Yu.

Our new baby, Zhao Gu, is content and sleepy-eyed, ready to take a snooze against her mom. Jin Yu is happily perched on my

shoulders, eating a snack of cereal from a plastic bag. But we are not the only people in the picture. Leaning into the frame, turning our foursome into five, is an old woman, her face lined, her hair a whitish gray. She peeks over Christine's shoulder.

I don't remember her being there when the picture was snapped.

Looking at this photo now, I imagine that this elderly woman is not merely another Buddhist come to worship on her knees. I imagine that she is a ghost. And not just any ghost, but a familial relation to my Jin Yu, a long-ago matriarch of her clan, made momentarily real and inadvertently captured by the camera's flash.

I like to imagine that this woman has journeyed through time and space to check on our family, to be sure that Jin Yu is happy and healthy, and that the couple entrusted with her care is worthy of the privilege and up to the task. I imagine that this long-dead ancestor allowed herself to be recorded on film to remind us that our girl's life did not begin at the moment she stepped into our arms. To remind us that Jin Yu has family in China, in this world, and in other worlds as well, people who will love her and watch over her no matter where she might live or what forces might separate them. I imagine that by her presence this woman is saying, Remember. Remember us. Remember this place.

Of course it's just a daydream. I know the old woman is no more than a passerby, intrigued by the spectacle of a foreign couple holding two Chinese children. But that knowledge doesn't diminish my image of her as a spirit come from the afterlife.

I have brought many ghosts home from China. I can always make room for one more.

ACKNOWLEDGMENTS

JOAN DIDION wrote: "A place belongs forever to whoever claims it hardest, remembers it most obsessively, wrenches it from itself, shapes it, renders it, loves it so radically that he remakes it in his image."

For a long time now I have been thinking about a place, a gritty, smog-choked city in Hunan Province, China, and about a time, the moment when I first became a father. In these pages I have attempted to accurately render the events of that day and those that followed, and through that to claim them forever, to remember most obsessively. I hope that someday one or both of my daughters will answer this book with a book of her own.

This work evolved over a period of years, and during that time I benefited from the skill and support of many people.

Foremost, I would like to express my profound gratitude to Avery Rome, my editor, my friend, my big sister. Avery gave freely of her time, expertise, and ideas to shape this book from its inception. She showed me a path through these pages when I could not see one for myself.

I'm indebted to the editors at the *Philadelphia Inquirer*—senior and junior, past and present—who have encouraged me to write about Chinese adoption and to tell the stories of the children, including my own. My work at the newspaper, particularly in the Sunday magazine, provided an invaluable springboard for this book. Thanks especially to Tom McNamara and Jill Kirschenbaum.

Editors Nancy Cooney, Eugene Kiely, and Linda Hasert, besides being great journalists and friends, graciously allowed me a leave of absence to complete this work. Colleagues Jennifer Lin and Karl Stark provided helpful advice, Denise Boal never met a question she couldn't answer, and the sharp pencil of Sharon O'Neal helped refine the early and late drafts.

Three people set my course in newspapers and thus in life, and my debt to them is enduring. Thank you, William K. Marimow, Maxwell E. P. King, and Robert J. Rosenthal.

Like everyone else who thinks or writes about Chinese adoption, I am indebted to Kay Ann Johnson at Hampshire College for the excellence of her research and her willingness to discuss it. Nobody knows more about Chinese orphanages than Kay. Likewise, thanks to Ellen Herman at the University of Oregon for her work in documenting the history of adoption in this and other countries. Some information in chapter 2 on the origins of foreign adoption comes from the Adoption History Project, which Ellen created and maintains at http://darkwing.uoregon.edu/~adoption/.

I would like to thank Lisa See for her interest and encouragement.

Fredrica S. Friedman, my literary agent and a woman of wise counsel, worked tirelessly on my behalf. Thank you, Fredi. (And thanks Peggy Anderson for the introduction.)

This work has profited from the guidance of a great book editor. My deep appreciation to Jennifer Brehl at William Morrow/Harper-

Collins for her deft hand and sound advice. Thanks also to associate editor Katherine Nintzel—the Great Kate—for her endless assistance and constant good humor.

Perhaps better than most, I know family is where you find it, and mine has been large and caring. My love and thanks to Lil, Dave, and Ellen, Tanya and Jack, Rena and her girls, and of course, all the families who took part in the journeys to Hunan and Gansu Provinces.

I would like to recognize and honor my daughters' Chinese parents, whoever they are and wherever they may be. No words can sufficiently convey my debt and obligation to them.

My father, the late William C. Gammage, may have been the last man in America to subscribe to three daily newspapers, and he often bought a fourth at the newsstand. My mother, Esther M. Gammage, is never without a book or a crossword puzzle. In me they instilled a love of the written word. I am forever grateful to my parents, and grateful for them.

Last, and most of all, my abiding love and gratitude to my wife and best friend, Christine, whose optimism and enthusiasm bring joy and laughter to our lives together. Christine's persistence set us toward China and her patience enabled me to tell this story. As our daughters sing in mystical tribute, "She's a mom, and she's a bird. . . ."

RESOURCE GUIDE

Jeff Gammage's Picks

FICTION ABOUT CHINA

Snow Flower and the Secret Fan, by Lisa See

The Good Earth, by Pearl S. Buck

China Men, by Maxine Hong Kingston

Typical American, by Gish Jen

Sons of Heaven, by Terrence Cheng

The Bonesetter's Daughter, by Amy Tan

NONFICTION ABOUT CHINA

Confessions: An Innocent Life in Communist China, by Kang Zhengguo

On Gold Mountain: The One-Hundred-Year Odyssey of My Chinese-American Family, by Lisa See

The Chinese in America, by Iris Chang

Coming Home Crazy: An Alphabet of China Essays, by Bill Holm

A Great Wall: Six Presidents and China: An Investigative History, by Patrick Tyler

The Good Women of China, by Xinran

BOOKS ABOUT CHINESE AND INTERNATIONAL ADOPTION FOR ADULTS

The Language of Blood, by Jane Jeong Trenka

I Wish for You a Beautiful Life: Letters from the Korean Birth Mothers of Ae Ran Won to Their Children, by Sara Dorow

The Lost Daughters of China: Abandoned Girls, Their Journey to America, and the Search for a Missing Past, by Karin Evans

Wanting a Daughter, Needing a Son: Abandonment, Adoption, and Orphanage Care in China, by Kay Ann Johnson

A Single Square Picture: A Korean Adoptee's Search for Her Roots, by Katy Robinson

BOOKS ABOUT CHINESE ADOPTION FOR CHILDREN

Kids Like Me in China, by Ying Ying Fry

When You Were Born in China: A Memory Book for Children Adopted from China, by Sara Dorow and Stephen Wunrow

The Red Blanket, by Eliza Thomas and Joe Cepeda

I Love You Like Crazy Cakes, by Rose A. Lewis and Jane Dyer

Motherbridge of Love, author unknown, illustrated by Josee Masse

The Red Thread: An Adoption Fairy Tale, by Grace Lin

CHILDREN'S BOOKS ABOUT CHINA

Chopsticks, by Jon Berkeley

The Seven Chinese Sisters, by Kathy Tucker and Grace Lin

Colors of China, by Iris Siao, Ken Lay, and Monique Jansen, available at www.momobooks.com

We're Riding on a Caravan: An Adventure on the Silk Road, by Laurie Krebs and Helen Cann

Coolies, by Yin and Chris Soentpiet

D Is for Dancing Dragon: A China Alphabet, by Carol Crane and Zong-Zhou Wang

WEB SITES

www.fwcc.org — National organization of Families with Children
from China

www.halfthesky.org — Half the Sky charity

www.lovewithoutboundaries.com — Love Without Boundaries charity

www.chinadaily.com.cn — Officially sanctioned news from *China Daily*

www.mocanyc.org — Museum of Chinese in America

www.aiisf.org — Angel Island Immigration Station Foundation

MAGAZINES

Adoptive Families, on the web at www.adoptivefamilies.com

Mei Magazine, on the web at www.meimagazine.com

DVDS AND VIDEOS

Found in China, by Carolyn Stanek

Globe Trekker: Chinatown

Globe Trekker: Unltimate China

China from the Inside, by PBS Home Video

Look Forward and Carry On the Past: Stories from Philadelphia's Chinatown,
by Debbie Wei, Barry Dornfeld, and Debora Kodish, available from the
Philadelphia Folklore Project at www.folkloreproject.org